Art as Therapy

Alain
de Botton
John
Armstrong

Φ

What is Art for?

The modern world thinks of art as very important – something close to the meaning of life. Evidence of this elevated regard can be found in the opening of new museums, the channelling of significant government resources towards the production and display of art, the desire on the part of the guardians of art to increase access to works (especially for the benefit of children and minority groups), the prestige of academic art theory and the high valuations of the commercial art market.

Despite all this, our encounters with art do not always go as well as they might. We are likely to leave highly respected museums and exhibitions feeling underwhelmed, or even bewildered and inadequate, wondering why the transformational experience we had anticipated did not occur. It is natural to blame oneself, to assume that the problem must come down to a failure of knowledge or capacity for feeling.

This book argues that the problem is not primarily located in the individual. It lies in the way that art is taught, sold and presented by the art establishment. Since the beginning of the twentieth century, our relationship with art has been weakened by a profound institutional reluctance to address the question of what art is for. This is a question that has, quite unfairly, come to feel impatient, illegitimate, and a little impudent.

The saying 'art for art's sake' specifically rejects the idea that art might be for the sake of anything in particular, and therefore leaves the high status of art mysterious – and vulnerable. Despite the esteem art enjoys, its importance is too often assumed rather than explained. Its value is taken to be a matter of common sense. This is highly regrettable, as much for the viewers of art as for its guardians.

What if art has a purpose that can be defined and discussed in plain terms? Art can be a tool, and we need to focus more clearly on what kind of tool it is – and what good it can do for us.

Art as a Tool

Like other tools, art has the power to extend our capacities beyond those that nature has originally endowed us with. Art compensates us for certain inborn weaknesses, in this case of the mind rather than the body, weaknesses that we can refer to as psychological frailties.

This book proposes that art (a category that includes works of design, architecture and craft) is a therapeutic medium that can help guide, exhort and console its viewers, enabling them to become better versions of themselves.

A tool is an extension of the body that allows a wish to be carried out, and that is required because of a drawback in our physical make-up. A knife is a response to our need, yet inability, to cut. A bottle is a response to our need, yet inability, to carry water. To discover the purpose of art, we must ask what kind of things we need to do with our minds and emotions, but have trouble with. What psychological frailties might art help with? Seven frailties are identified, and therefore seven functions for art. There are, of course, others, but these seem to be among the most convincing and the most common.

Methodology

The Seven Functions of Art

— I

Remembering

We begin with memory: we're bad at remembering things. Our minds are troublingly liable to lose important information, of both a factual and a sensory kind.

Writing is the obvious response to the consequences of forgetting; art is the second central response. A foundational story about painting picks up on just this motive. As told by the Roman historian Pliny the Elder, and frequently depicted in eighteenth- and nineteenth-century European art, a young couple who were much in love had to part, and, in response, the woman decided to trace the outline of her lover's shadow. Out of a fear of loss, she made a line drawing on the side of a tomb using the tip of a charred stick. Regnault's rendering of the scene is particularly poignant (1). The soft sky of evening hints at the close of the couple's last day together. His rustic pipe, a traditional emblem of the shepherd, is held absentmindedly in his hand, while on the left a dog looks up at the woman, reminding us of fidelity and devotion. She makes an image in order that, when he has gone, she will be able to keep him more clearly and powerfully in her mind; the precise shape of his nose, the way his locks curl, the curve of his neck and rise of his shoulder will be present to her, while, many miles away, he minds his animals in a verdant valley.

It doesn't matter whether this picture is an accurate rendition of the origins of pictorial art. The insight it offers concerns psychology rather than ancient history. Regnault is addressing the big question – why does art matter to us? – rather than the minor puzzle of what was the first pictorial effort. The answer he gives is crucial. Art helps us accomplish a task that is of central importance in our lives: to hold on to things we love when they are gone.

Consider the impulse to take photographs of our families. The urge to pick up a camera stems from an anxious awareness of our cognitive weaknesses about the passage of time: that we will forget the Taj Mahal, the walk in the country, and, most importantly, the precise look of

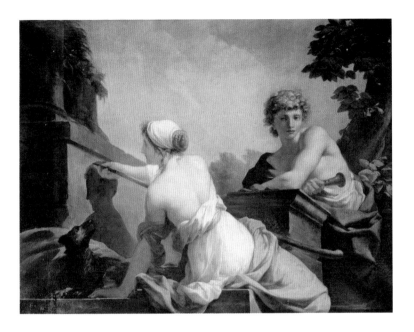

I don't ever want to forget the
way you look tonight.
—1. Jean-Baptiste Regnault,
The Origin of Painting:
Dibutades Tracing the Portrait
of a Shepherd, 1786

a child as they sat building a Lego house on the living room carpet, aged seven-and-three-quarters.

What we're worried about forgetting, however, tends to be quite particular. It isn't just anything about a person or scene that's at stake; we want to remember what really matters, and the people we call good artists are, in part, the ones who appear to have made the right choices about what to commemorate and what to leave out. In Regnault's image of painting, it is not simply the overall form of the departing lover that the woman wishes to keep in mind. She wants something more complex and elusive: his personality and essence. In order to achieve this, an art object needs to attain a certain level of sophistication. There are many things that could be recorded about

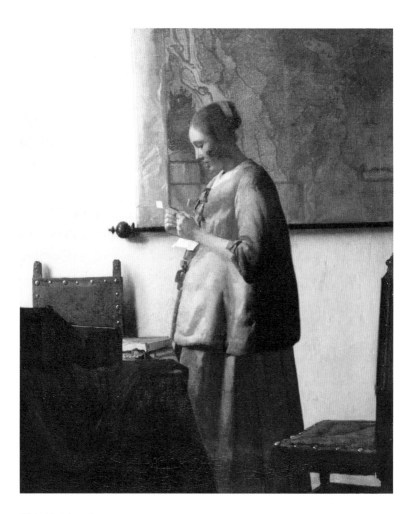

We don't just observe her, we
get to know what is important
about her.
— 2. Johannes Vermeer,
Woman in Blue Reading
*a Letter, c.*1663

a scene, a person or place, but some are more important than others. We describe a work of art, which might include a family photograph, as successful when it manages to foreground the elements that are valuable but hard to hold on to. We might say that the good artwork pins down the core of significance, while its bad counterpart, although undeniably reminding us of something, lets an essence slip away. It is an empty souvenir.

Johannes Vermeer deserves his status as a great artist precisely in this regard because he knows how to commemorate the appropriate details. The woman depicted in *Woman in Blue Reading a Letter* would often have looked rather different, such as when she was bored, cross, busy, embarrassed or laughing (2). There could have been lots of ways to paint 'her', but Vermeer has selected a particular situation and moment, when she is taken up, unselfconsciously, in thinking about a distant person or issue. By creating an atmosphere of intense stillness he conveys her capacity for absorption. The way her hands are holding the letter seems idiosyncratic: she lightly clenches her fists when another person might support the letter on their open fingers. Perhaps this is a continuation of a clumsiness of early childhood. We can see her quiet intensity in the slight pull of her mouth as she reads. Vermeer encourages us to look carefully at this part of her face by setting it against a map that is a very similar colour to her skin, almost as though her mind is off somewhere inside the map itself. The clear light is, perhaps, a bit like her mind, which may operate with a clear, steady emotional brightness. Vermeer captures the core of his sitter's personality. It is not just a record of a person, it is an image of what she was like in a particularly characteristic mood.

Art is a way of preserving experiences, of which there are many transient and beautiful examples, and that we need help containing. There is an analogy to be made with the task of carrying water and the tool that helps us do it. Imagine being out in a park on a blustery April day. We look up at the clouds and feel moved by their beauty and grace. They feel delightfully separate from the day-to-day bustle of our lives. We give our minds to the clouds, and for a time we are relieved of our preoccupations and placed in a wider context that stills the incessant complaints of our egos. John Constable's cloud studies

invite us to concentrate, much more than we would normally, on the distinctive textures and shapes of individual clouds, to look at their variations in colour and at the way they mass together (3). Art edits down complexity and helps us to focus, albeit briefly, on the most meaningful aspects. In making his cloud studies, Constable didn't expect us to become deeply concerned with meteorology. The precise nature of a cumulonimbus is not the issue. Rather, he wished to intensify the emotional meaning of the soundless drama that unfolds daily above our heads, making it more readily available to us and encouraging us to afford it the central position it deserves.

— 2
Hope

The most perennially popular category of art is the cheerful, pleasant and pretty kind: meadows in spring, the shade of trees on hot summer days, pastoral landscapes, smiling children. This can be deeply troubling to people of taste and intelligence.

The love of prettiness is often deemed a low, even a 'bad' response, but because it is so dominant and widespread it deserves attention, and may hold important clues about a key function of art. At the most basic level, we enjoy pretty pictures because we like the real thing they represent. The water garden that Monet painted is itself delightful, and this kind of art is especially appealing to people who don't have what it depicts (4). It would be no surprise to find a reproduction of a painting evoking watery, open-air serenity in a noisy, urban, high-rise flat.

The worries about prettiness are twofold. Firstly, pretty pictures are alleged to feed sentimentality. Sentimentality is a symptom of insufficient engagement with complexity, by which one really means problems.

The pretty picture seems to suggest that in order to make life nice, one merely has to brighten up the apartment with a depiction of some flowers. If we were to ask the picture what is wrong with the world, it might be taken as saying, 'you don't have enough Japanese water gardens' – a response that appears to ignore all the more urgent

problems that confront humanity (primarily economic, but also moral, political and sexual). The very innocence and simplicity of the picture seems to militate against any attempt to improve life as a whole. Secondly, there is the related fear that prettiness will numb us and leave us insufficiently critical and alert to the injustices surrounding us.

For example, a worker in a car factory in Oxford might buy a pretty postcard of nearby Blenheim Palace, the historic seat of the Dukes of Marlborough, and overlook the injustice of the undeserving aristocrat who owns it (5). The worry is that we may feel pleased and cheerful too readily – that we will take an overly optimistic view of life and the world. In short, that we will be unjustifiably hopeful.

However, these worries are generally misplaced. Far from taking too rosy and sentimental a view, most of the time we suffer from excessive gloom. We are only too aware of the problems and injustices of the world – it's just that we feel debilitatingly small and weak in the face of them. Cheerfulness is an achievement, and hope is something to celebrate.

If optimism is important, it's because many outcomes are determined by how much of it we bring to the task. It is an important ingredient of success. This flies in the face of the elite view that talent is the primary requirement of a good life, but in many cases the difference between success and failure is determined by nothing more than our sense of what is possible and the energy we can muster to convince others of our due. We might be doomed not by a lack of skill, but by an absence of hope. Today's problems are rarely created by people taking too sunny a view of things; it is because the troubles of the world are so continually brought to our attention that we need tools that can preserve our hopeful dispositions.

The dancers in Matisse's painting are not in denial of the troubles of this planet, but from the standpoint of our imperfect and conflicted – but ordinary – relationship with reality, we can look to their attitude for encouragement (6). They put us in touch with a blithe, carefree part of ourselves that can help us cope with inevitable rejections and humiliations. The picture does not suggest that all is well, any more than it suggests that women always take delight in each others' existence and bond together in mutually supportive networks.

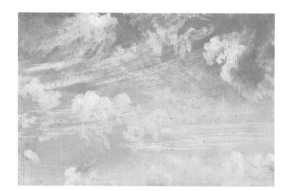

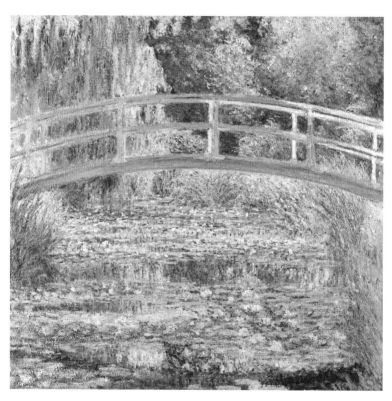

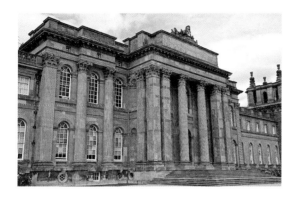

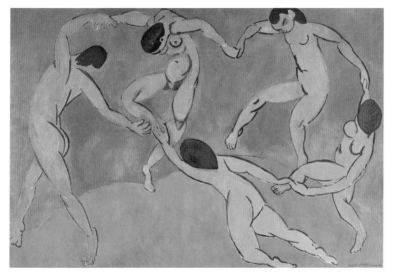

LEFT

*People without much of
an education in art tend to
think that art should be about
'pretty things'. The cultural
elite gets very nervous about
this. Beauty has been under
suspicion for a while.*
— 4. Claude Monet,
The Water-Lily Pond, 1899

TOP

*You have the postcard,
I'll keep the palace.*
— 5. John Vanbrugh,
Blenheim Palace,
*c.*1724

ABOVE

What hope might look like.
— 6. Henri Matisse,
Dance (II), 1909

It's sweet, but why might it
also make us tearful?
— 7. Sainte-Chapelle Virgin
and Child, before 1279

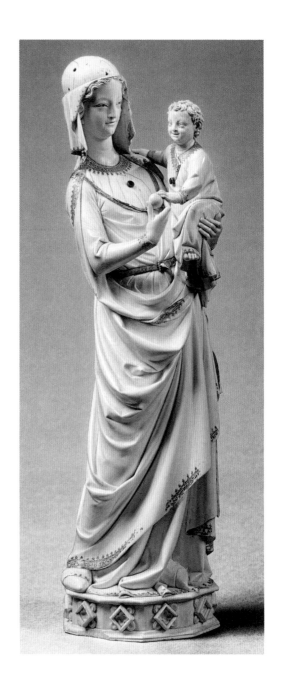

If the world was a kinder place, perhaps we would be less impressed by, and in need of, pretty works of art. One of the strangest features of experiencing art is its power, occasionally, to move us to tears; not when presented with a harrowing or terrifying image, but with a work of particular grace and loveliness that can be, for a moment, heartbreaking. What is happening to us at these special times of intense responsiveness to beauty?

The most striking feature of the small ivory statuette of the Virgin – just 41 cm (16¼ in) high – is the face (7). It is a face of welcome – the kind of look we hope to receive when someone is unreservedly glad to see us. It may remind us how rarely we have met with, or bestowed, such a smile. The Madonna looks full of life, and the incipient gaiety, which looks as though it might break through at any moment, is filled with kindness. It's the sort of good humour that will include you, rather than mock you. Her beauty can give rise to mixed emotions. On the one hand, we are delighted by an awareness of how life should more often be; on the other, we are pained by an acute sense that our own life is not usually like this. Perhaps we feel an ache of tenderness for all the lost innocence of the world. Beauty can make the actual ugliness of existence all the harder to bear.

The more difficult our lives, the more a graceful depiction of a flower might move us. The tears – if they come – are in response not to how sad the image is, but how pretty. The man who painted a picture of humble, beautiful chrysanthemums in a vase was, as his self-portrait suggests, intensely aware of the tragedy of existence (8, 9). The self-portrait should put to rest any worry that the artist has presented us with a cheerful image out of misplaced innocence. Henri Fantin-Latour knew all about tragedy, but his acquaintance with it made him all the more alive to its opposites.

Consider the difference between a child playing with an adult and an adult playing with a child. The child's joy is naive, and such joy is a lovely thing. But the adult's joy is placed within a recollection of the tribulations of existence, which makes it poignant. That's what 'moves' us, and sometimes makes us cry. It's a loss if we condemn all art that is gracious and sweet as sentimental and in denial. In fact, such work can only affect us because we know what reality is usually like.

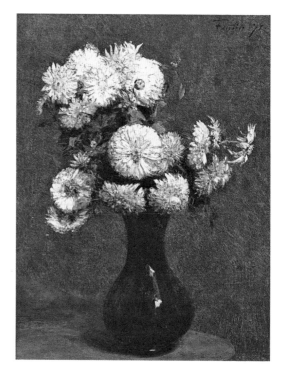

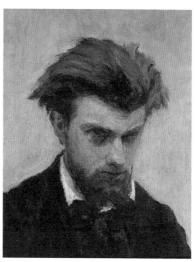

The pleasure of pretty art draws on dissatisfaction: if we did not find life difficult, beauty would not have the appeal it does. Were we to consider the project of creating a robot that could love beauty, we would have to do something apparently rather cruel, by ensuring that it was able to hate itself, to feel confused and frustrated, to suffer and hope that it didn't have to suffer, for it is against this kind of background that beautiful art becomes important to us, rather than merely nice. Not that we should worry. For the next few centuries at least, we have problems enough to ensure that pretty pictures are in no danger of losing their hold over us.

A lot of the world's art isn't just pretty; it seems to go further, presenting us with a thoroughgoing idealization of life. This can be even more troubling to contemporary sensibilities. The Royal College of Physicians stands in the middle of Edinburgh's New Town (10). Imagine the proceedings that are supposed to go on in this building – all dignity, erudition and calm authority, exactly the sort of professional face the doctors of Edinburgh would no doubt like to present. The building turns an august front to the world, demanding respect, even reverence. It embodies an idealization.

Idealization in art has a bad name because it seems to involve endowing something or someone (a profession, a person) with virtues more glowing than they actually possess, while disguising any imperfections with polish and subterfuge. In modern use, the notion of idealization carries a pejorative charge, as the idealizing artist strips away whatever is awkward or disturbing, leaving only the positive. The worry is that if we are attracted to such simplified objects, if we praise them and take pleasure in them, we will do an injustice to reality.

For example, a painting by Antoine Watteau that presents the countryside as a serene and elegant location for pleasure might be criticized for excluding the economic realities upon which the vision depends (11). Where are the servants who must bring the wine and fruit? Where are the peasants the leisured class rely on for their income? The fear is that in loving the picture, we ignore crucial aspects of existence, and even, in a sense, condone the exploitation of servants and peasants.

A more personal issue can also be at stake. We may worry that a person who has an idealized conception of some parts of life will

be less able to cope with the messiness of actual existence. Someone who imagines that little children are always sweet will approach a family weekend with alarmingly brittle and unhelpful expectations, and may turn away in disgust from perfectly normal behaviour and make unreasonable demands on the conduct of their own and other people's offspring.

It is hardly surprising, then, if being 'realistic' – the antidote to idealization – is judged a cornerstone of maturity, which in turn accounts for certain accepted artistic reputations. It is now normal to rate George Grosz, with his relentless exposure of the darkness below civilized institutions, more highly than Angelica Kauffmann and her pretty visions of Arcadian life (12, 13). Grosz seems to give us reality; Kauffmann a dream.

However, it is worth examining why idealization was for long periods of history understood to be a central aspiration of art. When painters present things as better than they are, they do not generally do so because their eyes are closed to imperfections. When we look at *The Artist in the Character of Design Listening to the Inspiration of Poetry*, we should not assume that Angelica Kauffmann was unaware of the realities of women's lives in the eighteenth century. She was attempting to give expression to her longings for harmony and fruitful endeavour, longings that were particularly intense because Kauffmann was so exposed to her own and others' failings (in 1767, when she was 26, she was tricked into marriage by a sociopathic adventurer who posed as a Swedish count).

We should be able to enjoy an ideal image without regarding it as a false picture of how things usually are. A beautiful, though partial, vision can be all the more precious to us because we are so aware of how rarely life satisfies our desires. Returning to the neo-classical facade of the Royal College of Physicians in Edinburgh, we should allow ourselves to enjoy it as an image of professional decorum and expertise without fearing that we are colluding with a subterfuge being played on a gullible public. The ideal it stands for is genuinely noble. We can love the ideal while being perfectly aware of the fallibility and imperfect motives of the group of men who commissioned its representation.

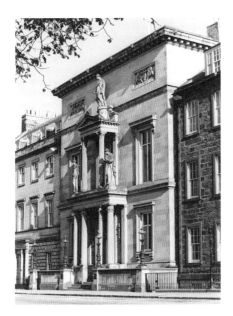

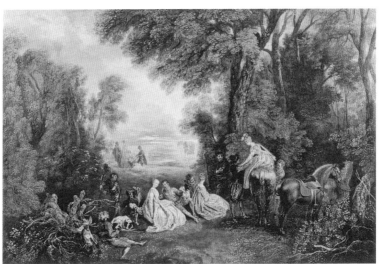

Methodology

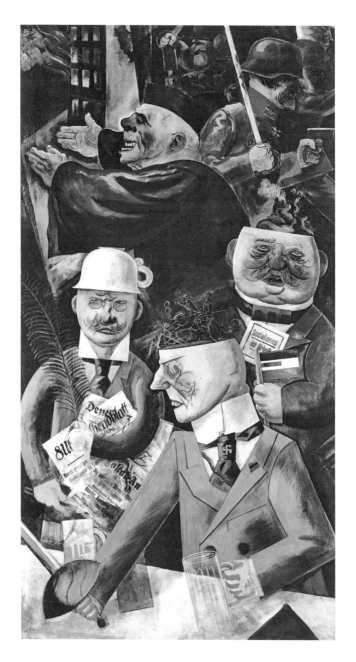

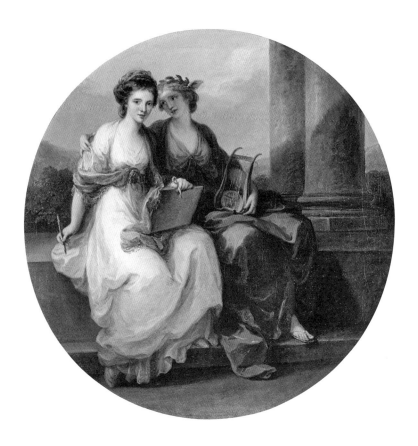

*Both are distortions; both
serve a purpose.*
LEFT
— 12. George Grosz,
The Pillars of Society, 1926

ABOVE
— 13. Angelica Kauffmann,
*The Artist in the Character
of Design Listening to the
Inspiration of Poetry*, 1782

The apparent opposite of idealization – caricature – has a lot to teach us about how ideal images can be important to us. We are very much at ease with the idea, exemplified by caricature, that simplification and exaggeration can reveal valuable insights that are lost or watered down in ordinary experience.

We can take this approach and apply it to idealized images, too. Strategic exaggerations of what is good can perform the critical function of distilling and concentrating the hope we need to chart a path through the difficulties of life.

— 3
Sorrow

One of the unexpectedly important things that art can do for us is teach us how to suffer more successfully. Consider Richard Serra's *Fernando Pessoa* (14). It is encouraging a profound engagement with sadness. The outward chatter of society is typically cheerful and upbeat – confess a problem to someone and they tend at once to look for a solution and point us in a brighter direction. But Serra's work does not deny our troubles; it doesn't tell us to cheer up. It tells us that sorrow is written into the contract of life. The large scale and overtly monumental character of the work constitute a declaration of the normality of sorrow. Just as Nelson's Column in the centre of Trafalgar Square in London is confident that we will admit the importance of naval heroism, so Serra's *Fernando Pessoa*, named after the Portuguese poet who knew about sorrow ('Oh salty sea, how much of your salt / is tears from Portugal') is confident that we will recognize and respond to the legitimate place of the most sombre and solemn emotions. Rather than be alone with such moods, the work proclaims them as central and universal features of life.

More importantly, Serra's work presents sorrow in a dignified way. It does not go into details; it does not analyse any particular cause of suffering. Instead, it presents sadness as a grand and ubiquitous emotion. In effect, it says, 'When you feel sad, you are participating in a venerable experience, to which I, this monument, am dedicated. Your sense of loss and disappointment, of frustrated hopes and grief

at your own inadequacy, elevate you to serious company. Do not ignore or throw away your grief.'

We can see a great deal of artistic achievement as 'sublimated' sorrow on the part of the artist, and in turn, in its reception, on the part of the audience. The term sublimation derives from chemistry. It names the process by which a solid substance is directly transformed into a gas, without first becoming liquid. In art, sublimation refers to the psychological processes of transformation, in which base and unimpressive experiences are converted into something noble and fine – exactly what may happen when sorrow meets art.

Many sad things become worse because we feel we are alone in suffering them. We experience our trouble as a curse, or as revealing our wicked, depraved character. So our suffering has no dignity; it seems due only to our freakish nature. We need help in finding honour in some of our worst experiences, and art is there to lend them a social expression.

Until far too recently, homosexuality lay largely outside the province of art. In Nan Goldin's work, it is, redemptively, one of its central themes (15). Goldin's art is filled with a generous attentiveness towards the lives of its subjects. Although we might not be conscious of it at first, her photograph of a young and, as we discern, lesbian woman examining herself in the mirror is composed with utmost care. The device of reflection is key. In the room itself, the woman is out of focus; we don't see her directly, just the side of her face and the blur of a hand. The accent is on the make-up she has just been using. It is in the mirror that we see her as she wants to be seen: striking and stylish, her hand suave and eloquent. The work of art functions like a kindly voice that says, 'I see you as you hope to be seen, I see you as worthy of love.' The photograph understands the longing to become a more polished and elegant version of oneself. It sounds, of course, an entirely obvious wish; but for centuries, partly because there were no Goldins, it was anything but.

Art can offer a grand and serious vantage point from which to survey the travails of our condition. This is particularly true of artworks that are sublime in the Romantic sense, which depict the stars or the oceans, the great mountain chains or continental rifts. These works make us aware of our insignificance, exciting a pleasing

A home for sorrow and sadness.
— 14. Richard Serra,
Fernando Pessoa, 2007–8

terror and a sense of how petty man's disasters are in comparison with the ways of eternity, leaving us a little readier to bow to the incomprehensible tragedies that every life entails. From here, ordinary irritations and worries are neutralized. Rather than try to redress our humiliations by insisting on our slighted importance, we can, through the help of an artwork, endeavour to apprehend, and come to appreciate, our essential nothingness.

A sense of the sublime in our ordinary lives is usually a fleeting state, one that occurs more or less at random. On the motorway we catch sight of the sunlight breaking through rain clouds over a distant hill; on a plane we glance away from the in-flight entertainment and notice the Bernese Alps or the lights of oil tankers across the Singapore Strait. Art can mitigate randomness and chance, though, for it provides tools for generating helpful experiences on a reliable basis, so that we can have continuous access to them whenever we are able to look up from our sadness.

Caspar David Friedrich uses a striking, jagged rock formation, a spare stretch of coast, the bright horizon, far-away clouds and a pale sky to induce us into a particular mood (16). We might imagine walking in the pre-dawn, after a sleepless night, on the bleak headland, away from human company, alone with the basic forces of nature. The smaller islands of rock, each swept endlessly by the grey sea, were once as dramatic and thrusting as the major formation just beyond them. The long, slow passage of time will, one day, wear it down as well. The first portion of the sky is formless and empty, a pure, silvery nothingness, but above are clouds that catch the light on their undersides and pass on in their random, transient way, indifferent to all our concerns.

The picture does not refer directly to our relationships, or to the stresses and tribulations of our everyday lives. Its function is to give us access to a state of mind in which we are acutely conscious of the largeness of time and space. The work is sombre rather than sad, calm but not despairing. In that condition of mind – that state of soul, to put it more romantically – we are left, as so often with works of art, better equipped to deal with the intense, intractable and particular griefs that lie before us.

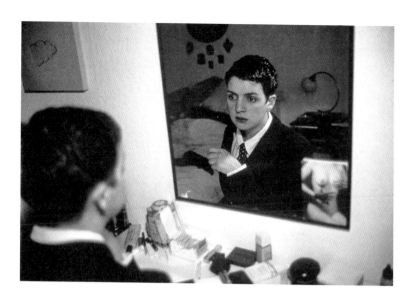

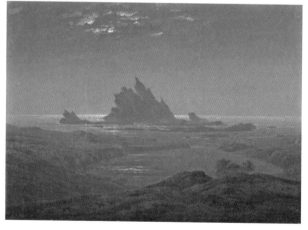

TOP

*Sublimation: the
transformation of
suffering into beauty.*
— 15. Nan Goldin,
*Siobhan in My Mirror,
Berlin,* 1992

ABOVE

*The tensions in my marriage and
the frustrations of my work are
not my problem alone, they are part
of the structure of the universe.*
— 16. Caspar David Friedrich,
Rocky Reef on the Sea Shore, c.1825

28 *Art as Therapy*

— 4
Rebalancing

Few of us are entirely well balanced. Our psychological histories, relationships and working routines mean that our emotions can incline grievously in one direction or another. We may, for example, have a tendency to be too complacent, or too insecure; too trusting, or too suspicious; too serious, or too light-hearted. Art can put us in touch with concentrated doses of our missing dispositions, and thereby restore a measure of equilibrium to our listing inner selves.

Imagine that we have fallen into a way of life that suffers from too much intensity, stimulation and distraction. Work is frantic across three continents. The inbox is clogged with 200 messages every hour. There is hardly time to reflect on anything once the weekday starts. However, in the evening we are occasionally able to return to a perfectly symmetrical and ordered one-bedroomed house in the suburbs of Chicago (17). Looking out of the vast windows at an oak tree and the gathering darkness, we have a chance to resume contact with a more solitary, thoughtful self that had otherwise eluded us. Our submerged peaceful sides are given encouragement by the regular rhythms of the steel I-beams. The value of gentleness is confirmed by the delicate folds of a gigantic curtain that wraps around the elegant living space. Our interest in a modest, tenderhearted kind of happiness is fostered by the unpretentious simplicity of a terrace inlaid with limestone tiles. A work of art helps return to us the missing portions of our characters.

Since we are not all missing the same things, the art that has a capacity to rebalance us, and therefore arouse our enthusiasm, will differ markedly. Imagine we happen to be a bureaucrat in one of the sleepier branches of the Norwegian civil service, based in the idyllic though rather quiet town of Trondheim near the Arctic circle. We last experienced an intense emotion many years ago, perhaps at university. Our days run like clockwork. We are always home by 5.15 pm and do the crossword before bed. The last thing we would need in such circumstances is to live in a pristinely ordered home by Mies van der Rohe. We might be advised instead to engage with Flamenco music,

the paintings of Frida Kahlo and the architecture of Mexico's Catedral de Santa Prisca y San Sebastián (18) – varieties of art that might help restore life to our slumbering souls.

The notion that art has a role in rebalancing us emotionally promises to answer the vexed question of why people differ so much in their aesthetic tastes. Why are some people drawn to minimalist architecture and others to the Baroque? Why are some people excited by bare concrete walls and others by William Morris's floral patterns? Our tastes will depend on what spectrum of our emotional make-up lies in shadow and is hence in need of stimulation and emphasis. Every work of art is imbued with a particular psychological and moral atmosphere: a painting may be either serene or restless, courageous or careful, modest or confident, masculine or feminine, bourgeois or aristocratic, and our preferences for one kind over another reflects our varied psychological gaps. We hunger for artworks that will compensate for our inner fragilities and help return us to a viable mean. We call a work beautiful when it supplies the virtues we are missing, and we dismiss as ugly one that forces on us moods or motifs that we feel either threatened or already overwhelmed by. Art holds out the promise of inner wholeness.

It is not only individuals who can use art to supply what is missing from life. Groups of people, and even whole societies, might look to art to balance out existence. The German poet, playwright and philosopher Friedrich Schiller developed this idea in an essay, 'On Naive and Sentimental Poetry', published in 1796. He was curious about the fact that in ancient Greece, artists and dramatists had paid little attention to landscape. Schiller argued that this made sense because of the way they lived. They spent their days outside, they lived in small cities with seas and mountains close by. He said, 'the Greeks had not lost nature in themselves.' Therefore, he surmised, 'they had no great desire to create objects external to them in which they could recover it.' It follows from this that art that pays a great deal of attention to the natural world would be prized only when there was some special need for it. 'As nature begins gradually to vanish from human life as a direct experience, so we see it emerge in the world of the poet as an idea.' As life becomes more complex and artificial,

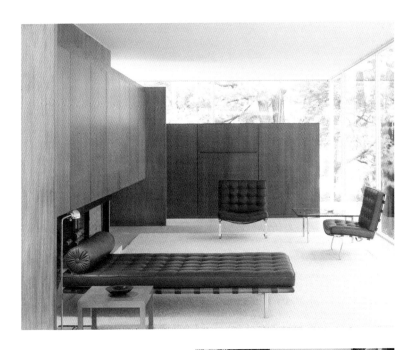

ABOVE
*A home to rebalance
a nervous soul.*
— 17. Ludwig Mies van der
Rohe, Farnsworth House,
Plano, Illinois, 1951

RIGHT
*Art to rebalance a
Norwegian civil servant.*
— 18. Catedral de Santa
Prisca y San Sebastián,
Taxco, Mexico, 1751–8

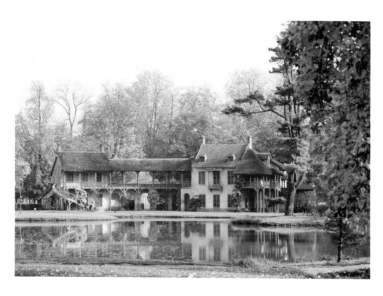

A cottage to correct the excesses of a palace.

— 19. Richard Mique and Hubert Robert, The Queen's Hamlet, Petit Trianon, Versailles, 1785

as life is lived more indoors, the longing for a compensating natural simplicity gets stronger. Schiller concludes, 'We can expect that the nation which has gone the farthest towards unnaturalness would have to be touched most strongly by the phenomenon of the naive. This nation is France.' As if to confirm Schiller's hypothesis, Marie Antoinette, the late French queen, had a few years earlier constructed a mock farm near the palace of Versailles so she could enjoy watching the milking of cows (19).

We can understand the particular imbalances of a historical period by considering which artworks have achieved new popularity within it. It is a sign that the contemporary developed world is exceptionally busy and materially satiated when there is renewed interest in the Italian paintings of Thomas Jones (20), which are attentive to noble decay and endurance, or in the quiet, austere colonnades once walked by the monks of the abbey of Le Thoronet (21).

A grasp of the psychological mechanism behind taste will not

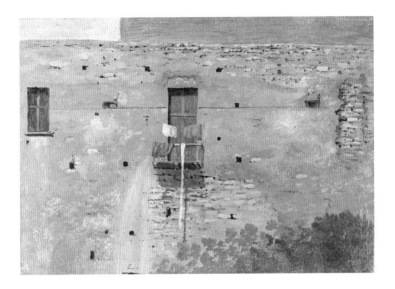

The art we love is a guide to what is missing from our societies.

— 20. Thomas Jones,
A Wall in Naples, c.1782

necessarily change our sense of what we find beautiful, but it can prevent us from reacting to what we don't like with simple disparagement. We should know to ask at once what people lack in order to see a given object as beautiful, and can come to appreciate their choices, even if we cannot muster any personal enthusiasm for them.

Not only does art have a role in rebalancing our characters, but it may also help us to be more moral. The word 'morality' has become hugely troublesome for the modern age. We don't tend to respond well to recommendations of how we should behave in order to be 'good'. We're terrified of being interfered with. People who readily accept the need to go to a gym will bristle at the suggestion that they might also work on their character and aspire to virtue as they might to physical fitness. A key assumption of modern democratic political thinking is that we should be left to live as we choose without being nagged, without fear of moral judgement and without being subject to the whims of authority. The impulse to probe at ethics trembles before

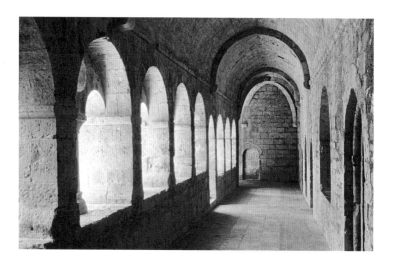

— 21. Cloister, L'abbaye
du Thoronet, Provence,
late 12th–early 13th century

the incensed question of who anyone might be to dare to tell anyone else how to live.

It is evident, though, that a lot of the best art produced throughout history has been concerned with an explicitly moralistic mission: an attempt to encourage our better selves through encoded messages of exhortation and admonition. We might think of works of art that exhort as both bossy and unnecessary, but this would assume that an encouragement to virtue would always be contrary to our own desires. However, in reality, when we are calm and not under fire, most of us long to be good and wouldn't mind the odd reminder to be so; we simply can't find the motivation day to day. In relation to our aspirations to goodness, we suffer from what Aristotle called *akrasia*, or weakness of will. We want to behave well in our relationships, but slip up under pressure. We want to make more of ourselves, but lose motivation at a critical juncture. In these circumstances, we can derive enormous benefit from works of art that encourage us to be the best versions of ourselves, something that we would only resent if we had a manic fear of outside intervention, or thought of ourselves as perfect already.

A painting that understands how easily one can get interested in the wrong things – and what the consequences can be.

—22. Robert Braithwaite Martineau, *The Last Day in the Old Home*, 1862

The best kind of cautionary art – art that is moral without being 'moralistic' – understands how easy it is to be attracted to the wrong things (22). It is alive to the fact that quite good people end up making big mistakes, and do so unwittingly. In Martineau's picture, we can pick up that the husband's problems stem from gambling and drinking (there are clues in the racehorse image propped sideways on the floor and in the decanter behind him). This man is now inducting his son into these gentlemanly vices. But he is not a monster; his charming and carefree smile is not forced. We imagine that he wants to make everyone happy – he is just unreliable and easily carried away. We can suppose how an accumulation of little follies has led eventually to the sale of his property. The home that had belonged to his family for generations (as the archaic fireplace, armour and portraits attest) has been lost on his watch. The whole power of the artist has gone into making us feel the shame and sadness of this in a way that might

impact our own behaviour, because many of us harbour a few of this man's tendencies in our own psyches.

Christianity has been a notable practitioner of the moral aspects of art. Fra Angelico worked in a society that took it for granted that people needed to be kept on track by ghoulish aesthetic evocations of hell (23). The artist hence strived to make his images of hell as haunting as possible; one was supposed to have nightmares inhabited by the flesh-eating demons one had seen on the wall, and to be horrified by the prospect of being boiled alive. The ideal response, from the artist's point of view, would be the anguished complaint, 'I simply can't get that image out of my head.'

We can think of secular, modern versions of hell that are far less theatrical and perhaps far more effective for us now. For the non-believing person, hell is just the abandonment of the path to the better self. Eve Arnold's photographs of divorcing Russian couples are hell in an everyday, godless form, and all the more convincing for picking up on the casual ubiquity of suffering (24). The real difficulty with presenting moral ideas in art ('be kind and compassionate', 'do not blame others for everything', and so on) is not that they seem surprising or peculiar, but rather that they appear obvious. Their very reasonableness strips them of their power to change our behaviour. We hear a thousand times that we should love our neighbour and strive to be good spouses, but these prescriptions lose any of their meaning when they are repeated by rote. The task for artists, therefore, is to find new ways of prizing open our eyes to tiresomely familiar, but critically important, ideas about how to lead a balanced and good life. It is no easy task to keep making what is hellish vivid: the attempt can easily yield just formulaic horror, which ends up touching no one, until a skilful artist like Arnold stops us in our tracks with an image that brings home what is truly at stake when we let ourselves and others down. We might long to hang her work in the bedroom or the kitchen, in just the right place so that it can be seen when one is tempted to say in anger, 'Well, that suits me fine, let's just fucking get divorced. See you in court.'

Moral messages – messages that encourage our better selves – can be found in works of art that seem, initially, to have little interest

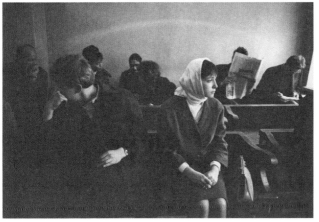

TOP
*Change your ways, while there
is still time.*
— 23. Fra Angelico, 'The
Pains of Hell' from *The Last
Judgement (detail), c.*1431

ABOVE
A reason to say sorry.
— 24. Eve Arnold,
Divorce in Moscow, 1966

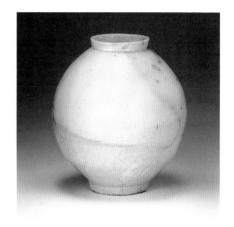

in 'saying' anything to us. Take a Korean moon jar (25). Aside from
being a useful receptacle, it is also a superlative homage to the virtue
of modesty. It stresses this quality by allowing minor blemishes to
remain on its surface, by being full of variations of colour and having
an imperfect glaze and an outline that does not follow an ideal oval
trajectory. Impurities have found their way into the kiln, resulting
in a random array of black dots all over its surface. The jar is modest
because it seems not to mind about any of this. Its flaws merely
concede its disinterest in the race for status. It has the wisdom not to
ask to be thought too special. It is not humble, just content with what
it is. For a person who is given to arrogance or anxiety about worldly
status, and who frets about being recognized at social gatherings, the
sight of such a jar may be intensely moving as well as encouraging.
Seeing the ideal of modesty so clearly may make it obvious that one is
in exile from it. All the same, here it is, waiting for us in the jar.
It would be understandable if a person who was at heart sincere
and good, whose arrogance was only a habit built up to protect
a vulnerable part of themselves, should, as they contemplated the
moon jar, find themselves yearning to make a change in their lives
under the aegis of the values encoded in a piece of ceramic.

Art can save us time – and save our lives – through opportune
and visceral reminders of balance and goodness that we should never
presume we know enough about already.

— 5
Self-Understanding

We are not transparent to ourselves. We have intuitions, suspicions, hunches, vague musings and strangely mixed emotions, all of which resist simple definition. We have moods, but we don't really know them. Then, from time to time, we encounter works of art that seem to latch on to something we have felt but never recognized clearly before. Alexander Pope identified a central function of poetry as taking thoughts we experience as half-formed and giving them clear expression: what 'was often thought, but ne'er so well expressed'. In other words, a fugitive and elusive part of our own thinking, our own experience, is taken up, edited, and returned to us better than it was before, so that we feel, at last, that we know ourselves more clearly.

Imagine you're drawn by the sight of a box, *Untitled (Medici Princess)*, by Joseph Cornell (26). Why the strange feeling of recognition? What part of oneself is like this box? Despite the overt visual reference to Bia, the daughter of the Duke of Florence, Cosimo I de'Medici, who died when she was only six, one is not being invited by Cornell to discover an inner princess. Rather, his box presents us with a model of how one might coordinate the diverse elements of a single identity. The box says, 'I am made of a web of relationships.' The iconic birds, ladder, flowers, sundial, maps and fox are emblems with special references to Bia's experience or personality. We can't tell what they are, but we respond to the idea of a complex set of symbols that make up a diagram of a life. The box contains a concentrated archive of the self. Here, something as fluid and indistinct as personal identity can be presented in a manageable and usable way. It's not so much that one identifies with everything in this particular box as with the nature of the underlying project. Ideally, there would be an artist like Cornell (who died in 1972) who could make a box for each of us, so that we might come to know ourselves better, and have a tool with which to make ourselves better known to others.

Contemplating Cy Twombly's dark, scratchy, suggestive surface is rather like looking in a mirror in which you notice an aspect of your appearance you had not paid much attention to before, except

that what's at stake here is not a row of molars, but your inner experience (27). There are moods or states of the mind (or soul) that are perplexingly elusive. One has them often, but can't isolate or examine them. Twombly's work is like a specially designed mirror of a part of our inner lives, deliberately constructed to draw attention to it and to make it clearer and easier to identify. It homes in on what it's like when you almost know what you think about something, but not quite. It pictorializes a moment in reflexive life suggestive of ambition and confusion; the thin, light marks on the surface might be rubbed-out words chalked on a blackboard; the smudges might be clouds through which we glimpse distant stars. Whatever they are, what matters is that we don't get to see them precisely, so we are held in the moment of being on the cusp of something. We are about to understand, but have not yet understood. This moment is important because it generally does not live up to its promise. We abandon the process of reflection. Not much of a decision about the personal meaning of love, justice or success is achieved, and we move on to something else. Looking at Twombly's painting assists us in a crucial thought: 'The part of me that wonders about important questions and then gets confused has not had enough recognition. I have not taken proper care of it. But now I see this part of myself reflected in the mirror of art; now I can make more of it.'

It's a strange thought, that personal identity and qualities of mind and character can be discovered not only in people, but also in objects, landscapes, jars or boxes. If this seems a bit odd, it's because we have, by and large, emptied the visual realm of personal character. Yet when we feel a kinship with an object, it is because the values we sense that it carries are clearer in it than they usually are in our minds.

Art builds up self-knowledge, and is an excellent way of communicating the resulting fruit to other people. Getting others to share our experiences is notoriously difficult; words can feel clumsy. Consider trying to describe a walk alongside a lake on a mild afternoon without the aid of an image. Christen Købke's unassuming depiction of an afternoon in a suburb of Copenhagen latches on to just those aspects of experience that are so hard to verbalize (28). The light in the picture is tremendously meaningful, even though it is

Methodology

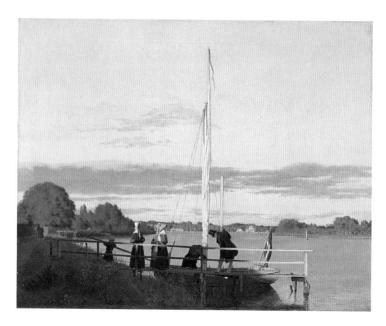

ABOVE
I have also known this kind of feeling.
— 28. Christen Købke,
View of Østerbro from Dosseringen, 1838

LEFT
My good self, as a plate.
— 29. Richard Riemerschmid,
'Blaue Rispe' Plate, 1903–5

difficult to say what this meaning is. One wants to point at the picture and say, 'When the light is like this, I feel like that.' Købke has created an image that is in love with nothing happening. The child hangs over the rails, the man in a top hat looks on while his friend makes some adjustment to the bottom of the furled sail. The women say something to one another. Life is going on, but there is no drama, no expectation of an outcome, no sense of getting anywhere. Rather than this being

a condition of boredom or frustration, though, it feels exactly right. It is tranquil but not tired. It is immensely peaceful but not inert. In a strange way, the picture is filled with a sense of delight in existence expressed quietly. It is not the light in itself that is so attractive; rather, it is the condition of the soul it evinces. The picture captures a part of who one is – a part that isn't particularly verbal. You could point to this image and say, 'That's what I'm like, sometimes; and I wish I were like that more often.' It could be the beginning of an important friendship if somebody else understood this too.

Since art has this ability to help us understand ourselves, and then to communicate who we are to others, we tend to care a lot about which works of art we place around us. Even on limited budgets, we spend a lot of time worrying about interior decoration, about the objects we use to communicate our identities to the world. An unkind way of analysing our concern with how we decorate our homes is that we're simply trying to show off – in other words, to tell people how impressive and successful we are. But there's generally a far more interesting and human process at work within the art of interior decoration. We want to show something off, but we're not merely boasting. We're trying to let others know about our characters in a way that words might not permit. That's why we might, for example, invest in some crockery by the twentieth-century German architect and designer Richard Riemerschmid (29).

The enthusiasm for Riemerschmid's plates is likely to reveal more than just a desire for our guests to think we have good taste and enough money to do something about it. Behind the liking for the plates we initially felt in the shop lay a recognition: 'This is the right crockery for me because it is like my deepest self. I can use such a plate to tell people something important about who I am: about what it is like to be me.' Such a statement might seem rather exaggerated, but perhaps it is simply unfamiliar; we are unschooled in taking aesthetic things and repositioning them in terms of our psychological lives.

We don't just like art objects. We are also, in the case of certain prized examples, a bit like them. They are the media through which we come to know ourselves, and let others know more of what we are really about.

— 6
Growth

It is one of the secret, unacknowledged features of our relationship with art that many of its most prestigious and lauded examples can leave us feeling a bit scared, or bored, or both. In the privacy of our minds, an uncomfortable proportion of the world's art collections can come across as alien and repulsive.

Imagine someone who felt ill at ease in front of a painting of a Catholic saint in ecstasy (30), or an African mask used in the initiation ritual of boys in eastern Angola (31), or a portrait of an aristocratic English Lord posing stiff and proud at the height of the British Empire (32). If one were to ask the viewer what was offputting about these works, they might ascribe the problem not so much to execution as to a set of negative associations (many with decidedly autobiographical origins) pegged to the very genre to which these works belong. For example, gentle enquiry might reveal that Baroque paintings made our viewer think of the apartment of a cloying and depressing elderly Spanish relative, stooped and sad, whom they were made to visit on Sunday as a child; or that people in top hats evoked a red-faced, patronizing and privileged group of history students who had terrorized them at university thirty years ago; or that African masks brought to mind a film they'd once seen about voodoo, as well as a do-gooding acquaintance who liked to pronounce upon the spiritual superiority of Africa.

Hostility to genres of art can grow out of genuinely distressing experiences. The problem with these negative moments, particularly those we have as children, is that they are at risk of tainting a disproportionate and ultimately unfair expanse of life – and they do so because they have a habit of triggering a variety of defensive behaviours in us. We come across this particularly clearly in relation to art, but it is a cognitive flaw that can poison existence more generally. It can be characterized as an inaccurate, overly jumpy warning system that is much too ready to anticipate danger. It generalizes wildly from specific negative events, often early ones, and uses these to come to global aversions, which undermine our ability to think and act effectively and creatively.

A defensive stance makes so many elements feel threatening. Due to an unfortunate situation or encounter, we might – for example, and just to start the list – become unable to have any sympathy or interest in religion, literature, football, Africa, communal showers, the music of ABBA, upmarket clothes shops, a chat at the school gate with a far richer parent. Our brittle defensive structures lead to impoverishment: we can't make progress in our lives if we keep generalizing about issues which are at heart particular in nature. We are debilitated when we are too quick to perceive threats, when the explosive anxieties of the past make us aggressive towards anything that semi-consciously reminds us of them in the present. We employ a powerful, erroneous emotional logic: a particular rich person looked down on me, and it was a wounding experience; therefore rich people in general will look down on me; therefore I loathe them; therefore a painting of a rich person is not for me. Or, the weird girl down the hall said she could see angels, and made me feel very awkward; therefore only weird people are interested in angels; this is a picture of a man looking at an angel, therefore it is a weird painting, which I cannot find interesting.

Engagement with art is useful because it presents us with powerful examples of the kind of alien material that provokes defensive boredom and fear, and allows us time and privacy to learn to deal more strategically with it. An important first step in overcoming defensiveness around art is to become more open about the strangeness that we feel in certain contexts. We shouldn't hate ourselves for it; a lot of art is, after all, the product of world views that are radically at odds with our own. Sebastiano Ricci believed angelic messengers could bring life-changing instructions to holy people. Sargent's sitter was convinced that people are not born equal and that some individuals are entitled to rule the earth because of their ancestry. The Chokwe people thought their masks would help adolescent boys to understand the sexual and emotional needs of their women. Therefore, an initial negative response – the feeling that the object has nothing to offer – is comprehensible, even reasonable. Beliefs in angelic orders, aristocratic entitlement and magical intervention are at odds with most reasonable views of modern life.

Museum curators tend to assume the existence of an audience

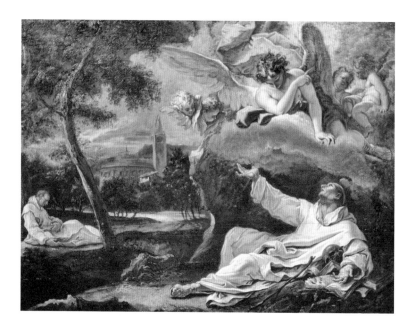

I don't do dark, weird religious stuff.
— 30. Sebastiano Ricci, *The Vision of Saint Bruno,* 1700

In secret, the problems of Africa depress me.
— 31. Chokwe People, East Angola, Mwana Pwo Mask, *c.*19th century

Snobs make me feel sick.
— 32. John Singer Sargent, *Portrait of Lord Ribblesdale,* 1902

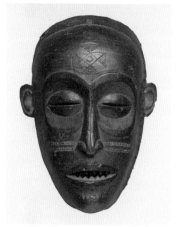

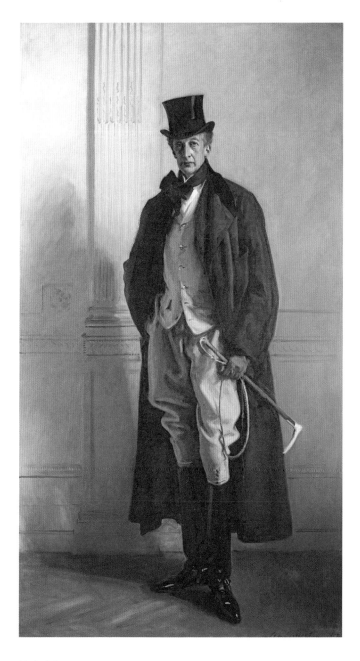

that, broadly, already likes the kind of art on display and just needs help with the details of particular works, which is blind to the way in which someone might be deeply resistant to an entire aesthetic category. If you were looking at the picture of Saint Bruno with a curator they might try to help you to engage with it by telling you a variety of factual details: that this man was the founder of the Carthusian monastic order in the eleventh century, that the sleeping man on the far left is a pictorial reference to the disciples who slept while Jesus was awake the night before the Crucifixion; that the work was owned in the eighteenth century by a certain Count Algarotti, and that the skull (lower right) and wings were particularly well painted in ways that bear comparison with Titian.

Such information might be helpful to some, but not to a person who is turned off by, and maybe hostile to, this kind of work in general. Expert knowledge too often presupposes that the viewer is already interested, but has one or two points of detail they would like cleared up. Museums display a lot of religious art, but rarely give much attention to what reaction this is likely to provoke in a largely secular, scientifically minded audience. They put up pictures of aristocrats, but seem to forget that class differences provoke intense reactions in meritocratic democracies. They organize exhibitions of African art, assuming that an invocation of ancestral deities will be relatively unproblematic.

To harbour doubts in these areas can, of course, feel rather embarrassing. We are socialized never to give voice to ambivalence, so a false assumption is maintained: that sensible people are already interested in such things. The taboo can be explained in part because museum curators are a self-selecting category so immersed in their fields that some of them can't remember what it was like to share the assumptions of an ordinary member of their society, which nowadays usually means someone secular, democratic and unacquainted with magical thinking. Unless they have, and listen to, children, they don't meet anyone who could frankly ask them with blunt but useful naivety, 'Why do you spend time bothering with African masks or dark pictures of medieval saints?' They are not best placed to ask what are, for many people, the urgent and basic questions. Like any close-knit

professional group that socializes in a specialist world, curators run the risk of forgetting precisely how unusual their interests are.

What, then, would help us engage with some of the categories of art we find most offputting? How could one learn to find aristocrats interesting? How not to recoil from a work of religion? How to get interested in African art? The first and crucial step to overcoming defensiveness is to be highly alert to its reality: to be generously aware of how normal it is to harbour strongly negative views about things. The second step is to make oneself more at home with the seemingly alien mindsets of people who created some of the world's most revered works of art. Ricci was truly convinced that spiritual messengers could give life-altering instructions to mortals. The makers of the African mask are convinced that spirits can dictate who in the village is ready to take a wife. The aristocratic portrait-sitter resolutely did not believe that everyone is created equal, and trusted that ancestry legitimates power. The major galleries should be more frank about these ideas, admitting and warning us that 'you are about to walk into a room with some very peculiar things on display', rather than merely, 'we come to room 22'.

A third step on the path towards resolving defensive responses is to look out for points of connection, however fragile and initially tenuous, between the mindset of the artist and our own. Although their work may seem very odd, there is likely to be an aspect of their ambitions that we can, with sufficient self-exploration, relate to in a personal way. One might – many years ago, on a crowded underground train – have had a moment's thought about whether everyone really is equal in temperament and nature, or whether there aren't natural classes of humans, some fundamentally better than others. The thought went nowhere; it didn't fit with our era and temperament, but it flitted across our consciousness nevertheless and might form one of the blocks of the bridge we would seek to build between ourselves and Lord Ribblesdale. Similarly, with religious art, despite our atheistic impatience with anything connected to the supernatural, perhaps we did once have a moment of panic and collapse in which we longed to be scooped up in the arms of a father figure who wasn't anything to do with our own father, someone with the power to reassure us that things would be all right, and that we would make it through our

present difficulties. These moments are awkward to remember once they have passed, but if we attempt to bring them to consciousness, they can help foster sympathy for works of art that feel painfully alien.

In other words, one has to reach out for quite fragile bits of the audience's experience in order to build an understanding of certain kinds of art: flickers of interest and enjoyment, which mean that the object, or the artist who made it, are revealed not to lie entirely beyond comprehension. With the right prompting, we can locate the points at which the mindset of the person who created a work overlaps, even if only briefly, with our own values and experiences.

Another way we can learn how to surrender defensiveness and still be ourselves around something that at first feels alien is to examine how artists engage with each other's work: they can be models of non-defensive reaction. *Las Meninas* is at first glance a perfect example of realistic, highly skilled courtly art (33). The suave gentleman-artist is painting a portrait of the king and queen, who are dimly reflected in the distant mirror. The young princess and the ladies-in-waiting, from whom the picture takes its title, are in attendance. The luxurious clothes shimmer, the texture of skin is exquisitely conveyed. It is, at first sight, almost the polar opposite of the kind of painting we associate with the great names of the twentieth century. What could it offer – what could it matter – to such an inventive and experimental artist as Picasso? Why did Picasso spend much of 1957 (when he was seventy-five) creating his own versions of this great historical work? (34)

How should we imagine what Picasso was up to? What did he get right? Instructively, Picasso likes the idea of inhabiting a classic. Rather than feel that this is a sacred object that must only ever be treated with chilly reverence, he allows himself to play around with it and to view play as a valid way of engaging with it, rather than the sad outcome of ignorance and lack of sophistication. There is something thoroughly child-like about Picasso's version. Two of his own children, Claude and Paloma, were aged ten and eight at this time and were often running in and out of his studio. The dog in the foreground is slightly cartoonish; arms stick out from bodies, hands are just fingers. Velázquez painted a picture of a child, the little princess, touchingly sweet and innocent in the middle of a very adult, very wealthy and

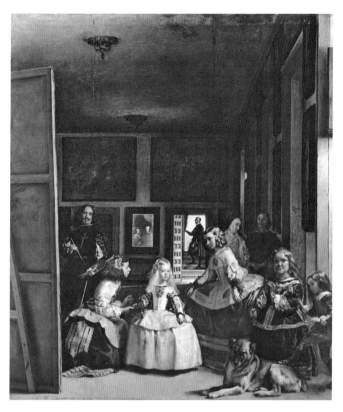

How can you make a very
famous work your own?
— 33. Diego Velázquez,
Las Meninas or *The Family*
*of Felipe IV, c.*1656

Remake it to suit your needs.
— 34. Pablo Picasso,
Las Meninas, 1957

Methodology

powerful world. Picasso has reimagined the work in a more innocent way. He has rehabilitated a sense of spontaneity and simplicity that is rather drowned out in the work of his great Spanish predecessor. It is clear that Picasso admires the pronounced rectangles and triangles in Velázquez. In the earlier picture, these are subordinated to realistic depiction: they are the shapes of the room and things in it. Picasso, however, gives the geometrical forms a life of their own. In other words, he is taking a theme he likes, and expanding on and developing it. Picasso is not trying to copy Velázquez. He is being himself around it, in the same way a good friendship allows two people to be themselves in each other's presence.

Encounters with art that seem initially offputting – *Las Meninas*, Sargent's aristocratic portrait, the African mask or Ricci's picture of Saint Bruno – offer us lessons in psychological growth. Growth occurs when we discover how to remain authentically ourselves in the presence of potentially threatening things. Maturity is the possession of coping skills: we can take in our stride things that previously would have knocked us off course. We are less fragile, less easily shocked and hence more capable of engaging with situations as they really are. Along with the Roman playwright Terence, we can say, 'I am human. Nothing human is foreign to me.' The phrase captures the idea of being able to find personal resonance, even in areas far from one's own direct experience and culture.

Art that starts by seeming alien to us is valuable because it presents us with ideas and attitudes that are not readily available in our familiar environments, and that we will need in order to accede to a full engagement with our humanity. In an emphatically secular or egalitarian culture, important thoughts get lost. Our usual routines may never awaken the important parts of ourselves; they will remain dormant until prodded, teased and usefully provoked by the world of art. Alien art allows me to discover a religious impulse in myself, or an aristocratic side to my imagination, or a desire for rituals of initiation – and such discovery expands my sense of who I am. Not everything we need is at the forefront in every place or era. It is when we find points of connection to the foreign that we are able to grow.

—7
Appreciation

One of our major flaws, and causes of our unhappiness, is that we find it hard to take note of what is always around. We suffer because we lose sight of the value of what is before us and yearn, often unfairly, for the imagined attractions of elsewhere.

The problem is partly caused by our skill at getting used to things: our mastery of the art of habituation. Habit is the mechanism whereby behaviour becomes automatic across a range of areas of our functioning. It offers us many benefits. Before we've picked up the habit of driving, we need to be acutely conscious of everything that is going on as we sit at the wheel; our senses are highly alert to sounds, lights, movement, and to the sheer, alarming implausibility of steering a box of steel at speed through the world. This hyper-awareness can make driving a test of nerves. However, after years of practice, it gradually becomes possible to drive for miles while hardly thinking consciously about changing gears or indicating. Our actions become unconscious, and we can ponder the meaning of life while negotiating a roundabout.

However, habit can just as easily become a cause of misfortune, when it makes us prone to barely registering things that, although familiar, deserve careful engagement. Instead of editing out the lesser things, so that we can concentrate on what is crucial (as ideally happens on the road), we end up editing out elements of the world that have much to offer us.

Art is one resource that can lead us back to a more accurate assessment of what is valuable by working against habit and inviting us to recalibrate what we admire or love. Few people pay much attention to the appearance of beer cans. They are amongst the most lowly, utilitarian objects we encounter. However, in 1960 the American artist Jasper Johns used the resources of art to encourage us to see them afresh. He cast two examples in bronze, painted the name of their company (Ballantine Ale) on the sides and placed them close together on a small base (35). When we see them in a gallery, or look at them in a photograph, our attention is arrested and directed. We pay a great deal more attention than we normally would to their shape and design, recognizing the elegance of the maker's elliptical logo and

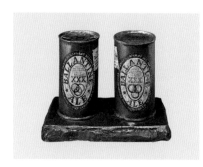

Paying attention to
ordinary life.
— 35. Jasper Johns, *Painted*
Bronze, 1960

The pleasure of organizing
things.
— 36. Ben Nicholson,
1943 (painting), 1943

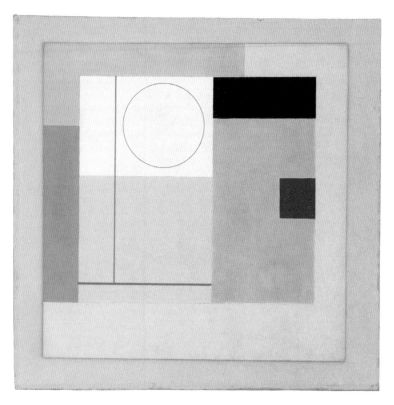

the attractive proportions of each cylinder. The heavy, costly material they are made of makes us newly aware of their separateness and oddity: we see them as though we had never laid eyes on cans before, acknowledging their intriguing identities as a child or a Martian, both free of habit in this area, might naturally do.

Johns is teaching us a lesson: how to look with kinder and more alert eyes at the world about us. This particular instance may be very modest. Learning to appreciate the look of a beer can may in itself make little improvement to our daily lives, but the lesson grows more substantial when we consider its general applicability to the many other objects, situations, moods and people that lie before us in a state of pre-artistic neglect. Our ordinary responses, not just to beer cans but to the sky, our friends, the shapes of rooms, the joys of our children, the buildings we drive past every day and the expressions on the faces of our spouses, are too often flattened and clichéd. We may take little note because we rest assured that we have already seen them clearly enough – a prejudice that art proudly contradicts by foregrounding all that we are likely to have missed.

Like Johns' cans, *1943 (painting)*, by the English artist Ben Nicholson, is a testament to the basic pleasures of simple things (36). One can imagine Nicholson absorbed by the task of carefully working on the arrangement – and subtle rearrangement – in search of a particular kind of harmony. There is a kinship here with the pleasures of doing a jigsaw or organizing the household accounts. The work is a product of a spirit that loves small manoeuvres, a spirit that could with ease be translated into the language of domestic tasks or quiet hobbies (stacking a dishwasher, designing a model railway layout). The artwork lifts these moods and moments of happy concentration into the public realm and directs some of the accumulated prestige of art towards them. This is an act of justice and not of condescension, because in the scheme of life these satisfactions, which have received so little acclaim and have not been much celebrated in the history of philosophy, genuinely need to be taken more seriously. They are not heroic, disturbing or dramatic, but this is their virtue. Given how life generally goes, we need all the reliable, unassuming and inexpensive satisfactions we can get. The work is not arguing that organizing paper

is always more important than fighting for one's country, forming good relationships or being a reliable employee. It simply speaks up gracefully in the name of some of our more neglected capacities, and thereby helps us to live more easily with ourselves and others.

What we call 'glamour' usually lies elsewhere: in the homes of people we don't know, at parties we read about, in the lives of people who have been adept at turning their talents into money and fame. It's in the nature of media-dominated societies that they will, by definition, expose us to a great deal more glamour than most of us have the opportunity to participate in. We are left peering, painfully, through the window at enticements beyond. Commercial images help generate a longing for the higher realms promised by contemporary capitalism; they give us a ringside seat at the holidays, professional triumphs, love affairs, evenings out and birthdays of an elite we are condemned to know far better than they know us.

If images carry a lot of the blame for instilling a sickness in our souls, they can also occasionally be credited for offering us antidotes. It is in the power of art both to disgust us with the apparent tedium and colourlessness of our condition, and to effect intelligent reconciliations with it. Consider Chardin's *A Lady Taking Tea* (37). The sitter's dress might be a bit more elaborate than is normal today, but the painted table, teapot, chair, spoon and cup could all be picked up at a flea market. The room is studiously plain. Yet the picture is glamorous: it makes this ordinary occasion, and the simple furnishings, seductive. It invites the beholder to go home and create their own live version. The glamour is not a false sheen that pretends something lovely is going on when it isn't. Chardin recognises the worth of a modest moment and marshals his genius to bring its qualities to our notice.

It lies in the power of art to honour the elusive but real value of ordinary life. It can teach us to be more just towards ourselves as we endeavour to make the best of our circumstances: a job we do not always love, the imperfections of middle age, our frustrated ambitions and our attempts to stay loyal to irritable but loved spouses. Art can do the opposite of glamourizing the unattainable; it can reawaken us to the genuine merit of life as we're forced to lead it.

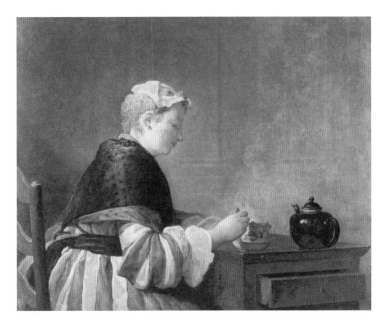

A modest moment, appreciated for its true worth.

— 37. Jean-Baptiste-Siméon Chardin, *A Lady Taking Tea*, 1735

What is the Point of Art?

What, then, are the consequences of holding to a therapeutic vision of art? Principally, the conviction that the main point of engaging with art is to help us lead better lives – to access better versions of ourselves. If art has such a power, it is because it is a tool that can correct or compensate for a range of psychological frailties. To summarize some of these frailties:

1. We forget what matters; we can't hold on to important but slippery experiences.
2. We have a proclivity to lose hope: we are oversensitive to the bad sides of existence. We lose out on legitimate chances of success because we fail to see the reasonableness of keeping going at certain things.
3. We incline towards feelings of isolation and persecution because

we have an unrealistic sense of how much difficulty is normal. We panic too easily, as we misjudge the meaning of our troubles. We are lonely – not that we have no one to talk to, but because those around us can't appreciate our travails with sufficient depth, honesty and patience. This is partly because the ways we show the pain of our choppy relationships, envy or unfulfilled ambitions can easily seem pejorative and insulting. We suffer and we feel that this suffering lacks dignity.

4. We are unbalanced and lose sight of our best sides. We aren't just one person. We are made up of multiple selves, and we recognize that some of these are better than others. We meet our better selves too often by chance, and when it is too late; we suffer from a weakness of will in relation to our highest ambitions. It's not that we don't know how to behave, we simply fail to act upon our intermittent best insights because they aren't available to us in sufficiently convincing forms.

5. We are hard to get to know: we are mysterious to ourselves and therefore no good at explaining who we are to others, or being liked for reasons we think are appropriate.

6. We reject many experiences, peoples, places and eras that have something important to offer us because they come in the wrong wrapping and so leave us unable to connect. We are prey to superficial, prejudiced judgements. We think things are 'foreign' far too defensively.

7. We are desensitized by familiarity and live in a commercially dominated world that highlights glamour. Hence we often end up dissatisfied that life is humdrum; we are gnawed by the worry that life is elsewhere.

It is in relation to these seven psychological frailties that art finds its purpose and value as a tool, and offers us seven means of assistance:

1. A CORRECTIVE OF BAD MEMORY: Art makes memorable and renewable the fruits of experience. It is a mechanism to keep precious things, and our best insights, in good condition and makes them publicly accessible. Art banks our collective winnings.

2. A PURVEYOR OF HOPE: Art keeps pleasant and cheering things

in view. It knows we despair too easily.

3. A SOURCE OF DIGNIFIED SORROW: Art reminds us of the legitimate place of sorrow in a good life, so that we panic less about our difficulties and recognize them as parts of a noble existence.

4. A BALANCING AGENT: Art encodes with unusual clarity the essence of our good qualities and holds them up before us, in a variety of media, to help rebalance our natures and direct us towards our best possibilities.

5. A GUIDE TO SELF-KNOWLEDGE: Art can help us identify what is central to ourselves, but hard to put into words. Much that is human is not readily available in language. We can hold up art objects and say, confusedly but importantly, 'This is me.'

6. A GUIDE TO THE EXTENSION OF EXPERIENCE: Art is an immensely sophisticated accumulation of the experiences of others, presented to us in well-shaped and well-organized forms. It can provide us with some of the most eloquent instances of the voices of other cultures, so that an engagement with artworks stretches our notions of ourselves and our world. At first, much of art seems merely 'other', but we discover that it can contain ideas and attitudes that we can make our own in ways that enrich us. Not everything we need to become better versions of ourselves is already to hand in the vicinity.

7. A RE-SENSITIZATION TOOL: Art peels away our shell and saves us from our spoilt, habitual disregard for what is all around us. We recover our sensitivity; we look at the old in new ways. We are prevented from assuming that novelty and glamour are the only solutions.

What Counts as Good Art?

We grow up with a canon of art: a widely accepted list of the art we should revere if we want to lay claim to being intelligent, educated citizens. One is more or less required to regard certain artists as important. Caravaggio and Rembrandt are the great painters of the seventeenth century. In the eighteenth century, Chardin is quite important, but Goya more so. In the nineteenth century, Manet

and Cézanne deserve special respect; in the twentieth, the key names are Picasso, Bacon and Warhol. Of course, the canon varies from time to time and is nuanced by experience, but we tend to be fairly loyal, perhaps without really noticing, to some approximation of this list. It would take a lot of nerve to depart publicly from it. This leads to a strange paradox: we may well end up unimpressed or cold before works that, in theory, we regard as masterpieces. Or we may dutifully attempt to force the appropriate reaction.

Faced with Caravaggio's depiction of the Biblical Judith's decapitation of the Assyrian general Holofernes, one might feel one ought to like it because it doesn't try to be prim about what it might be like to cut someone's head off, because the light falling on Judith's dress is particularly vivid and because it shows that women can be violent, thereby counteracting the patronizing notion of the gentle sex (38). Many people enthuse about this artist's work, but in honest moments one might admit to not really liking it.

We all have some version of this story. That is, an experience of the gulf that can separate the prestige of the work from its power to touch one's soul. This happens because the canon is in many ways disconnected from our inner needs. There may be instances of overlap, but the disconnect is not really very surprising because the list of prestigious works and artists is not really intended to focus on what is going on in our lives. This becomes clear when we look at how – until now – works of art became canonical or prestigious. Ideas about what is 'good art' are not formed by themselves. They are the result of complex systems of patronage, ideology, money and education, supported by university courses and museums, all of which guide our sense of what makes a work of art especially worthy of attention. In time, this becomes just common sense. In 1913, for example, Raphael was very popular and many people at the time would have thought him the greatest painter who had ever lived. In 2013, this may be far less likely. At either point, people would probably struggle to explain the reasons behind their convictions. This is why it's worth studying some of the principal reasons why art has historically been judged important.

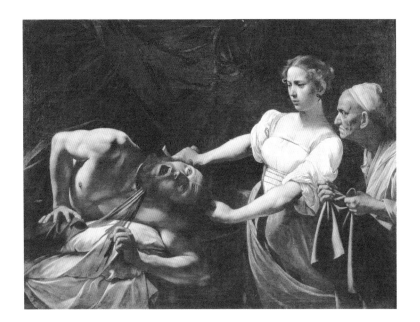

It can be even more frightening
to feel that one doesn't get
a famous work.
— 38. Caravaggio,
Judith Beheading
*Holofernes, c.*1599

Methodology

Technical Reading

This method of evaluating art sees it as a succession of 'discoveries' or inventions in the representation of reality, and privileges those artists who made the first move towards them. It is akin to a scientific way of reading history, in which we look out for inventors and explorers (Who discovered America? Who put together the first steam engine?). This method tells us that Leonardo da Vinci was crucial because he was an early adopter of *sfumato*, an artistic technique for showing shapes without using outlines. Braque was important because he introduced, or was the first to extensively explore, the idea of depicting the same object from more than one point of view.

Cézanne's *Mont Sainte-Victoire* is sometimes described as one of the most important paintings in the world because it is one of the earliest works to radically emphasize the flat surface of the canvas (39). In his image of the mountain as seen from Les Lauves, his property near Aix-en-Provence, Cézanne uses blocks of paint to evoke shrubs, but they are first and foremost coloured marks forming an abstract pattern. (This is most apparent if the top half of the painting is covered.)

—

Political Reading

According to a political reading of art, a work is seen as good to the extent that it makes important points about man's search for dignity, truth, justice and the due allocation of financial rewards. According to these criteria, Gainsborough's *Mr and Mrs Andrews* is a very significant picture, for it can be understood as a thesis about land ownership (40). The couple stand in solitary possession of their acres. They don't have to till the soil or bring in the harvest, they simply enjoy the fruits of others' labour. Gainsborough has suggested, by the way he has painted their faces, that these are smug, mean-spirited people, so the picture can be seen as making a point against the moral corruption of the dominant land-owning class. From the political point of view, this is positive and progressive art, for it is on the side of the future.

TOP
*How important is the artist's
technique to you?*
— 39. Paul Cézanne, *Mont
Sainte-Victoire*, 1902–4

ABOVE
*Part of the long history of man's
search for justice.*
— 40. Thomas Gainsborough,
Mr and Mrs Andrews, c.1750

Methodology 63

—

Historical Reading

A work of art can be valued for what it tells us about the past.
Carpaccio's painting is a rare visual record of a famous bridge before it
was reconstructed, and has a lot to teach us about the architecture
of Venice around 1500 (41). However, it is also highly instructive
about the role of religion in civic life; the ceremonial processions; how
patricians and gondoliers used to dress; what kinds of hairstyle people
went in for; how the painter imagined the past (the ceremony had
taken place more than a hundred years before the picture was painted);
the economics of art (the image is part of a series commissioned by
a wealthy commercial fraternity); how business was linked to social
and religious life. And – of course – very much more. In a less scholarly
way, the richness with which a past era is made visually present allows
us to imagine what it would be like to clatter across the wooden
bridge, to be rocked along the canals in a covered gondola and to live
in a society where belief in miracles was part of the state ideology.

—

Shock-value Reading

We are conscious that, individually and collectively, we may grow
complacent. Art may therefore be highly valued for its capacity to
disrupt and shock. We are particularly in danger of forgetting the
artificiality of norms. It was once taken for granted that women should
not be allowed to vote, and that the language of ancient Greek should
dominate the curriculum of English schools. It is easy to see now that
those arrangements were far from inevitable, and that they were open
to change and improvement.

Chris Ofili has worked against received ideas about what art can be
made of. After its first appearance in the 'Sensation' exhibition of 1997
in London, his painting *Holy Virgin Mary* caused controversy around
the world, from raising the ire of New York Mayor Rudolph Giuliani
to being smeared with white paint by a gallery visitor as a protest (42).
Through his use of dried and varnished elephant dung in place of a

An insight into what the
Rialto Bridge in Venice looked
like in the early fifteenth
century (it collapsed about
30 years later).

— 41. Vittore Carpaccio,
*The Healing of a Man
Possessed by a Demon
(The Miracle of the Reliquary
of the Holy Cross), c.*1496

*The power to shock sometimes
seems like the most important
quality in art.*
— 42. Chris Ofili,
Holy Virgin Mary, 1996

more traditional representation of the Virgin's breast, Ofili challenges our assumption that excrement, and all it symbolizes, is worthless. We are being shaken from our views of what is respectable and what is not, and nudged towards a more positive evaluation of a by-product of digestion. If we are shocked, the problem lies not with Ofili, but with the inflexibility of our own ideologies. We are being encouraged not to make the same mistake as those who, in previous eras, would have denied women the vote or insisted that ancient Greek was an indispensable part of the curriculum.

—

Therapeutic Reading

This book introduces a fifth criterion for judging art: that it can be deemed important in so far as it helps us in a therapeutic way. A work can be 'good' or 'bad', depending on how well it caters to our inner needs, how well it can address one of the seven psychological frailties we have identified, from a poor memory to a failure to appreciate the more modest unnoticed details.

To adopt this fifth criterion will have a range of consequences for our understanding of the canon. This way of reading will outline what might be happening in our inner depths when we say that works of art are good or bad. We may well end up liking the same works judged worthy by other readings, but we would love them for different reasons: because they had helped our souls. Getting something out of art won't just mean learning about it – it will also mean investigating ourselves. We should be ready to look into ourselves in response to what we see. Art will be deemed not good or bad *per se*, but good or bad *for us* to the extent that it compensates for our flaws: our forgetfulness, our loss of hope, our search for dignity, our difficulties with self-knowledge and our longings for love. Before one reaches a work of art, it will therefore help to know one's own character, so that one knows what one might be seeking to soothe or redeem.

What Kind of Art Should One Make?

The question of what art one should make feels strange because we don't expect non-artists to raise it. We implicitly believe that artists should decide what they do, and according to processes that they don't themselves entirely understand. We are in the grip of a Romantic deference to high art that regards it as having a quality so mysterious that outsiders can't, and shouldn't try to, interfere with it. However, this reluctance by non-artists to give guidance to and make demands on artists fatally weakens the power of art and reflects an underlying fear of addressing the question of what art is for. Since we don't know in a clear way what we want from art, we lack the confidence to ask for specific things; we abandon to chance the hope that our key needs will be covered by the unstructured and mysterious inspiration of artists.

Such haphazardness has not always been the rule. For long periods of history, religions and governments have considered art as a fundamental shaper of personality and public life, and therefore believed it was in the interests of the wider polity for the artistic agenda to be led by more than just individual inspiration. Religions and governments wished to direct art according to their particular understanding of the needs of the soul and of society; artworks might have to be created to guide people to the values of sacrifice and redemption, or else to inspire respect for manual labour and the renunciation of capital. These religions and governments were unembarrassed about using a term that has now become one of the most poisonous in the lexicon: propaganda. For them, art was quite simply propaganda for the most important ideas in the world.

Take Jan and Hubert van Eycks' Ghent Altarpiece: the central panel of the lower section depicts a lamb on an altar (43). The lamb bleeds into a golden cup; to the left there is a wooden cross and two figures are holding a spear and a crown of thorns. Above, in the centre of the sun, we see a dove with outstretched wings. Van Eyck produced an extraordinary visualization of a set of ideas that were worked out in great detail by others. The society in which he lived did not demand that, on top of his ability to make paint seem like blood and to evoke sorrow from pigment, van Eyck should also be a philosopher

or theologian. It rewarded him for his creativity – not for the ideas themselves, but for the visualization and rendering of the ideas.

The widespread loss of trust in the particular agendas of religions and states (in particular, of Catholicism and Communism) have brought the entire notion of an agenda for the use and commissioning of art into disrepute. The self-aggrandizing actions of numerous tyrants and dictators have tarnished what was not necessarily a bad idea: that an agenda for art can come from outside the artist's own imagination, and reflect the needs of society and the viewer's soul.

At this point, a nagging worry comes to mind: who is to decide the agenda? What will happen if I don't agree with it? Could I be locked up in prison? We associate propaganda with enforced belief, but the liberal societies painfully built up by our ancestors are founded on consent. Even the most ambitious corporations or political parties have to win market share or votes by persuading people of the worth of their products or policies. Falling congregation numbers in the twentieth century demonstrate that even a long-established, wealthy and prestigious institution such as the Catholic Church, with many educational resources to hand, can only dream of imposing its doctrines in democratic, market-orientated states. There is no mechanism by which assent could be fully compelled here.

Therefore, suggesting an agenda for art has, today, nothing to do with enforcement. We are not faced with a choice of being dragooned into a police state or abandoned to the whims of chance. We should feel safe enough to be able to think of art as propaganda for some rather nice – and important – things. We can imagine a commissioning structure that would be akin in its sharp definitions to those given by the Catholic Church or the Communist state – but the commissions would be focused on achieving entirely different ends, and would not be interested in coercion. The agenda for art in a liberal society would be to assist the individual soul in its search for consolation, self-understanding and fulfilment. Commissions would flow from the seven basic themes discussed. Artworks would look to commemorate, give hope, echo and dignify suffering, rebalance and guide, assist self-knowledge and communication, expand horizons and inspire appreciation (see Appendix: An Agenda for Art, page 230).

The artists didn't pick the topic themselves, but their work is still great.

— 43. Jan and Hubert van Eyck, *Ghent Altarpiece* or *The Adoration of the Mystic Lamb*, 1423–32

Consider the third theme: the need to find a dignified echo of our sorrows and the power of art to help us feel less alone with and confused by it. At present, this need is very fitfully handled. In a large museum we might find one or two artists taking this on in unrelated ways, in stark contrast to the systematic ambition for art set by the Catholic Church with its canon of 'sorrowful mysteries'. In the early Middle Ages, five episodes of suffering from the life of Jesus were carefully analysed by theologians to bring out their intimate resonance. Artists were then repeatedly commissioned to create works around these precise themes. The first of these, 'The Agony in the Garden', refers to the terrified loneliness of Jesus the night before he was put to death (44). It provides an immensely prestigious focus for a distinctive aspect of grief: the feeling that one is utterly alone and that a dreadful but unavoidable task awaits one in the morning.

Such art seeks, as best it can, to help us at particular times. In the

Christian artistic schema it is sequentially linked to the second sorrowful mystery, 'The Crowning with Thorns', which addresses humiliation and cruel mockery. Considered as a whole, the cycle of sorrowful mysteries constitutes an elaborate psychology of sorrow that shows us the role of suffering in life and seeks to offer a perspective that strengthens our capacity to bear our afflictions, inculcates sympathy and removes the stigma that sometimes attaches to admissions of anguish.

Since this canon is framed within a very particular set of religious beliefs, its power is dimmed in a secular age, but it offers inspiration for a neglected, albeit potentially very rewarding, endeavour: the deliberate and systematic harnessing of art to our inner sorrows. Imagine a secular world in which one of the key ambitions for art was for it to be a mirror for sorrows. This would be connected to a psychological agenda as purposeful and rich, in its own way, as the theological agenda set by the Catholic Church for Jan van Eyck. Consider just some of the essential sorrows we face: the inability to find love, panic around money, unhappy family relations, frustrating work, adolescent uncertainties, mid-life regrets, anguish in the face of one's own mortality and unfulfilled ambitions.

One of the sorrowful areas is relationships, yet surprisingly few artworks in current circulation focus on this major theme. Imagine a brief given to artist that reads something like this:

Many couples have painful conflicts that break out over dinner. The spark often looks quite small, such as the way someone asked 'How was your day?' with what feels like a sarcastic or sceptical intent. One person says something harsh, the other looks numb with misery; the one who storms out is furious but feels like a monster ('How can this be happening to me?'). There is a spiral of 'I hate you' and 'I hate myself' and 'I hate you for making me hate myself.' We would like an artwork to carry indications of an underlying but frustrated longing to be happy together. Perhaps the table is beautifully laid. One person is feeling they have done nothing wrong; the other is crying. These are nice people. We are not condemning them. They have to be likeable. They are in the grip of a genuinely difficult problem. Can their suffering gain in dignity and be less catastrophic and lonely because of a work of art?

ABOVE
*The artist reached for a ready-
made theme.*
— 44. Paul Gauguin,
Christ in the Garden of Olives,
1889

RIGHT
*Imagining a new post-
Christian canon for art.*
— 45. Jessica Todd Harper,
The Agony in the Kitchen,
2012

The exercise was undertaken for the purposes of this book, and it yielded an image from the American photographer Jessica Todd Harper, which seemed to carry out the brief successfully (45). There could, of course, be a hundred other ways to honour this challenge. There could be galleries full of it, as there are of Agonies in the Garden.

The challenge is to rewrite the agenda for commissioning so that art can start serving our psychological needs as effectively as it served those of theology or state ideologies for centuries. We should dare to conceive of art as more than just the fruits of the irregular imaginations of artists. We should channel and co-opt artworks to the direct task of helping us achieve self-knowledge, remember forgiveness, and love – and to remain sensitive to the pains suffered by our ever-troubled species and its urgently imperilled planet.

Far from humbling art, this is a strategy to give artistic activity the central place it has often claimed, but rarely managed to occupy in practice. It's not that art is not appealing. It's just that we don't actually turn to it with any regularity when we want effective help. Our actions betray the feeling that our lips hesitate to speak. If we want art to be more powerful, and of more consequence in our individual and collective lives, we should be ready to embrace this unfamiliar strategy.

How Should Art be Bought and Sold?

Our uncertainty about quite what art is for comes to a head around the vexed question of what it should be worth. As we don't have solid criteria by which to judge the importance of art, the public response to the art market is ambivalent. On the one hand, individual works are seen as repositories of great value and will fetch enormous prices at auction as a result. On the other, these high valuations are deemed a folly by many, and a sign that the world has lost its moral bearing. Beneath the conflict around price, though, another set of questions is trying to break through. What is the point of ownership? What are we trying to achieve when we purchase works of art? What is a 'collection' of art for?

Three kinds of buyers of art can be identified: institutions, private collectors and the general public. To start with the first of these, consider the acquisitions policy of the Tate Gallery in London, which

includes Tate Britain and Tate Modern:

> The Tate Gallery collects British art from 1500 and international
> modern and contemporary art from 1900 to the present. It seeks to
> represent significant developments in art in all areas covered by this
> remit. It seeks to collect works of art that are of outstanding quality as
> well as works that are of distinctive aesthetic character or importance.

In this respect, the Tate is typical of the world's great public galleries.
It aims to present 'the significant developments in art' in both national
and international terms and across time. The guiding assumption
is that we need to encounter the development of art and that large
institutions should set out to buy and display certain works that
chart its unfolding story. An acquisition committee might decide, for
example, that its host institution already had enough good examples
of Pre-Raphaelite religious painting, but was weak on the Italian
Futurists, and would adjust their purchasing priorities accordingly.
This 'representative' strategy is so familiar that it seems strange to
ask what it is for and whether it is right. It is entrenched because we
have not taken the question of the purpose of art seriously enough.
It says: art has changed a lot over time, and we should trace those
changes. Imagine reformulating a more purposeful and significant
policy for the Tate in line with a therapeutic understanding of art:

> The Tate purchases art from any place and any period. It aims
> always to educate the British soul. It seeks to collect works that meet
> the psychological needs of the nation.

If this were the mission of the museum, the deliberations of the
acquisition committee might sound very different. They might take
the view that they were strong on works that addressed loneliness
but short on art that helped people form better relationships. The
purchasing of new works would be guided by an analysis of the
nation's collective psychological frailties. This, of course, would be a
controversial matter, but not necessarily more so than an analysis of
what was missing in a historical collection. A new qualification for
joining an acquisition committee would emerge: accuracy and clarity
in diagnosing the state of the national psyche, and in particular its

imbalances and biases. The committee would hope that art might amend and compensate for these flaws.

Whatever the possible problems with museums, few people could accuse them of consciously practising deception or fraud. Not so with art dealers, who have been routinely accused of both ills for two centuries or more. But we shouldn't blame the dealers. The problem with the art market must ultimately be located with the buyers: it is because so many don't know what they are looking for that they can let themselves be swindled and led astray.

The task of the private gallery is a serious one: to connect purchasers with the art they need. The chief skill required for running a gallery should therefore be not salesmanship, but the ability to diagnose what is missing from the inner life of the client. The art dealer should strive to identify what kind of art a person needs to rebalance themselves, and then meet that need as efficiently as possible.

The key activity of a dealer would be to conduct consultation sessions that would reveal the state of the client's soul. Before one can know what someone should buy, one has to know who they are, and, more importantly, what areas of their psyches are vulnerable. The role of the dealer would overlap with that of a therapist. The standard layout of a commercial gallery would evolve to include a therapy room, which one might need to pass through before getting to see any works for sale. Thus the dealer would operate as a matchmaker, bringing together an inner need of the client with a work best able to assuage it.

Today, this would look like a very strange process for buying and selling because we have the wrong picture of what art is. At present the task of the gallery dealer is to convince the client that a given work has a special kind of prestige: public but elusive, tangible yet confusing for the uninitiated. Such prestige is essentially dependent on what other people are thinking. The suggestion is always that if you buy this work, art-world insiders will approve. Hence, galleries seek to create an atmosphere that combines exclusivity and the sense of being at the cutting edge; that is, they build on our anxieties about being an outsider or old-fashioned (46). But galleries could get involved in a more important type of business. They could set out to help clients live better lives by selling them the art they need for the sake of their inner selves.

A wise purchase for someone susceptible to hype.

— 46. Banksy, *I Can't Believe You Morons Actually Buy This Shit*, 2006

Largely on grounds of cost, most people don't buy art in galleries. The chief vehicle for selling art on any mass scale is the museum gift shop. This is quite simply the most important tool for the diffusion and understanding of art in the modern world. Though it appears to be a mere appendage to most museums, the gift shop is central to the project of art institutions. Its job is to ensure that the lessons of the museum, which concern beauty, meaning and the enlargement of the spirit, can endure in the visitor far beyond the actual tour of the premises and be put into use in daily life.

The means deployed, however, may not always be on target. Apart from books, gallery gift shops usually sell postcards and associative objects. Postcards are successful and important mechanisms for improving our engagement with art. Our culture sees them as tiny, pale shadows of the far superior originals hanging on the walls a few metres away, but the encounter we have with the postcard may be deeper, more perceptive and more valuable to us, because the card allows us to bring our own reactions to it. It feels safe and acceptable to pin it on a wall, throw it away or scribble on it, and by being able

to behave so casually around it, our responses come alive. We consult our own needs and interests; we take real ownership of the object, and, since it is permanently available, we keep looking at it. We feel free to be ourselves around it, as so often, and sadly, we do not in the presence of the masterpiece itself.

Gift-shop managers have discovered that people also like to buy objects heavily decorated with names of artists and their works, so we have Picasso table mats and Monet tea-towels. Such objects try hard to pay homage to artists. They would like to beautify the world and carry the message of artists deep into our homes, so that the spirit of Monet would be alive when we prepared the morning tea and Picasso would be with us as we mopped away the orange juice from the kitchen counter. The ambition is noble, but its method of execution is perhaps less so. The objects in a gift shop do have a faint link to the names they honour. Monet may well have liked tea towels, but it is unlikely that he would have wanted one with his own painting printed on it. The spirit of his best works of art, the things we love in them, may be much more consistent with, for instance, a completely plain and beautifully textured towel. This is more truly a Monet towel than one with his name on it. The point is not to surround ourselves with objects that carry the actual identity of the artist and his or her work. It should be to get hold of objects that the artists would have liked, and that are in keeping with the spirit of their works; and, more broadly, to look at the world through their eyes, therefore staying sensitive to what they saw in it.

One can imagine a different range of products to sell in the world's gallery gift shops: objects that are aligned with the values and ideals of artists, rather than merely with their identities. The urge to buy something at the end of a museum visit is a serious one because it involves an attempt to translate a sensibility we've come to know in one area – on landscape canvases, portraits of ladies with parasols, and so on – and carry it over into another part of life, such as keeping the kitchen clean. This points to the heart of what museums should really be about: giving us tools to extend the range and impact of what we admire in works of art across our whole lives. This is why the gift shop is, in fact, the most important place in the museum – if only its true potential could be grasped and made real.

How Should We Study Art?

In general, we are comfortable with the idea that we need to study art. We take the generous view that works of art deserve knowledge and effort on our part before they will unlock their secrets. This has resulted in the emergence of a multinational art-history industry, which has its headquarters in places such as the Courtauld Institute in London and the Department of the History of Art at Yale University.

Some of the dominant trends in looking at and thinking about art, such as technical, political, historical and shock-value readings, were identified earlier. The prestige of these approaches is tied up with the reputation and influence of the great academic machines of art history. There is something reassuring and dignified in this scholarly approach to art. Consider the outline of a course, which you can take at Yale, and that is representative of the current ideal:

> Italian Renaissance Art
> Mon, Wed 1.00 pm – 2.15 pm
> This course will treat the history of Italian Renaissance art from 1300 to 1500, not only the history of painting, but also that of sculpture, drawing and the print medium. Although the lectures will be arranged chronologically, they do not offer a survey. Instead, the course focuses on a set of problems and issues that were specific for the time and place. The lectures are presented as a series of vignettes: important episodes in the history of Italian Renaissance art, viewed from the perspective of one painter or sculptor. Together, these painters and sculptors tell a story of the period.

Here, the assumed task is to help us know as much as possible about what the works in question meant to the people who created them. This is a very generous undertaking. In effect, the course addresses the Italian Renaissance artists like this: 'I don't know enough about your perspective on the problems and issues specific to your time. I'm sorry about that and I'm going to try very hard to put it right.'

The course is deliberately impersonal. It carefully avoids asking, 'what do these works mean to me?' Or, 'what problems and issues might I have in common with a painter or sculptor from 1300 to 1500?' This vision of objective scholarship is a culmination of a trend

that started in Germany in the late nineteenth century, and was pursued as a corrective to wild projections and chaotic responses. However, it could be argued that the problem the course description identifies has generally already been solved. There is no shortage of good information about the history of art. The worry that not enough people know about the Renaissance may persist, but the solution to that lies in mass communication, not ever more exacting research.

A less evident – but significant – presupposition of academic scholarship is that the message of the work is hard to understand and complicated. Both require a great deal of learning. The facts that are hardest to discover take centre stage. It may require immense labour and ingenuity to discover in which precise year an altarpiece was painted, or to reconstruct the power struggles that accompanied the construction of a palace. It is assumed that these are the crucial things to know, if you are to get the most out of art. Influenced, perhaps unconsciously, by these suppositions, we construct a fantasy of what is supposed to be going on in our heads when we 'understand' art properly.

Take the Sistine Chapel (47). Having spent a few years at the Courtauld or at Yale, one might be expected to say of it, 'The work was painted around 1511. Michelangelo was born in 1475, so he would have been 36 at this point. You can see the heavy shadow bringing out the structure of the muscles. Michelangelo had an ideal of male beauty derived from classical sculpture, some of which was discovered in Rome around this time; in fact, Vasari tells the story that at a young age Michelangelo produced a statue which he buried in the garden of one of the Medici properties; it was then dug up and people thought it was an original ancient work. The pose of Adam is reminiscent of that of the so called Theseus (although today it is understood to have been a representation of Dionysus), so it may be that Michelangelo is incorporating classical mythology into Christian theology. Adam's right hand, on the far left of the picture, is an example of radical foreshortening, which emphasizes the optical and mathematical knowledge of the artist: the artist is an intellectual, not merely an artisan.'

This all sounds impressive because it accords with the idea that the meaning of an artwork should be complicated, and that grasping

Such images make us nervous because we feel we are supposed to know a lot about them before we can enjoy them.

— 47. Michelangelo,
*The Creation of Adam, c.*1511

it must reflect a great deal of information that is not widely known. But what if the meaning of a work is really quite straightforward, and if the important task is to extend it into our lives, which is where the message belongs?

This book suggests a different approach. Scholars should study how to make the spirit of the works they admire more connected to the psychological frailties of their audiences. They should analyse how art could help with a broken heart, set the sorrows of the individual into perspective, help us find consolation in nature, educate our sensitivity to the needs of others, keep the right ideals of a successful life at the front of our minds and help us to understand ourselves. In this light, scholars would approach the Sistine ceiling as they should approach all works of art, with the humane question, 'What lessons are you trying to teach us that will help us with our lives?' Everything other than this,

however intelligent and dense with information it might be, would
simply be preparation or distraction.

How Should Art be Displayed?

Large museums and public galleries are at the centre of our experience
of art today. They are the places where we're most likely to spend
time engaging with individual works. They shape our expectations
and guide our ideas of what we are supposed to do and how we are
supposed to behave around art. The great museums – the Louvre, the
Metropolitan Museum, the Tate, the Getty Center – are amongst the
most authoritative, trusted and alluring places in the world.

However, these institutions present a very complicated and
muddled set of messages about art, which often undermines its
potential. The problems start with the captions. Most people
instinctively edge towards the caption as they approach a work of
art, and although this is occasionally frowned upon by sophisticates,
it makes sense. A caption seeks to tell you what you need to know in
order to engage fruitfully with a work of art. It makes the promise,
'Read me and you will get more out of the work I accompany.'

At present, most captions focus on providing stylistic or historical
information. At the Metropolitan Museum of Art in New York,
a depiction of Christ appearing to Mary by Juan de Flandes carries
the following caption (48):

> Workshops routinely produced copies of paintings that were prized
> for their spiritual powers or for the status of their authorship
> and/or ownership. Such factors prompted Queen Isabella of
> Castile to order a copy of Rogier van der Weyden's *Mary Altarpiece*
> (Gemäldegalerie, Berlin), which was given by her father, King Juan
> II, to the Carthusian monastery of Miraflores, near Burgos, Spain,
> in 1445. This picture is the right panel of Isabella's triptych and can
> tentatively be attributed to her court artist Juan de Flandes on
> the basis of documentary and technical evidence. The center and
> left panels remain at Isabella's burial site, the Capilla Real, Granada,
> where she bequeathed the triptych upon her death in 1504.

At the very moment when it has the best opportunity to guide the response of the beholder, the gallery gives priority to certain facts: by whom an earlier version of this image was owned, the location of a monastery and when Queen Isabella died. The caption imagines the typical visitor approaching the work with some complex questions in mind, such as 'Didn't I see something like this in the Gemäldegalerie in Berlin?' 'Was Queen Isabella of Castile's father King Juan the I or the II?' or 'Are you sure this isn't a Rogier van der Weyden?' To these questions, it provides the perfect 200-word answer. That the image was regarded (500 years ago) as having 'spiritual power' is mentioned only to help explain how such a prestigious museum comes to be displaying a copy and not an original work. An alternative label might read thus:

> The picture shows us a shocking encounter between a mother and a son. She has seen him humiliated and abandoned. But now, despite everything, he is restored to her. She thought she had lost him. But he is here.

> The Biblical story speaks of universal themes raised to maximum dramatic pitch. In her eyes, her son is perfect: he is the most important being who has ever lived. But the world rejects him. His suffering is her suffering. She has been powerless to help or protect him. She could not keep him safe. He left her; he had to go out into the world and pursue his own tasks. We see the ending that all mothers crave: that the horrors will be over. And that in the future people will love her son as she loves him.

> This is an image of a loving mother-son relationship. But it does not avoid conflict or grief: these are precisely what the picture says are central to love. It is a very restrained image. They do not embrace. He will soon leave. How often has this scene been re-enacted?

> The picture makes the claim that such moments of return (and of survival), though fleeting and rare, are crucially important in life. It wants men to understand – and call – their mothers.

The problem with museums extends from captions to the whole philosophy of how rooms are laid out and how the visitor progresses

In search of a good label?
— 48. Juan de Flandes,
Christ Appearing to His
Mother, 1496

Methodology

through the building. In large galleries today, the display rooms tend to be named in ways that are overtly academic and historical, in line with the education of their curators, so we may stroll from the 'North Italian School' to 'The Nineteenth Century' via the 'The Art of the Enlightenment'. This reflects a scholarly attitude to categories, as can also be found in literature courses on 'The American Novel' or 'From Allegory to Realism', rather than the range of needs the visitor might bring.

A more ambitious, and beneficial, arrangement would be to arrange the works in line with the concerns of our souls, bringing together those objects which, regardless of their origins in space and time, address the troubled areas of existence (49). Aided by wise and forthright labels, a tour of the gallery would keep at the front of our minds the things we most need to hold on to, but which so easily fall from view.

The rehang committee could look for guidance to the Venetian Basilica di Santa Maria Gloriosa dei Frari (50). The Frari makes no concession to scholarly organization of the many artworks it contains, for it is committed to what it holds to be a grander task: that of saving our souls, as understood by Catholic theology. Paintings (there is a large altarpiece by Titian) join with monuments, window traceries, frescoes, sculpture, metalwork and architecture to make a coherent and sustained impression on our deepest thoughts and feelings. The question of where a work was made, or the precise intentions of the marker, are subordinated to the overall mission.

A modern museum might seem highly organized, but this masks a deeper and very serious disorder when it comes to the true purpose of art. Devotion to academic categories actually gets in the way of creating and sustaining emotional order and insight. Museums are thus prevented from taking up the conception of the transformative, redemptive power of art pioneered in churches and temples. Curators should dare to reinvent their spaces so that they can be more than dead libraries for the creations of the past. Together with the revised vision for captions, our encounters with art would be transformed.

In 1966, the board of the wealthy Kimbell Art Foundation in Fort Worth, Texas, hired the American architect Louis I. Kahn to design a

An art gallery reorganized according to a therapeutic vision. The art wouldn't need to change, only the way it was arranged and presented. Each gallery would focus not on dates and provenance, but on the important rebalancing emotions encouraged by particular works.

— 49. The floor plan for the Tate Modern, revised

A machine for the therapy of the soul.

— 50. Basilica di Santa Maria Gloriosa dei Frari, 1250–1338

ABOVE
The architecture says that
something truly wonderful
is going on here – but what?
— 51. Louis I. Kahn,
Kimbell Art Museum,
1966–72

RIGHT
Currently used to refine our
understanding of fifteenth-
century gender politics.
— 52. Donatello,
Virgin and Child
(The Borromeo Madonna),
*c.*1450

new museum to house its collection of works, ranging from antiquities to contemporary abstract paintings (51). The benefactors, trustees and architect went to extraordinary lengths to create a beautiful environment that would focus our attention on the artworks and proclaim the dignity of art; thus the museum implicitly argues that tremendously significant experiences are to be had within its galleries.

What are these experiences, exactly? The Kimbell takes us to the brink of a crucial idea: that the great themes of existence can be addressed in elevating material spaces. It makes all the right preparatory moves: it creates the luminous space, it assembles prestigious objects. But then it stops short, and never encourages us to reform our lives under the guidance of art. It is often said that the great museums are the cathedrals of the modern world, but the comparison reveals the weakness of contemporary secular galleries, rather than flattering them. Cathedrals were created as compelling statements of a complete theory of life: of our deepest needs, our spiritual destiny and the guidance necessary to live the right life. This religious project may have lost its allure, but we should hold on to the scale and sincerity of its intent.

At one end of a gallery at the Kimbell Museum is a niche designed by Kahn out of travertine marble framed by supporting beams of polished beige concrete, in which Donatello's *Virgin and Child* has been placed and dramatically lit from three sides (52). We know we are being invited to recognize a moment of supreme importance – but what precisely is the moral here? The museum suggests that Donatello is the star of this gallery, which is dedicated to Italian Renaissance art. But the artist should only matter because he is supremely effective at evoking a quality that is of general human importance, in this case tenderness. In a gallery system rearranged under the guidance of a therapeutic approach, we should appreciate maternal tenderness through Donatello's work, but not remain fetishistically arrested in front of the work itself. The Kimbell shouldn't, perhaps, even provide us with rooms dedicated to Italian art of the fourteenth and seventeenth centuries. It should have a gallery dedicated to focusing our minds on important aspects of our emotional functioning.

There could be a gallery named Tenderness to help us understand what this quality is and why it is so hard to preserve in the conditions

of daily life. We would meet Donatello here, but his presence would be subsumed under a higher heading and enriched by items from other parts of the collection. There would be space for Henry Raeburn's portrait of the Allen brothers (53), currently marooned in the British room, because it matters less that this is a work by a Scottish painter of the European Enlightenment, as the caption tells us, than that it, like the *Virgin and Child*, has many important things to tell us about how to bolster the more delicate inclinations of our hearts.

To accompany visitors to this putative room, we shouldn't need lectures on Florentine altarpieces or Scottish society in the late eighteenth century; we would need lessons in how to make tenderness more active in our lives. The point of museums should not primarily be to teach us how to love art, but to inspire us to love what artists have loved through an appreciation of their work: a minor but critical difference.

Today's museums attempt to draw in visitors by making claims for the rarity of the objects in their collections. They suggest that what they possess is not only good, but also unusual and very scarce. In contrast, the true ideal of the museum should be to make what is good and important very normal and widely distributed. The energies of those who love art shouldn't be devoted to piling up treasures behind high walls, but instead should be to spread the values found in works of art more widely through the world. The mission of the true art lover should be to reduce the relative importance of museums, in the sense that the wisdom and insight currently collected there shouldn't be so jealously guarded and fetishized, but instead scattered generously and promiscuously across life. To guide us in this ambition, we might follow the example of the Dutch twentieth-century designer Gerrit Rietveld (54, 55). It is an irony of his career that many of his works are now found only in museums; for example, his legendary *Red Blue Chair* has pride of place in the design gallery of the Museum of Modern Art in New York. Rietveld, however, was suspicious of art museums and the snobbery he felt they attracted. His desire was for his furniture to break free from the high-art ghetto of the museum and to enter daily life. Like many designers of his era, he was interested in mass production because of a feeling that the one-off masterwork

*We need to learn more
about affection.*
— 53. Henry Raeburn,
The Allen Brothers,
early 1790s

Methodology

TOP
You can't sit on it in
the museum.
— 54. Gerrit Rietveld,
*Red Blue Chair, c.*1923

ABOVE
The values captured in art
shouldn't remain in the
museum – they should go with
us into the playroom.
— 55. Gerrit Rietveld,
Bolderwagon, 1918 (designed),
1968 (made)

90 *Art as Therapy*

could not sufficiently change reality, and that only if everyday objects were permeated with the correct values would human conduct change in the direction he wished for it to travel – he wanted us to be more playful, kinder to our children, less judgemental about class distinctions and more relaxed about sex. Moreover, he felt that the right sort of furniture was an important part of any plan to reform humanity in these directions.

It was this engagement with daily life that led Rietveld to take an interest in so-called humble objects such as brooms, waste paper baskets, umbrella stands, prams and buggies. He wisely sought to take the values he loved out of the museum and make them breathe in the playroom.

The museum once had an important role to play. It preserved objects that might otherwise have been lost, democratized their availability and established a reliable set of facts about works. But the museum is only a prelude to a life well lived. It is not its summation. It contains a series of hints of how we might live, but ultimately it stands in relation to art as school does to life – at a certain point we must go out into the world and learn to abandon our guides with the utmost respect and gratitude. The fulfilment of the mission of the museum is the closing of its own doors, so that the playroom, the kitchen, the bathroom, the park and the office can become temples to our values as much as the quiet, marble halls of galleries once were.

Love

Can We Get Better at Love?

Love is meant to be a pleasurable part of life, yet there are no people we are more likely to hurt, or to be hurt by, than those we are in a relationship with. The degree of cruelty that goes on between lovers puts established enemies to shame. We hope that love will be a powerful source of fulfilment, but it sometimes turns into an arena for neglect, unrequited longing, vindictiveness and abandonment. We become sullen or petty, nagging or furious, and, without quite grasping how or why, destroy our lives and those we once claimed to care for.

Can *art* help?

In a famous maxim, the seventeenth-century French moralist La Rochefoucauld makes the point that 'some people would never have fallen in love if they hadn't heard there was such a thing.' While making us laugh at our slavish and imitative tendencies, the maxim also points us towards a genuine phenomenon that we can observe in contexts other than love: we have a huge range of emotions and decide socially rather than individually which of these we should take seriously and which we should ignore. We receive external cues that will lead us to regard some emotions as especially significant, and inspire us to dampen or neglect others. Whatever La Rochefoucauld might suggest, this is not necessarily a bad thing.

In the eighteenth century, for example, Romantic poets recast the seemingly minor pleasures of a country walk into one of the central experiences of a sensitive and good life. Twentieth-century feminism rendered patriarchal attitudes unacceptable and pointed out their prevalence in the small moments of relationships. In the 1960s, the American Civil Rights movement transformed racial contempt from an unremarkable attitude into one of the worst feelings a person could have. In their different ways, Romanticism, Feminism and Civil Rights activism have revolutionized our sense of which parts of our emotional spectrum we should pay attention to and which parts we would be wiser to reject.

If we accept that guiding our emotions is an important part of the process of creating a civilized society, then culture should be

We had seen but not noticed the fog.

— 56. James Abbott McNeill Whistler, *Nocturne: The River at Battersea*, 1878

recognized as one of the central mechanisms by which we do it, along with politics. It is the music we listen to, the films we see, the buildings we inhabit and the paintings, sculptures and photographs that hang on our walls that function as our subtle guides and educators.

Almost two centuries later, and referring to the most fashionable artist of his day, Oscar Wilde formulated a maxim that applied La Rochefoucauld's idea about love to art: 'There was no fog in London until Whistler started painting it.' Wilde did not mean that people had failed to glimpse the thick vapours that can drift over the water flowing through the English capital; his point was just that the experience of seeing the fog was not considered interesting or exciting until an artist raised its status through his talent (56). Great art has the power to sensitize us to the appeal of diners by the American roadside (Edward Hopper); the richness of velvet against skin (Titian); the grandeur of modern industry (Andreas Gursky) or the resonance of artfully arranged stones in the landscape (Richard Long).

Take a quiet afternoon, with clouds scuttling over our heads, on a river near Amsterdam (57). It is not that the beholder would never

We start to see things which
artists point out to us.
— 57. Salomon van
Ruysdael, *River View*, 1642

Teaching us to be better lovers (of lines and
circles of granite, slate and limestone).
— 58. Richard Long, *Tame Buzzard Line,*
2001

have felt the appeal of such a scene before alighting on a Ruysdael; he or she may, from time to time, have had a tentative and fleeting sense, but would then have forgotten or ignored it. Ruysdael's canvas concentrates and focuses our attention on a fragile experience, endowing it with greater prestige. It says that this sort of atmosphere is important too, and helps us to grasp why. Skies start to loom larger in our lives; it may become part of our sense of identity that we love this sort of weather, which we might term Ruysdaelian in honour of the person who helped us to take it seriously.

To define a mission for art, then, one of its tasks is to teach us to be good lovers: lovers of rivers and lovers of skies, lovers of motorways and lovers of stones (58). And – very importantly – somewhere along the way, lovers of people.

To demonstrate the therapeutic qualities of art in relation to love, we can imagine systematically arranging – in a book, a set of postcards, a website or an entire museum – particular works that highlight the attitudes we should adopt if we are trying to love someone. It could start by showing us what feelings of gratitude to a lover look like, a quality about which there are many clues, for example, in the work of Niccolò Pisano. In his *An Idyll: Daphnis and Chloe*, Pisano evokes the beginnings of love, a moment when the sweetness and grace of the other is intensely present to us (59). Daphnis regards Chloe as so precious he hardly dares to touch her. All his devotion, his honour and his hopes for the future are vivid to him. He wants to deserve her; he does not know if she will love him and this doubt intensifies his delicacy. In his eyes, she absolutely cannot be taken for granted. This is a representation of how one should properly appreciate a person one loves. The beauty of it should in turn help us see, and be convinced by, an attitude we might not have taken seriously enough had it been depicted in words in a philosophical tract. Seen by someone in a long-term relationship after years of shared domestic life, and hence the inevitable conflicts about sex and money, childcare and holidays, and when habit has made the other completely familiar, this image seems particularly necessary because of its power to return us to a woefully forgotten sense of tenderness.

Pictures that sensitize us to important aspects of loving someone

need not be obviously romantic. They can just foreground a state of mind that helps us to remember and stay sensitive to part of what love is about. Given how easily we can get bored in a relationship, and long for what is glamorous and new, a picture by Pieter de Hooch of a courtyard in Delft might be a useful guide to strengthening our capacity for enduring mature love because it studies a quiet, modest moment with deep appreciation (60). Look, for instance, at the old door in the wall on the right, or at the angled (and mended) wooden support holding up the trellis. These are far from perfect; if there was more money around they might have been replaced with something more elegant. It is certainly not an image of material deprivation, though. It focuses in, one might say, on the art of making do. They can't get a new door, but the courtyard can be kept clean. And de Hooch rather likes the old door, the distempered bricks and the warped boards of the compost bin; they are not actually ugly, just at odds with the demand that everything should be pristine. That can be like a marriage after a few decades. De Hooch knows how to shape our responses and expectations of love in ways that counteract some of the less good models we have around.

What is it Like to Be a Good Lover?

The idea of consciously attempting to become a good lover has cheap and absurd connotations. One imagines someone attending a school for opening champagne bottles decorously or executing rare sexual manoeuvres. The connotations are derogatory because we live in a Romantic age that associates sincere love with spontaneity: the more we are unaware of, and unschooled for, what we're doing in love, the more estimable and trustworthy we are held to be as lovers. The 'practised' lover has something cynical and unsettling about him or her. Unfortunately, the paucity of successful relationships doesn't seem to endorse our charmingly naturalistic beliefs. Love doesn't seem to belong to that elect group of activities that one performs better the less one thinks about and practises it. But if some kind of forethought seems advisable, what exactly should we be rehearsing – and what does any of this have to do with art?

*A reminder of how much
we knew to be grateful for
on the first date.*

— 59. Niccolò Pisano,
An Idyll: Daphnis and Chloe,
*c.*1500–1

Love

Homage to tidying up.
— 60. Pieter de Hooch,
*The Courtyard of a House
in Delft*, 1658

Knowing how to love someone is different from admiring them. Admiration asks little of us, save for a lively imagination. The problems come when we try to build a shared life, which might include a home, children and the running of a business and household, with the person we had at first esteemed from afar. It's then we need to draw on qualities that seldom spring forth naturally and almost invariably benefit from a little practice: an ability to listen properly to another person, patience, curiosity, resilience, sensuality and reason.

Art can be a useful guide to such qualities. There are deep reasons why the ingredients of a successful work of art might have analogies with those required for the flourishing of a relationship, and therefore why the contemplation of art might help us to be better lovers. In Platonic philosophy, goodness is held to be a transferable element that is fundamentally the same wherever it is found, be it in a person, a book or the design of a chair. Furthermore, spotting goodness in one arena can make us more sensitive to recognizing, and encouraging it, in another. In a museum of the future, the Love Gallery might use the resources of art to excite our admiration for some of the following qualities.

Attention to Detail

We often say that a work of art was made 'with love'. This offers us a valuable insight, not just into certain works of art, but into the nature of love itself. The two vases of flowers at the bottom of Hugo van der Goes's *The Adoration of the Shepherds* are only a tiny part of what is a much larger work, but van der Goes has devoted immense care to the depiction of each flower and leaf; every petal has seemed to him to deserve an individual recognition (61).

He has, we can imagine, been motivated by kindly interest, which is how being loved feels. It is as though he has asked each flower, 'What is your unique character? I want to know you as you really are, rather than as a passing impression.' In painting, this becomes a sensitivity to the precise shape of each part of the flower and the patterns of light and shadow upon them. This attitude towards a flower is moving because it rehearses, in a minor but vivid way, the kind of attention that we long to receive from, and which we hope to be able to give to, another human being.

*I will pay attention to
the whole of you.*
— 61. Hugo van der Goes,
*The Adoration of the
Shepherds* (detail right),
c.1475

The prevailing culture prompted van der Goes to regard each detail as important by assigning it a symbolic meaning within a Christian cosmology. The white irises are there to suggest purity, and the seven pairs of purple flowers in the glass stand for the seven last words spoken by Jesus. Van der Goes quite naturally saw details as connected to grand and important themes; a relationship between small and large that may also be present in our feelings for another person. When our lover inclines her head in a particular way, we may be excited because the gesture speaks of a quizzical, slightly shy part of her whole nature that we deeply admire. When our lover struggles to locate Greenland on a map, this tiny moment of hesitance is charming because it speaks of his strong sense of priorities and his practical nature; it has simply never mattered to him that Greenland is located to the east of Canada, and we appreciate that he has the solidity and courage to care only about what does matter.

We long to find a person who will be as attentive to the details of our characters, to the movements of our bodies and to the quirks of our geographical understandings, as van der Goes has been to the shadows of his irises.

Patience

The most important lessons are not necessarily complicated. In fact, they are likely to be very simple. Richard Long, for instance, finds ways of reminding us of the value of patience (62). Our problem is not that we are in intellectual denial, or that we go about proclaiming the worthlessness of patience. It's simply that we lose sight of what we really believe in the tumult of our daily lives.

The calm greys and blacks, the tree and stream-like patterns can all be grasped very easily. A few major strands divide and become thinner as they ascend the page (or many small strands unite and become thicker as they descend the page). We make no discovery; there is no mystery here. As we look more closely, though, we see exactly how each strand goes, which joins with which, and where the divisions are. This is slow, soothing looking. Perhaps the walk Long memorialized in the work was like this. He was not on a voyage

WATERLINES

EACH DAY A WATERLINE
POURED FROM MY WATER BOTTLE
ALONG THE WALKING LINE

FROM THE ATLANTIC SHORE TO THE MEDITERRANEAN SHORE
A 560 MILE WALK IN 20½ DAYS ACROSS PORTUGAL AND SPAIN

1989

Long's work settles us into
a patient frame of mind.
— 62. Richard Long,
Waterlines, 1989

Love

*I don't know, but I'm going
to find out.*
— 63. Leonardo da Vinci,
*Studies of a Foetus, c.*1510–12

of discovery; we already know how to get from Portugal to Spain.

The typeface and the words are plain and direct. Patience is not thrilling. It is, in fact, the capacity to do without excitement, to delay gratification, to stick with what feels boring or bland. Long's artistic achievement is to integrate these unromantic aspects of patience with an endeavour that charms the imagination: walking across the Iberian peninsula, from the Atlantic coast to the Mediterranean, from sea to shining sea – a poetic image of romantic fulfilment. The central statement of the work is the comparison of water being poured from a bottle with a waterfall. One is small and inconsequential, the other grand and powerful. But a waterfall is just an accumulation of drops: the reward of repetition.

Long is not trying to convince us, but seeks to keep an obvious but much-neglected truth at the front of our minds: that good things have banal ingredients. We cannot internalize this enough. We have to renew the recognition of this dreary fact every day of our lives until it becomes entirely habitual.

The work is a love lesson. It preaches a quality central to the realistic maintenance and growth of love: that good relationships depend upon patience. We have to forego an immediate satisfaction (winning an argument, making the other person feel guilty, getting our own way) because these foregoings are the drops of water that, multiplied and accumulated, will enable a couple to complete their pilgrimage.

Curiosity

Leonardo's extremely beautiful notes and diagrams of a baby growing in its mother's womb teach us something important about love. It's not that they fill gaps in our understanding of pregnancy – their importance lies, rather, in the quality of mind they exemplify.

Leonardo is a hero of curiosity (63). He was the preeminent figure in an era that had an unprecedented interest in how things work. Curiosity takes ignorance seriously, and is confident enough to admit when it does not know. It is aware of not knowing, and it sets out to do something about it. The fine quality of this page of investigations presents curiosity as an elegant accomplishment. Leonardo is not

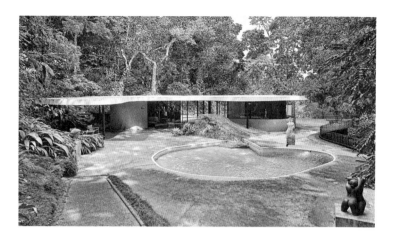

Or: 'We're drifting apart; we hardly ever have fun together. It's your fault; you are such a hyper-organized person that there's no spontaneity, things don't ever just happen, it's all got to be planned to the last degree and the life goes out of everything. You treat me like just another problem

to be solved.' In other words, the lines we rehearse in our heads – and occasionally shout through the bathroom door – are chains of supposed reasonings. Even in our rage, we desperately want to explain and justify.

The gracious promise of the Ospedale degli Innocenti (66) is that our need for explanation and justification could become a constructive part of a relationship. Instead of arguing at 2.00 am, if only we could confront our problems in the calming, inspiring presence of Brunelleschi's arcade. We would examine each element more carefully, finding out what it can bear, what its individual character is. What is actually going on with my trouble at work? What does being organized mean to you? Why are we really spending less time together? We take the hugely beneficial, but extremely difficult step, of not jumping to conclusions. Like Brunelleschi, we try to put the elements carefully together. What is the link between what is happening at home and at work? What is the link (if any) between your commitment to being organized and our need to enjoy ourselves together? In the ideal home there might be two photographs of the loggia: one inside and one outside the bathroom door.

Perspective

Bringing perspective to one's experience of relationships means striving to set love within the context of a broader understanding of the suffering endemic to our species. In the Bible, the sixth book of *Genesis* tells of God's frustration with human beings. He is disappointed with creation: everyone seems to be selfish, violent and preoccupied with sex. So God sends the Flood to wipe humanity from the face of the earth. Only Noah, his family and the animals are spared. In Poussin's picture of this moment, the famous ark is just visible as a grey smudge on the horizon (67).

Poussin is a pessimist. He believes that suffering is normal and suggests that in the main, our hopes are not fulfilled; just surviving is an achievement. He invites us to share God's disenchanted attitude that human life seems a bit of a disaster. This is intended as a corrective to our tendency to be shocked and embittered when things do not turn out as we wish, when the good things that we have

sought fail to materialize, or when a relationship breaks down. If one was already very given to thoughts of the hopelessness of existence, Poussin's image would not be advisable. However, if one erred on the side of naivety or embittered anger, it could be crucial.

When we start from the assumption that life generally goes rather badly, when we think that a good relationship is unusual rather than a birthright, we take less for granted. Happiness will not come to you simply because you are a fairly nice and well-intentioned person. By spending a lot of time around *The Deluge* and other such images, we do not seek to make ourselves gloomy, but more appreciative. The painting says to us, 'This is how life tends to be: clinging to the wreckage, desperately seeking temporary security on a bare rock. Therefore the failure of a relationship, and the breaking of one's heart, is not an aberration.'

The suffering of a broken heart seen from this point of view changes its meaning. It moves from being a cruel blow aimed unjustly at you to a common experience. This may seem obvious, but we often harbour the secret belief that we are unusually unlucky individuals, unfairly deprived of the happiness that everyone else seems to enjoy. And this is a terrible addition to our sorrows.

Am I Allowed to be Turned On?

One of the paradoxes of love is that it is often inspired by the way people look, but isn't generally meant to be based on looks. This leaves us with a conundrum: how much should one care about physical appearance? Is beauty entirely beside the point or an essential part of the feeling of love? Throughout history, many philosophies and religions have waged war on our physical forms, arguing that real value must lie elsewhere, in our souls and in our minds. Christianity did not invent guilt and shame around the body, it was merely drawing upon a permanent human proclivity.

There is one tradition of art which provides a welcome way out of this dilemma. In the art of the ancient Greeks, we get the first and clearest expression in the West of what one might call paganism, not merely in the obvious sense – that the Greeks were not Christians – but in their attitude to physical allure.

Clinging to the wreckage:
our usual lot in life.

— 67. Nicolas Poussin,
Winter or *The Deluge*, 1660–4

The ancient Greeks were unusual, compared with Christians, in being immensely concerned with the outward as well as the inward excellence of their divinities. Apollo was the god of light, truth and healing. To the Greeks he couldn't have had such a status and possessed such wonderful powers if he did not also have ideally beautiful pectoral muscles and a graceful posture (68). In opposition to this thesis, some early Christian thinkers, notably Tertullian, claimed that Jesus must have been ugly so as to keep his spiritual worth independent of any outward charm. By contrast, paganism trusts physical beauty, and is optimistic about the promise proffered by our outer form. The Greek term for beauty, *kalon*, does not distinguish between physical loveliness and inner goodness: good things simply are simultaneously beautiful, an idea that lingers on in our day only in very restricted areas, for example, in our thinking about clothes. It would be strange to say, 'I've got a very good pair of trousers, but unfortunately they are ugly.' The Greeks thought about the appearance of people the

Love 115

way we think about the appearance of clothes: they read the wisdom and nobility of Apollo in his face, in the way his cloak was draped over his arm and in the lightness of his back leg, with his big toe just touching the ground. These were not, to their mind, minor matters. This is what they thought a supremely admirable man should look like.

Since the Greeks, a line of artists have followed the pagan spirit: among them, Botticelli, Titian, Klimt and Picasso (69). Their message to us has been that we do not need to divorce the body from the spirit, that our physical envelopes are not shameful or opposed to the so-called 'higher' values. This may belong to a movement in the history of art, but it is also evidence of a mature integration of different strands of our psyches. The ancient Greeks would have been puzzled by the modern distinction between pornography and art. There was simply good and bad art. As currently constituted, pornography asks that we leave behind our ethics, our aesthetic sense and our intelligence when we contemplate it, but the lesson of pagan artists is that we shouldn't need to make a choice between sex and virtue: sex can be invited to support, rather than permitted to undermine, our higher values.

During a few wise periods in its history, even Christian art understood that physical desire did not have to be the enemy of goodness, and could, if properly marshalled, lend energy and intensity to it. In altarpieces by Fra Filippo Lippi or Sandro Botticelli, not only is the Madonna beautifully dressed and set against an enchanting background, she is also attractive and, though this point is not typically dwelt upon in art-historical discussions or museum catalogues, often quite simply a turn-on (70). In deliberately striving for this effect, Christian artists were not contravening the caution generally shown by their religion towards sexuality; rather, they were affirming that sexuality could be invited to promote a project of edification. If viewers were to be persuaded that Mary had been one of the noblest human beings who ever lived – the embodiment of kindness, self-sacrifice, sweetness and goodness – it might help if she was also pictured as having been, in the most subliminal and delicate of ways, physically attractive too.

Through such works we derive a more joined-up sense of human nature, in which our capacity for erotic excitement, our need for emotional closeness and our longing for stable family life are not

pulling us in opposite directions. These works are the opposite of pornography, which pulls us apart by making us feel that sexual fulfilment requires us to suspend or ignore the rest of our needs. They matter because a harmony between the body and the spirit is part of the way we spontaneously imagine love to be at its best. In the intense, usually brief, phase of being in love at the start of a relationship, our hormones ensure that eroticism and moral admiration are at one. Art could, and should, be a vital technology for renewing and safeguarding this kind of ideal alignment in the long term.

How to Make Love Last

One of the most depressing aspects of relationships is how quickly we get used to people who, when we first knew them, we felt immensely grateful for. A person whose mere wrist or shoulder could once excite us can lie before us entirely naked without arousing a flicker of interest.

When considering how we could re-evaluate and re-desire our partners, we might find it instructive to look at the ways artists learn to re-see what is familiar. The lover and the artist come up against the same human foible: the universal tendency to become bored, and to declare that whatever or whoever is known is unworthy of interest. It is a striking feature of some artistic masterpieces that they are able to renew our enthusiasm for things that have grown dull; they can awaken the hidden charms of experiences that familiarity makes us overlook. Contemplating such works rekindles our capacity for appreciation. A child tidying up, the falling light of dusk, the wind in the high branches of a tree in full leaf, the anonymity of a diner late at night in a great Midwestern city – thanks to art, such sights can touch and move us once more. A great artist knows how to draw our attention to the most tender, inspiring and enigmatic aspects of the world; they help us put aside our dismissive haste and learn to seek and find in our own surroundings something of what de Hooch or Hopper, Cézanne or Rembrandt found in theirs.

Other than as an ingredient and a marketable crop, the asparagus held little interest for the average French citizen of the nineteenth century; that is until 1880, when Édouard Manet painted a tender

There are lessons for long-term relationships in the way that Manet approached asparagus.

— 71. Édouard Manet,
Bunch of Asparagus, 1880

portrait of a few stems and drew the eyes of the world to the quiet charms of this edible flowering perennial (71). For all his delicacy with the brush, Manet was not especially flattering the vegetable; he was not using art to endow it with qualities it does not really possess. Rather, what he did was reveal its pre-existing but generally ignored merits. Where we would just see a plain stalk, Manet noted and recorded subtle individuality, the particular hue and tonal variation of each and every frond. By so doing, he redeemed this humble vegetable, so that today, standing before his picture, one might see a plate of asparagus as emblematic of an ideal of the good and decent life.

To rescue a long-term relationship from complacency, we might learn to effect on our spouse much the same imaginative transformation that Manet performed on his vegetables. We should try to locate the good and the beautiful beneath the layers of habit

and routine. We may so often have seen our partner pushing a buggy, crossly berating the electricity company or returning home defeated from the workplace that we have forgotten the dimension in him or her that remains adventurous, impetuous, cheeky, intelligent and, above all else, worthy of love.

Courage for the Journey

One of the greatest risks when love has failed us is that people will be tempted to say cheerful things to comfort us. Keen to mitigate our pain, they will assure us that happiness is around the corner, that suffering will be brief and that the ex wasn't even worth shedding tears over. Such bromides could not be more misguided, and it would be far better to side with Edwin Church instead (72). He could have painted a reassuring image; perhaps a ship coming back safely into harbour or a tranquil night with an island in the distance. In other words, he could have said that everything is going to be fine. Instead, the picture makes plain that voyages are perilous, that danger is real. He leads us to a more accurate appreciation of courage – the journey is magnificent, but the risks have to be recognized and the capacity to cope with them honoured.

The ideal place to hang Church's work would be on the walls of a naval academy. Unfortunately, since it would help humanity, we don't yet have relationship academies, but, if we did, they would want to teach us the same kind of lesson, and would benefit from having some works of art around to help them do so. Rather than make comforting noises about relationships that fail, they would focus on the awkward questions we need to tackle head on to have any chance of succeeding at love. What did you get wrong? To what extent should you have foreseen the problems? What should you have done to put it right, and what will you do next time? We should not expect that our preparations for love should be any less rigorous than those we might make for a journey to sea. We want art to help us capture the connection between the recognition of difficulty and success at achieving things we value.

The thought of sailing around the Cape of Good Hope is daunting, but the task is more likely to go well if we devote ourselves

*Don't expect valuable journeys
to be easy.*

— 72. Frederic Edwin
Church, *The Iceberg*, 1891

wholeheartedly to acquiring the skills it demands. Identifying these
skills depends upon the frank assessment of the nature and dangers
of the task. Our culture is lopsided in that it is terribly honest about
what is needed to help someone sail a ship through glacial waters,
but intensely sentimental when it comes to love. In the case of
seafaring, the relevant knowledge was slowly gained by rigorous
de-briefing and analysis across generations: what went wrong last
time? What would help us overcome that problem in the future?
But when it comes to the most important thing – how to find and
keep love – we are fatally coy. Art has a crucial role to play in creating
and keeping images of the lessons of love at the front of our minds.
Ideas, habits, attitudes and insights are the equivalent in love of what
anchors, sextants and harnesses are in seafaring. In the ideal culture
of the future, no one would be allowed out on to the field of love
without first getting hold of, and learning to use, the right equipment.

Nature

Remembering Nature

We are so familiar with the idea that nature is attractive that it can be a struggle to recollect that often in the history of humanity, and in our own experience too, it hasn't seemed at all obvious that it is worth admiring. Occasionally (to a hard-pressed Scottish crofter, for example), the natural world may have felt like the enemy, but mostly it's not that we dislike nature, just that other concerns are more pressing or immediately rewarding. There are plenty of reminders of the appeal of nature: perhaps a photograph of the Iguazu Falls on the border of Brazil and Argentina, or a postcard of the Jungfrau mountain seen from a lush Alpine valley. These can be immediately seductive, but if we are asked to expand on why they matter to us, what their meaning in our lives should be, it can be surprisingly hard to give a proper answer. Our encounters with nature can be poignant because they remind us that nature is something we are always meaning to get more interested in, but rarely get around to actually attending to.

We have psychological frailties connected with looking at nature. Nature itself is not articulate about its powers, while we are unable to isolate its best parts and do not always accept the significance of the experiences we have in its presence. For help, here too we can turn to art.

Art is a record of good observation and encourages us to follow its spirit, even if only a few of us end up replicating its products. For three decades, the British artist Hamish Fulton has been recording his walks around different parts of the world, listing their time, place, route and the prevailing meteorological conditions (73). These are written up in solemn fonts on large, framed prints, some many metres high and wide. The effect is incongruous. We expect this sort of treatment for the commemoration of a battle or the efforts of a national government. That it is merely a walk by an ordinary citizen is an argument for us to reconsider the value of this sort of activity. Fulton doesn't tell us what he thought about or felt when he left the northern suburbs of Kyoto on foot and made a circuit of Mount Hiei. We are left – intriguingly – to imagine. His concern is more elemental. The august, refined lettering and the short, precise statements of his work conveys the dignity he rightly feels that his walks, and ours, deserve. He wants us to recognize

TEN ONE DAY WALKS FROM AND TO KYOTO

TRAVELLING BY WAY OF MOUNT HIEI

WALKING ROUND THE HILL ON A CIRCUIT OF ANCIENT PATHS

FIVE DAYS WEST TO NORTH TO EAST TO SOUTH TO WEST

FULL MOON

FIVE DAYS WEST TO SOUTH TO EAST TO NORTH TO WEST

JAPAN JULY 1994

Making more of a fuss
about going for a walk –
in a good way.

— 73. Hamish Fulton,
Ten One Day Walks from
and to Kyoto, 1994, 1996

that some walks ('on a circuit of ancient paths') can be central events
in our lives; our inner transitions assisted by our outer wanderings.

The project of according prestige to our encounters with nature
is further developed by more representational works that guide
our perception in greater detail. In his small painting *A Rising Path*,
Corot is doing with precision what Fulton was pursuing in outline with
his memorial statement (74). He too is pointing to the significance
of nature, but at the same time he can show us what exactly it was about
the path and the surrounding greenery that touched him.

A painter does not just reproduce whatever happens to be around;
given the limitations of the canvas, there is no option but to emphasize
certain features and omit others, which allows the attention of the
viewer to be directed in specific ways. Corot gets us to appreciate
a sense of enclosure; we feel the grassy hill rising above us and we are
alive to the stillness. He likes the rocks either side of the sandy path
and the scrubby vegetation, so these are given prominence. Note
also what he leaves out: there are few sharp accents of focus, no precise

leaf shapes, no small stones on the road. Corot is saying that it was the overall atmosphere and character of the place that enchanted him, and that he hopes will delight us too. In other words, Corot, like any good landscape artist, is trying to define – and hence help us understand – what it was about an aspect of nature that seduced him.

We can get a clearer sense of how many ways there are of looking at and loving nature by contrasting Corot's way of painting with that of another great artist (75). It is clear that Lorrain loves the countryside too, and shares a few broad interests with Corot; they both like bushes

and hills and slightly cloudy skies. Claude, though, is particularly interested in distance. He likes glimpsing a horizon through a cluster of trees. The juxtaposition of near and far enchants him. He delights in the unfolding of layer upon layer of ridges and lines of hills that become more and more blue and hazy until they grow almost indistinguishable from the sky at dusk or dawn.

What we call the style of a landscape artist is a record of the aspects he or she has focused on in nature. The aim of looking at art is not to teach us to respond exactly as a given artist did. Rather, we should be inspired by his or her underlying method, which means that we should work out what we particularly like about a given stretch of nature, take our experiences there seriously and be selective in our enthusiasms, so that nature can become a more enduring and therapeutic force within our imaginations.

The Importance of the South

London in the winter of 1949 was sombre and challenging. The weather was unremittingly damp, the economy was in crisis, food was rationed and large parts of the city remained scarred by wartime bombing. An unhappily married, thirty-six-year-old aristocratic ex-actress had recently returned to the capital and was having a particularly bad time of it. She had spent the war years in the South of France, Greece and Egypt, and, now settled in a draughty flat in Chelsea, she reported feeling an 'agonized craving for the sun', by which she meant not just the climate but the people, lifestyle and architecture of the Mediterranean. Her longings focused on food. While people in London were being served 'flour-and-water soup seasoned solely with pepper; bread and gristle rissoles; dehydrated onions and carrots; corned beef toad in-the-hole', she was dreaming of paella, cassoulet, apricots, ripe green figs, the white ewes' milk cheeses of Greece, thick, aromatic Turkish coffee, herb-scented kebabs, *zuppa di pesce*, *spaghetti alle vongole* and fried zucchini.

Elizabeth David expressed her sensory desires in a series of articles and recipes for *Harper's Bazaar*, which were then collected into her first published work, *A Book of Mediterranean Food* (1950). She would

go on to write a succession of beguiling and influential recipe books including *French Country Cooking, Italian Food, Summer Cooking* and *French Provincial Cooking*. When she died in 1992, Auberon Waugh remarked, without intended hyperbole, that she was the writer who had single-handedly brought about the greatest improvement in English life in the twentieth century.

From a narrow perspective, David's work was focused on how one should go about preparing pizza dough or fry calamari. Its deeper theme, however, was a celebration of the values of the South, intended for an audience in the North that appeared to have forgotten them, to its psychological as well as dietetic impoverishment. From the seventeenth century to the modern day, the colder, northern parts of the globe have been at the centre of events, and their spirit has shaped our civilization. It is during the dark, long winters and unreliable summers of Amsterdam, Berlin, Edinburgh, London, Tokyo and Seattle, that many of the key moves in the realms of ideas, science and industry have been made. The values of the north have dominated the modern imagination; among these are rationality, science, the mind rather than the body, delayed gratification rather than the pleasures of the moment and the needs of the individual rather than the call of the collective.

For many people, artists and thinkers foremost among them, this northern dominance has brought with it a powerful yearning for the converse. Nostalgic and lyrical advocates of the south have been alert to the dangers and frustrations of over-intellectualization and the denial of the claims of the body; they have lamented puritanism and social isolation, they have worshipped instinct over science. They have made a case for the South as a state of mind rather than merely as a geographical location. For example, in the 1780s Goethe was so moved when he went to Italy for the first time that he regretted everything that had occurred in his life up to that point (76). This was where he truly belonged, he declared, the previous thirty-eight years having been like 'a whaling expedition to Greenland'. He was 'experiencing this happiness as an exception which by rights we ought to be able to enjoy as a rule of our nature'. It was not just antiquities and Renaissance art that drew Goethe to Rome. He liked the person

he could be there. He ate a lot of fruit (he was especially fond of figs and peaches, which were hard to get at home in Weimar), he found a lover, a local woman he called Faustina, and spent warm afternoons in bed with her. He exchanged his formal ministerial life for a more liberal existence amongst the artists of Rome.

Goethe was only the most notable of many distinguished Germans who have taken a trip to the South and been transformed, recognizing that their characters hitherto had been unbalanced by an excess of northern darkness. Following in Goethe's footsteps, Nietzsche headed to Sorrento on the Bay of Naples in 1876. He went swimming, visited Pompeii and the Greek temples at Paestum, and, at mealtimes, discovered lemons, olives, mozzarella and avocados. The trip changed

the direction of his thought: he moved away from his previous neo-Christian pessimism and embraced a more life-affirming Hellenism. Many years later, with his Italian sojourn very much in mind, he wrote, 'These little things – nutriment, place, climate, recreation, the whole casuistry of selfishness – are beyond all conception of greater importance than anything that has been considered of importance hitherto.'

Cyril Connolly would have agreed. In the London winter of 1942, the English literary critic and essayist, a keen reader of Goethe and Nietzsche, playfully declared a wish to start a new religion whose most sacred items would be the olive and the lemon – in other words, the two totemic culinary items of the Mediterranean. Connolly remembered a happier version of himself, driving through France towards the Mediterranean, 'peeling off the kilometres to the tune of "Blue Skies" sizzling down the long black liquid reaches of the Nationale Sept, the plane trees going sha-sha-sha through the open window, the windscreen yellowing with crushed midges, she with the Michelin beside me, a handkerchief binding her hair…'
For people like Goethe, Nietzsche and Connolly, the South was happiness, but they could not stay for any extended period. The question for them, and for us, is how to keep hold of some of the fulfilment we have found in southern lands. How might one lay claim on an ongoing basis to the virtues of the South when one is back in the North? The answer, here as so often, lies with that supreme preserver and transmitter of experience: art.

Elizabeth David preserved the South in casserole dishes. In early nineteenth-century Prussia, the architect Karl Friedrich Schinkel sought to preserve it in bricks and mortar (77). He designed a number of Italianate villas in the suburbs of Berlin, whose open loggias and pergolas were architectural memorials of the warm evenings he had experienced around Rome and Naples. Although the traditional northern house sees nature as the enemy, Schinkel was determined to recast the argument and create a building that would speak to the parts of ourselves that are at home with the elements.

The same spirit was active a century later in the work of Le Corbusier (78). In 1911, having finished his studies, the Swiss architect

Taking the south home
with you.

— 77. Karl Friedrich
Schinkel, Court Gardener's
House, 1829–33

travelled around the Mediterranean, stopping off for extended periods
in Greece and Turkey. The temples aside, what fascinated him was
the architecture of the whitewashed seaside villages and the spirit
their simple, uncluttered, unornamented designs exuded. What we
now know as Modernism is in large measure an attempt to recreate
white vernacular Hellenic architecture in a northern climate, with
the help of steel, glass and concrete. On the upper floor of his Villa
Savoye outside Paris, Le Corbusier designed what he called a 'solarium'
and informed his initially reluctant clients that a good life involved
regular sunbathing among its concrete ramps. Like a pergola in
Prussia, a sun terrace might not seem the most essential or practical
amenity in the Île-de-France. Such structures, however, were making
an argument for a paganism of the spirit, whatever the weather might
be doing outside.

We shouldn't expect artistic representations of the South made by
northerners to be accurate about what it's like to live in sunny climates.
When considering much of the architecture, art and writing on Greece
and Rome that emerged in the eighteenth and nineteenth centuries,
for instance, we shouldn't be offended by incomplete representations

A house that wants you to
live in it with the South in
your heart.

— 78. Le Corbusier,
Solarium at Villa Savoye,
1931

of conditions in the ancient world. What we learn is more interesting –
what people wanted these places to be like. In other words, correctives
of their overly intellectual, not body-focused, hampered, awkward,
asexual selves. When the Anglo-Dutch artist Lawrence Alma-Tadema
painted supra-realistic scenes of daily life in the Roman Empire, his goal
wasn't historical truth (79). Real Roman baths were far dirtier, more
practical and less lyrical than he ever cared to show them. The point of
his work wasn't the recreation of reality; instead he sought to influence
his Victorian and Edwardian audiences, used to wearing crinolines
and corsets, into accepting their physical natures and finding their way
to a more expansive, playful and natural eroticism.

A similar motive can be observed in David Hockney, an English
artist who grew up in Yorkshire and found his way to California –
a place that for many artists of the twentieth century was the
equivalent of what Greece and Rome had been to their nineteenth-
century predecessors. *Portrait of an Artist* is not a social commentary
on West-coast life; it was not intended for the man in the pool (80).
It was back in Britain that the lessons of sensuous ease and delight in

elegant swimming pools needed to be taken to heart. A Californian might say, on contemplating the picture, 'that is me', but it was the narrow-minded Yorkshire businessman who was being prompted to take the work to heart and recognize an invitation to inner reform along the lines of, 'that should be me'.

We shouldn't conclude that the South gets forgotten by accident. The demands of life in colder climates means that we lean on the values of the North for good reasons. One of the central dilemmas of being human is how we can properly deal with an intrinsic tension between reason and the body, between instinctual and intellectual life. In many places and for long periods of history, it has seemed obvious that there was no option for societies but to organize themselves against the inadequacies of climate and geography. Great achievements of science, technology and enterprise have been concerned with escaping from

bondage to nature. Animals have been domesticated and put to work; rivers have been dammed, canals dug, marshlands drained and forests cut down so that crops could be grown in previously unpromising places. Most of culture has been devoted to the task of overcoming the limitations of our untouched state in the service of our flourishing.

A welcoming, trusting delight in nature has been the exception. Historically, it has been odd for people in the North to want to wear loose-fitting clothes, eat simply prepared seafood on open terraces and take strolls by the seashore. It takes a lot of order and reason before a section of society decides that the proper aim of existence should be unity with nature.

A good life must surely contain a judicious balancing of the contrasting claims of the South and the North. For many of the world's inhabitants the balance has swung towards an excess of artifice, so our need for the past 200 years has been to find ways of doing justice to our instinctual, pagan needs. There is no universal solution for what we lack and what art we should therefore surround ourselves with; it will depend on what is unbalanced within us and in which direction we are listing.

We should make a careful survey of our inner geography before judging whether we belong to the group that would benefit from leafing through a recipe for Elizabeth David's slow-cooked squid and tanning ourselves imaginatively around the Santa Monica swimming pools of David Hockney's California.

Anticipating Autumn

Nature is not only an agent of life – it is also the force that will lead us to death. When we say we need to live 'according to nature', this means not only opening ourselves up to the passions of youth and the beauty of sunlight, but also an acceptance of autumn and decline.

There is a technical sense in which we know we must die, but this is not at all the same as being conscious of our own mortality day to day and in a sensory way. Every mouse and giraffe will die, but, we suppose, such creatures are not preoccupied with their own ends. However, to live as rational, conscious beings 'according to nature' means having

to approach the future in the knowledge that our lives will draw to a close, that we will be ripped away from our loved ones, that our bodies will suffer shocking indignities, and that when such matters happen is almost entirely beyond our control. This is perhaps the hardest thought to keep in mind. We rarely let it enter our consciousness; it catches us sometimes in the early hours, but we are masters of its brutal denial.

The concern we repress is not just about the specific last moment of life. It is with the fact that we will age, lose our health, become wizened and frail. Our current phase of life is transient, and in retrospect it will appear fleeting. To the twenty-year-old, the thousands of hours spent being seven feel like almost nothing. To the fifty-year-old, the whole decade of his or her twenties may seem like a fleeting moment. We face the strange but deeply significant fact that the issues that loom so large in our lives today, the days that seem to spread out and the hours of intensity or listlessness, will all eventually be minute, scarcely remembered details of a distant past.

Art here too can help, for it is an imaginative force that goes ahead of the present and prepares our rational and sensory selves for where nature will eventually lead us. In Jan Gossaert's portrait of an elderly couple, each face shows, in slightly different ways, the weight of the life they have led (81). They do not look particularly happy, either with themselves or with each other, but neither do they seem disenchanted or depressed. On the man's cap there is a small golden badge, on which is wrought an overtly erotic image of a much younger, naked couple. The badge is like a memory, now small and far away, of the couple as they were at the very start of their relationship. This is an image to be looked at not in old age, but in youth. Art can bring us news of the future.

In 1972, the psychologist Walter Mischel of Stanford University conducted a now-famous experiment at the Bing Nursery School. Children were shown a marshmallow, and told they could either eat it right now, or, if they waited a further fifteen minutes, they would be given an additional marshmallow. Only about a third of the children were able to delay gratification long enough to get the additional treat. This simple observation has profound implications: it suggests that for some people the future seems more real than it does to others.

You too will end up a little
like this.

— 81. Jan Gossaert,
An Elderly Couple (detail
right), *c.*1520

The ability to wait depends on the degree to which what will happen later carries weight in our minds. The fact that later one will think, 'I wish I hadn't eaten that marshmallow because then I'd now have two' can be more or less powerful, depending on the mind. The children who delayed had a more realistic, intimate connection with who they would be in the future; they were skilled at picturing time. This is a faculty that art can help us with.

The psychologist's experiment reproduces in miniature, and at the level of childish wants, the same theme that art addresses on a grander scale and in an adult mode. A picture such as that by Jan Gossaert seeks to show us a future state of our own existence. This is the point of the golden badge: if they were once a version of you, the youthful beholder, and are now like this, then you too will one day be a version of them. Recognize this now while there is still a little time.

Art rectifies the failings of our minds: we are simply not very good at grasping the fact of ourselves as time-bound creatures. We don't know where we are truly heading and how long we have until we get there, and we forget where we have been; eighty years is just too many for one imperfect mind to hold together vividly without help. As in so many other areas, warning is key. Time loses some of its power if we are ready for it. We will make wiser decisions now if the reality of our future, or at least the likely path that life will take, is

made vivid and powerful to our minds in the present. Thus a valuable project for artists is to act as a herald, and art is a support to our fragile imaginations.

The presiding spirit of this support can be found in Ian Hamilton Finlay's work at Little Sparta, his garden near Edinburgh (82, 83). Among the thin birch trees and simple flowers on the rough land of the Pentland Hills is set a tablet, like an ancient tomb stone, on the base of which has been carved the resonant Latin phrase *et in arcadia ego*. The words are the voice of the tomb: *I, death, am here, in the midst of life*. Arcadia was, for the classical world, the ideal countryside – the place where life is simple, straightforward and sweet. The tablet says: even in this place, where life seems good and right, you cannot escape from your mortality. We are being called to recollect our time-bound nature at the point when we are inclined to forget it. Versions of this image should hang in boardrooms, the foyers of business schools, and should be displayed in the side-bars of internet dating sites. These are Arcadian sites of the modern world: the places where the appetite for success, for being busy and preoccupied, for being filled with hope and a sense of future possibilities are especially brought to the fore.

The point of such images is not to cast us down and leave us depressed and lacking drive or sense of purpose. On the contrary, the ambition is to sober our judgement about what is really important in the present by instilling a serious and realistic sense of our own mortality. From that point of view, the present does not become worthless – in fact its value is augmented. What happens is that the need to give our lives to genuinely worthwhile endeavours becomes more obvious to us, more clear and persuasive in the present.

In the ideal Gallery of Time, once visitors had contemplated the work of Hamilton Finlay they would be guided towards a painting by Jacques-Louis David (84). It shows an old man, the former general Belisarius, who had worked under the Emperor Justinian in the sixth century AD and reconquered some of the lands of the former Roman Empire. After many successes, Belisarius lost his strengths and wit, fell foul of court politics and was, according to legend, reduced to begging for money in the street. The soldier on the left was once under his command and is

ABOVE

*Keeping our time-bound selves
at the front of our minds.*
— 82. Ian Hamilton Finlay,
Little Sparta, Dunsyre,
Scotland, 1966–2006

RIGHT
— 83. Ian Hamilton Finlay,
Et In Arcadia Ego, 1976

He was once in charge. — 84. Jacques-Louis David,
Belisarius Begging for Alms,
1781

now shocked to encounter his former leader in a condition of extreme want and abasement. The sufferings and humiliations of old age feel all the more significant because of the general's earlier triumphs. The painting argues that power and competence are no safeguard against nature. It happened to him, and he was once like you, or even a finer and more impressive version of the qualities you might see in yourself – and so it will happen to you in one form or another.

Imagine next a photograph of trees and leaves in autumn (85). Here we see something that, in a way, is immensely familiar. Leaves always do wither and fall. Autumn necessarily follows spring and summer. If we encounter this image, however, in a gallery devoted to time, ageing and death, with the previous works fresh in our minds, it gains

Contemplating our own mortality in the falling leaves.

— 85. Ansel Adams, *Aspens, Dawn, Autumn, Dolores River Canyon, Colorado*, 1937

a special purpose. It is asking us to frame our thoughts about mortality in the broad purview of nature. We are part of nature; its sequences apply to us as much as they do to plants.

A central feature of human experience is that while we know ourselves from the inside, and have an immediate, intuitive grasp of what it is like to be ourselves, we meet others only externally. We may feel close, we may get to know them well, but a gap remains. Hence, the sense of one's own individuality has a slight quality of separateness and difference from all others. What we see happening to others need not happen to oneself; this is a natural outcome of the way our minds are structured. Of course, it is not true, and we will not escape the common fate of all of our kind. We are always in need of cultural objects and practices that will press upon us the shared, inevitable features of existence. Our own life may feel special, but it cannot be essentially different.

The trees in autumn are an aid to reflection. They ask us to see ourselves as tied to the rhythms of the natural world. This may lessen,

Solemn calm.

— 86. Hiroshi Sugimoto,
*North Atlantic Ocean, Cliffs
of Moher*, 1989

even if it cannot fully assuage, the sting of knowledge that we too will die. This is not a special horror; it is not a unique curse or punishment.

With these thoughts in mind, we turn to an image of profound and solemn calm (86). Hiroshi Sugimoto's work is not explicitly about ageing or death, but by being placed in a sequence of images that have already impressed these fearsome, serious matters upon us it becomes powerfully relevant. This is the state of mind we want to cultivate in the face of what we have been exposed to. Our mortality does not call for panic, but for a sense of awe. We should be encouraged to let our eyes wander over the vast grey swell of the sea. We should immerse ourselves in an attitude of indifference. The waters of time will close over us; it will be as if we have never lived; the world will go on in our absence. In the huge scale of things, we are unimaginably small.

These thoughts could, of course, be crushing if they came to us at the wrong moment. But now they have a strange power to comfort

The ultimate perspective
on life.

— 87. NASA, ESA and
the Hubble Heritage Team,
Globular Cluster NGC 1846,
2006

and tranquillize. This image draws us away from ourselves; we forget
our immediate hopes and preoccupations as we give ourselves over
to contemplation of the hazy horizon and the even, pure tones of the
watery sky.

Finally, we proceed to view the death of a distant galaxy, as seen
from the Hubble telescope (87). Somewhere here, although the
untrained eye does not know where to locate it, a star is in the final
throes of a cataclysmic explosion. All the unimaginably vast residue
of its matter, which was pulled together so infinitesimally slowly
and which burnt for aeons in a blinding furnace of power, is finally
flung back into the universe. Science here joins art to dignify and lend
tragic grandeur to our appalling fragility.

The result of a closer attention to our mortal selves would be
being more attuned to what was coming, and therefore grateful and
more appreciative of what we have; we would be nicer. The sequence

of experiences and thoughts laid out in this imaginary gallery are not novel or particularly complicated. That is how it should be: our problem is not that we cannot understand them or need special occasions to teach us recondite ideas. The problem is that we forget what is obvious. These are ideas that call for daily renewal in our inner lives; we must always return to them. By enfolding them in memorable images, they live more intently in our minds; they spring forward into consciousness more readily; they are always to hand.

Art invites us to a culture that anticipates suffering and decay, which our own culture denies. The galleries of the future will take it seriously, and make an adequate, public and consoling home for our fleeting, middle-of-the-night apprehensions.

The Sense of What is Beautiful

A particular type of unhappiness results when we devalue our circumstances because they are not those we recognize from art. Art lends prestige, and when it is not around, when it has not yet caught up with our reality, we can feel an aching, envious sense that the realm of beauty and interest is utterly removed from our own situation.

It is helpful to realize that feeling as though glamour is elsewhere has always been present, including in places where now, thanks to art, we have no problem identifying some value. We have been taught that we shouldn't necessarily blame the places we're in; rather, we should be aware that we damn them because artists have not yet opened our eyes to them. For example, mountains, which we are used to assuming are inherently attractive, seem so to our eyes largely as a result of lengthy efforts by artists.

In 1844, the American writer Ralph Waldo Emerson published an essay called 'The Poet', in which he complained about the traditional tendency, in poetry and painting, to find beauty mainly in rural landscapes and unspoilt, tranquil nature. As the Industrial Revolution took hold, Emerson lamented the attitude of nostalgic poets who turned away from the increasingly common sight of railways, factories, canals, warehouses and cranes in disgust and saw them merely as visual intrusions that spoil the world. By contrast, he says, 'the true poet sees

them fall within the great order of nature not less than the beehive or the spider's geometrical web. Nature adopts them very fast into her vital circles, and the gliding train of cars she loves like her own.' He encourages us to approach such things without prejudice, without looking only for confirmation of our current habits of perception, and to make room in our souls for the recognition of alternative forms of beauty.

The challenge for modern artists is to open our eyes to the charms of modern landscapes, which means, predominantly, landscapes marked by technology and industry. The first impulse is to protest that there can be nothing beautiful in water towers, motorways or shipyards – but how wrong we would be to remain stuck there. Artists, who were once at the forefront of helping us to appreciate unsullied sublime nature, have taken a lead in guiding us to the unusual beauty of the landscapes of modernity.

The leading proponents of this have been two married photographers who have spent most of their adult lives teaching at the influential Kunstakademie in Düsseldorf. Bernd and Hilla Becher devoted their creative energies to producing beautiful, spare images (they only ever shot on overcast days, so as to remove any shadows) of bits of the industrial landscape no one had previously paid much attention to (88). The titles of their books capture their incongruously technical interests: *Water Towers, Blast Furnaces, Pennsylvania Coal Mine Tipples, Gas Tanks, Industrial Facades, Mineheads, Industrial Landscapes, Basic Forms of Industrial Buildings, Cooling Towers* and *Grain Elevators*. After several decades of neglect, their work eventually caught on. They acquired a gallery in New York, the Museum of Modern Art picked up some of their work, and they are now firmly in the pantheon of fashionable artists of the twentieth century. Their pupils at the Kunstakademie (Andreas Gursky, Thomas Ruff, Thomas Struth, Candida Höfer and Elger Esser) have taken their message even further. Thanks to this group, it now seems utterly normal – which it wasn't at all in 1950 – to pause before a water tower and comment on its beauty.

Andreas Gursky's image of Salerno invites us to share his experience of the harbour as a place of deep fascination and unexpected beauty (89). We are so negligent of such places that it is surprising just to encounter a photograph of a port in an art gallery.

NEAR RIGHT
Learning to see beauty
here too.
— 88. Bernd and Hilla
Becher, *Water Towers*, 1980

FAR RIGHT
The beauty of industry.
— 89. Andreas Gursky,
Salerno, 1990

We rarely wonder where goods have come from, or how they arrived
in our lives – unless, occasionally, a small-print reference to the
town of Shenzhen in the province of Guangdong on a packet of
mints, or a 'Made in Ecuador' label on a new pair of socks, suggests
a history more intriguing, grander and more mysterious than hitherto
suspected. Gursky knows how to home in on such hints.

The great doors of a cargo ship open: within it are a thousand
medium-sized family cars, at present all perfect and alike, but time will
give each one a unique identity. Some will be places of carnage
and tragedy; others will be mobile concert halls; one will witness
a passionate scene of reconciliation in which, after years of awkward
distance, a couple tell each other of their mutual love and sorrow;
in another, a child will munch a sandwich on the way to the tennis
match that will set her on a path to sporting glory. Massed like this,
one sees the astonishing abundance and creative energy of our times.

The crates hold the unsung additives that make our lives better
in so many tiny ways: polyols, which keeps toothpaste fluid; citric acid,
which stops detergents decomposing; isoglucose, which makes cereal

sweeter; glyceryl tristearate, which helps make soap; and xanthan gum, which stabilizes gravy and stops it getting lumpy. When we think of economics, we usually think of numbers: the GDP is expanding, employment is falling. How little we know of the processes that lie behind it – the supply chains, the chemistry, the mechanics – or the ports we can visit in the educative company of Andreas Gursky.

The New Artists of Nature

Throughout the history of art, artists have seen it as their task to represent their experience of nature. This has often taken the form of creating an image of some part of the natural world that has especially moved them. Dürer, for example, went to immense trouble, and deployed great technical skill, to reproduce the visual details of stalks and leaves (90).

One of the most welcome and interesting developments of twentieth-century art has been the broadening of our understanding of the term 'artist'. Artists aren't necessarily people who show us

a work that represents nature, or anything else for that matter. They might also be people who create opportunities for you to see nature – or anything else – directly in a more immediate or meaningful way. This is an evolution, not a rejection, of Dürer's ambition. For Dürer hoped that, having looked at his work, one would head outside and do what he had originally done: to look with great care and devotion at some significant aspect of the natural world.

In this new way, the artist becomes the choreographer of an experience you might have, rather than a recorder of an experience they once had. We are still digesting the full implications of this interesting epochal shift, which moves artists away from the studio and the easel and gives them things in common with business leaders, politicians, religious figures, architects, town planners and circus managers.

The main proponent of this new approach is the American artist James Turrell. At first sight, an image of his work appears to show an oval painting of the sky, set in a very dark grey frame of the same shape. What we are actually seeing is an opening in the roof of a specially designed observation chamber. Gradually, the fringe of cloud will expand and drift across the aperture; the light will fade. Rain might even fall. But the concern is not only with what we see. Around the edge of the chamber there is a simple stone bench; the idea is to have a group of people in there together, each one looking upwards towards the sky. The search is for a profound individual experience, but one that others are also having. In this way, the chamber is like a church, in which it is important that there is a community experience, although one which is transcendent in character. The place invites silence, patience and awe. It feels wrong to stay only for a moment, to gossip or have mean-spirited thoughts about other people.

Turrell is interested in an art of participation, rather than just spectatorship. One joins with others in experiencing the evening light, or the waves lapping at the shore line, or the mountains ahead in the distance. At the Roden Crater, a 200-metre (656-feet) high cone of volcanic ash, Turrell has been working since the late 1970s on developing various inner spaces that frame and intensify celestial experiences (91). The crater promises to rival cathedrals in terms of its emotional impact and scale.

*Taking the trouble to look
properly.*
— 90. Albrecht Dürer,
The Large Piece of Turf, 1503

An artist who choreographs
an entire experience.

— 91. James Turrell,
Roden Crater, Arizona, 1979–

Turrell's work is pivotal. Art is turning from creating memorials to, or representations of, nature towards creating opportunities for the closer or more meaningful perception of nature. Instead of looking at a picture, we are now looking at the real thing. The role of the artist remains crucial, though: the experience is shaped and structured by the insight and imagination of a creative mind.

Consider Antony Gormley and David Chipperfield's observation tower in Sweden, which likewise sets up an opportunity for looking at nature (92). You will stand here alone, 18 metres (60 feet) up in the mist, among the wet leaves. What the artists contribute is a structure for the experience of nature. The route to the top is crucially important: one ascends via a harsh, geometrical concrete entrance chamber, an open landing and an enclosed spiral staircase. Gormley and Chipperfield are attempting to remove some of the random elements of experience. They intuit that the deeper, more intimate significance of our encounters with nature are liable to slip through our fingers because we are distracted or unprepared. The observation pavilion is devoted to putting that right.

How might this concept of a choreography of experience work in relation to other good things? What might an equivalent choreography

What part of yourself
is at home here?

— 92. Antony Gormley
and David Chipperfield,
Observation Tower, Kivik
Art Centre, Sweden, 2008

of 'love' look like? Might the job of the artist go beyond depicting love and evolve to taking steps to orchestrating opportunities across the globe for experiencing love more successfully? The ambition that underpins participatory art is just beginning to be understood and its consequences examined. There should be nothing strange at all about an artist helping you to relate more successfully to death, get on better with your children or manage problems with money. We need to move beyond thinking of an artist as someone at an easel.

The artist of the future might be adept with brushes and paints, or with film; but they will also have the skills of an architect, a geologist, a public speaker, a politician or a scientist. What will identify him or her as an artist is an interest in art's true, historic mission: the promotion of a sensory understanding of what matters most in life. He will create occasions, which might mean a tower, a crater, a dinner party or a kindergarten, for events that will promote the values to which art has always been devoted. We shouldn't be surprised, or see it as a loss of what art has always been about, if many of the artists of the coming decades do not produce traditional objects, and instead head directly for the underlying mission of art: changing how we experience the world.

When taste and money come adrift.

— 93. The lobby of Caesars Palace, Las Vegas, 1966

of capitalism boil down to failures of consumer choice, or taste. If we lament the vulgarity of a Las Vegas casino complex, or shudder at the thought of the quality of the meat in low-cost burgers, we should refrain from simply condemning the owners and managers of the businesses that provide them (93). It is not their fault that the wrong sort of food sells in vast quantities or that so many people want to stay in mindless resorts. The producers of the most inane television programmes are not ideologically committed to making poor-quality entertainment. They are our servants and will provide us with whatever we want, so long as it makes them money. The problem is that too many people are keen on, and are willing to pay for, the wrong things.

What is meant by *wrong*? One answer focuses on externalities, on the hidden costs that certain businesses pass on to society. The casino can inspire depression, family distress and alcoholism, yet the private equity group that owns it does not have to pay for the problems it provokes. The low-grade burgers are linked to obesity and ill-health, but the hospital bills do not appear on the company's balance sheets. The scope of such discussions can be broadened to include the sufferings of the planet.

to be identified within the field of art. Until now, this crucial source of insight has not been tapped because, at first sight, art is such an unlikely candidate for good advice about macroeconomics.

Art can seem entirely distinct from money and work. We tend to position it along with luxury, holidays and special occasions. Artistically minded people may regard capitalism rather like polite people in the nineteenth century regarded sex. Like all eras, the nineteenth century was obsessed with sex, but sensitive, thoughtful types were so conscious of its dangers, and found it such a painful topic for frank discussion, that they ended up preaching sermons about purity and chastity. In return, the temptation for later commentators was to run to the opposite extreme and glorify sexuality, imagining contentment if only they could be utterly uninhibited. The truth, of course, is that sexuality is both essential and a source of suffering and confusion. So too with capitalism, which is an equally troubling mix of the deeply impressive and the highly unsatisfactory.

At the moment we tend to have two dominant but polarized fantasies. Either, like the economic version of a Victorian social reformer, we are drawn to the idea that money is sinful and capitalism should be abolished. Or, like a free love guru of the 1960s, we glorify the market without due consideration of its abuses. What we need, as individuals and as societies, is to form a better, wiser and more honest relationship with money. We want an economy that harnesses the magnificent productive forces of capitalism to a more accurate understanding of the range and depth of our needs. Art may offer a high road to such progress.

The Problem of Taste

At its heart, the economic system we call capitalism involves the pursuit of profit through the sale of goods and services in a market in which consumers can make purchases as they choose. Producers only strive to provide whatever their consumers are willing to pay for. In this sense, capitalism is only as good or as bad as the tastes of its consumers. Rather than only blame the wickedness of corporations, we should direct some criticism at ourselves. Many of the problems

Art as a Guide to the Reform of Capitalism

The harshest critics of capitalism have not been able to resist the odd sideways glance at its strengths – its capacity to marshal resources, its managerial disciplines, its prodigious energies.

> The bourgeoisie, during its rule of scarce one hundred years, has created more massive and more colossal productive forces than have all preceding generations together. Subjection of Nature's forces to man, machinery, application of chemistry to industry and agriculture, steam-navigation, railways, electric telegraphs, clearing of whole continents for cultivation, canalisation of rivers, whole populations conjured out of the ground – what earlier century had even a presentiment that such productive forces slumbered in the lap of social labour?

Karl Marx and Friedrich Engels, *The Communist Manifesto*, 1848

However, as the entire planet is now painfully aware, capitalism has a great number of shortcomings. From the point of view of the consumer, it is focused on far too many of the wrong kinds of goods and services. To start the list, there is an astonishing array of chocolate bars for sale, but much less to help us to deal with the causes of domestic rows; there are plenty of cut-price fares from Kuala Lumpur to Manchester, but little chance of getting a house with a garden near where you work. Industrial capitalism has made many cheap trinkets, but it has not produced many beautiful cities. When it comes to production, low-paid factory workers turn out sports shoes designed to exploit adolescent status anxiety; kindergarten teachers who help shy children discover their voices are paid next to nothing compared with reckless commodities traders who strip bare the hillsides of Borneo; richly rewarded executives devote their best years to working out how to promote one brand of toothpaste over another almost identical one; the system prioritizes short-term success over long-term benefits and treats workers as means rather than as ends.

It is widely agreed that capitalism needs reforming. It is the claim of this book that there are vital clues about the nature of this reform

Money

Art as a Guide to the Reform of Capitalism

The Problem of Taste

The Role of the Critic in the Education of Taste

Towards an Enlightened Capitalism

Enlightened Investment

Career Advice from Artists

However important these issues of externalities are, they do not touch on the central question of why the original preference is wrong. There is another kind of 'wrong': a sense that these products are not in line with the highest potential of mankind, that a love of certain kinds of food or leisure resorts or television shows is an insult to what we are properly capable of as human beings. It is this nagging awareness that intensifies the hostility around externalities. We especially mind them because the sacrifice of the planet, health, tax revenues and labour have been in the name of something deeply squalid. If warming the oceans were a by-product of our noblest endeavours, it would be sad. But fear and panic sets in when we realize that we may be ruining the future for the sake of pitiful and unrealistic distractions.

It can feel mean-spirited to hold up the preferences of decent and possibly disadvantaged people as unworthy. We fear that we will be cast as elitist or snobbish, although in our heart of hearts we don't usually think we are either of these things. Privately, we don't really doubt that the Nevada lobby is grotesque or that the burger is substandard. But when it comes to uttering our thoughts in public we often hold back, possibly because of a laudable anxiety about hurting the feelings of others.

We needn't always be quite so polite. In the face of our own hesitancy, we can focus on cases of very obvious failures of taste on the part of those who scarcely deserve our pity. The extremely wealthy entrepreneur and his wife who built the Prix d'Amour mansion in Perth, Western Australia, were the social and economic superiors of pretty much anyone who might criticize their architectural enthusiasms (94). The problem was that they had too little taste relative to the opportunities their wealth afforded. From a financial point of view, they had exactly the same potential as a Medici prince, but whereas the Medici used their economic resources to create some of the most moving and noble buildings in the world (95), they created an eyesore that few people mourned when it was eventually pulled down.

The spectacular missed opportunities of the vulgar rich speak of an overall problem within capitalism. The failure of Prix d'Amour is really just a magnified version of what occurs in the burger chain and the casino lobby, on crass television shows and in low-brow

newspapers. When money is allied with taste – that is, with sensitivity to what is good and beautiful as well as true to our rather inarticulate needs – very good results can follow, in areas from food to housing to media. The problem is that wise expenditure is extremely rare. The fault does not lie with the money system itself; rather with the tastes of consumers.

The contrast between the Medici Chapel and the Prix d'Amour brings into view a painful difficulty for capitalism. Our current economic system is primarily geared towards wealth creation. It has gone to immense lengths to maximize the opportunities for some people to accumulate financial resources. It has very little to say, though, about how money should be used once acquired. The qualities that lead to making money are not reliably aligned with the qualities that guide its noble expenditure. This occurs because we are collectively unsure of what the point of private wealth really is. We feel at a loss to make demands and so leave things to the whims of the consumers.

Part of the reason why cars in many areas of the world are now a little better than they were a few decades ago is because some critics have tirelessly tried to educate public sentiment in relation to the virtues and vices of cars (96). These critics have taught us to be more

unhappy about problematic aspects of some vehicles on the market,
such as sub-standard gears, errors of styling, uncomfortable seats,
vulgar fascias, poor brakes. They have taught us how to spend our
money more accurately – and they've done so without fear of seeming
snobbish or mean. Indeed, they have proceeded from the assumption
that they have done us a favour and saved us from error. They have
taught us to have taste in a small but crucial aspect of our lives: they
have shown us how to be like the Medicis on the forecourt.

A process whose merits we readily accept when it comes to cars
needs to spread into all areas of life. We should become as demanding
about what we consume in terms of food, media, architecture or
leisure as we are in relation to the cars we drive. We should accept the
legitimacy of the project of raising taste across the board. To this end,
we should make ourselves at home with the role of the figure present
at key junctures in the history of art: the critic.

The Role of the Critic in the Education of Taste

In the 1920s, very few people in Britain thought it was a good idea to like, let alone spend money on, contemporary art. By the 1960s, leading opinion almost unanimously believed otherwise. One of the reasons for this dramatic change was the tireless work of the critic Herbert Read, who wrote articles and books, appeared on the radio, mounted exhibitions, founded London's Institute of Contemporary Arts (ICA) and travelled around the country giving lectures in defence of the virtues of great contemporary artists such as Ben Nicholson, Pablo Picasso and Barbara Hepworth. Like Jeremy Clarkson in the realm of cars, Read changed the dominant sense of what it might be good for us to love in art (97).

We like to pride ourselves on having our own taste, but the truth is, given the demands on our time and the flaws in our psychological make-up, it's very likely that we won't know what we like unless we are encouraged to look rather deep inside ourselves and benefit from the input of others to guide our enthusiasms in fruitful ways. Our doubts about our tastes can be the stuff of rich comedy. Consider the fun that Marcel Proust has with a Madame de Cambremer, who has trouble knowing what it is 'right' to like in art. Towards the end of *In Search of Lost Time*, she declares an enthusiasm for Monet and Degas but a deep suspicion of Poussin, a stance that Proust's narrator, a covert educator of taste, gently interrogates:

> 'But' I said to her, feeling that the only way to rehabilitate
> Poussin in the opinion of Madame de Cambremer would be to
> tell her that he was once again fashionable. 'Monsieur Degas
> insists that the Poussins at Chantilly are the most beautiful
> things he knows.'
> 'Really? I don't know the ones at Chantilly,' said Madame de
> Cambremer who did not wish to disagree with Degas,
> 'but I can speak for those in the Louvre, they're horrible.'
> 'He also admires them enormously.'
> 'I must go and look at them again. My memory of them is rather
> vague,' she replied after a moment of silence, as if the favourable
> judgment she would soon have of Poussin would depend not

The challenge isn't just to
have money: it is to know how
to spend it.
— 96. Jeremy Clarkson
presenting the BBC
television programme
Top Gear

ABOVE
We don't always know
what we like until someone
is there to guide our tastes.
— 97. Herbert Read
at the opening of the
Institute of Contemporary
Arts, London, 1947

on what I had just told her but on the additional and this
time definitive examination to which she intended to submit
the Louvre pictures.

Marcel Proust, *In Search of Lost Time*, vol. 4: 'Sodom and
Gomorrah', 1921–2

We shouldn't let the relish with which Proust skewers Madame
de Cambremer distract us from the more patient task of trying to
understand what precisely her error is, and, since we're more like
her than we might like to admit, our own. Madame de Cambremer
doesn't know her own mind. This is a forgivable eventuality: how are
we supposed to know from the outset which painter has talent?
The problem here isn't really uncertainty, though. It is rather the
refusal to humbly acknowledge an inability to know one's own
concerns; a frailty masked by arrogance. Madame de Cambremer –
like many other people – pretends she knows what is important
in art and that she is making judgements on the basis of authentic
experience, while in fact she hasn't taken the trouble to think and feel,
and with a degree of panic simply tries to mimic what she imagines
the current fashion to be.

If you were trying to turn the situation around for Madame de
Cambremer, mockery wouldn't be the best starting point. After all,
part of this woman's problem is that she thinks she should already have
sound taste in art without ever having benefitted from a process of
education. She thinks she should know the answer, and is therefore less
inclined to work through her ignorance. Read knew this problem well.
He began from a position of great sympathy for doubt and ignorance,
and, in response, kindness was a key part of his educational strategy.
He took it for granted that decent, intelligent, well-intentioned
people might not know very much about art. Why should they? In
particular, he knew that they might be very sceptical of abstract art,
but he didn't chastise them for being idiots or nostalgic fools. He
didn't have fun at their expense, as Proust would have done. All true
education has this structure. The kindergarten teacher doesn't think
children are contemptible because they cannot write or are confused
about what number comes after fourteen. You are allowed to start,

with honour, wherever you are. Read's tactic was to begin with things that people already acknowledged and approved of. In lectures, he liked to point out that a Madonna and Child by Raphael – one of the most respectable and widely admired artists in the 1930s – was in fact deeply devoted to abstract composition, just like Barbara Hepworth, a contemporary artist he was fond of (98). Read was a master at getting you to admit new works into your private pantheon by directing you towards subtle similarities with ones that had already won your trust.

The greatest critics help us find personally resonant reasons why we might like or dislike certain objects. They take seriously a very strange fact about experience: that we don't automatically know why we love or hate things. We often cannot explain accurately to ourselves or others what it is, really, that is at stake. For example, when we say that something is 'awesome', 'cool' or 'amazing', we are registering our positive reactions, but not explaining them (these words can be grating because we feel bullied rather than seduced into admiration). Criticism is the process of going behind the scenes in the hunt for true reasons.

Even when contemplating extremely celebrated and much-loved images, we are liable to feel painfully silenced by the basic question of why we like them. A good critic can track what is really going on when we are moved by a work, and can put the enthusiasm into words.

Even if we like it, it's a challenge to say what is nice about this picture.
— 99. Leonardo da Vinci, *Mona Lisa*, 1503–6

For example, many people have felt there is something special about Mona Lisa's smile (99). In 1869, however, the *Fortnightly Review* published an essay by the art critic and philosopher Walter Pater that gave an articulate, if slightly flowery, insight into what the power of this smile might actually be based upon:

> She is older than the rocks among which she sits; like the vampire, she has been dead many times, and learned the secrets of the grave; and has been a diver in deep seas, and keeps their fallen day about her; and trafficked for strange webs with Eastern merchants; and, as Leda, was the mother of Helen of Troy, and, as Saint Anne, the mother of Mary; and all this has been to her but as the sound of lyres and flutes, and lives only in the delicacy with which it has moulded the changing lineaments and tinged the eyelids and the hands. The fancy

of a perpetual life, sweeping together ten thousand experiences, is an old one; and modern thought has conceived the idea of humanity as wrought upon by, and summing up in itself, all modes of thought and life. Certainly Lady Lisa might stand as the embodiment of the old fancy, the symbol of the modern idea.

In other, less ornate words, what we may like in Mona Lisa's face is an impression of a combination of vast experience and serenity; a sense that here is a human being who is aware of all sorts of eventualities and dynamics in other people, and is still able to be fond of them. It is really the kind of attitude we long to find in an ideal lover or a friend, someone who might know us for who we truly are, with all our secrets and our darkness, yet still regard us with tenderness and generosity.

There is a crucial continuity between the rather arcane task of teaching us what to look out for in Renaissance paintings and the more popular role of the educator of taste in relation to cars, houses or hamburgers. At root, the work of the critic involves getting people to grasp what is genuinely satisfying and pleasing about something, or what might be disappointing and half-baked about it. Criticism is the effort of being as clear as possible about the basis for our loves and hates. Sometimes it can seem as if it is only concerned with the hating part, with pointing out with derision what is sub-standard, but this negative stance should only ever be an incidental part of the far more important project of identifying what is worthy of admiration.

Nevertheless, improving taste should mean that people regularly get a little more unhappy about certain aspects of their lives. For example, rather than putting up with bad architecture, there should be a collective gasp of horror at the new poor-quality housing development or brutal shopping mall, a gasp which, to return to capitalism, should then translate itself into severe financial punishment for those responsible for desecrating the earth.

The largest and most commercially successful shopping centre in the southern hemisphere, Chadstone, in the suburbs of Melbourne, was built by a family business called Myer Emporium, which also happens to have a fine record of philanthropy (100). The leading members of this family are conspicuous for their gracious homes

Not enough people are annoyed by this.

— 100. Main entrance to Chadstone Shopping Centre, Melbourne, Australia, 1960

and sophisticated outlook on life. In other words, they did not build a vast, mean-looking, architecturally disastrous complex because as individuals they thought it was a delight. It's just that they wanted to make a lot of money, and they believed that such a shopping centre would be the most reliable way to do so.

The original owners of Chadstone may well have preferred the style of the Galleria Vittorio Emanuele II in Milan, the largest shopping centre in Italy (101). Despite this, they made the rational, accurate calculation that not enough of their customers would mind what it looked like, that not enough people would refuse to buy a toaster or tennis racket in it simply on the basis of its appearance. Myer Emporium were exploiting a vacuum of taste in which the public were still awaiting the Walter Pater, the Herbert Read or (more likely) the Jeremy Clarkson of shopping mall aesthetics, and in the meantime were unaware that they had any particular distress to articulate.

The history of the careers of critics shows us both the opportunities and the challenges facing anyone setting out to raise standards of taste in a new area. It took Read 40 years to accomplish his goal; he had

The people who built
this knew they could make
a profit from beauty.

—101. Giuseppe Mengoni,
Galleria Vittorio
Emanuele II, 1865

to write dozens of books and deliver hundreds of lectures. Still, all
he managed to do was to get a very narrow section of British society
to look more favourably on certain objects in museums. But that
wasn't nothing. With enough determination, and in a wide range of
commercial areas, good critical voices should be able to spur on
a love of goodness and a hatred of mediocrity. In the process, and over
time, this could be enough to substantially transform where money
can be made, and hence how capitalism operates.

Towards an Enlightened Capitalism

What we are aiming for is enlightened capitalism: a system within which businesses remain sufficiently attuned to economic reality to be profitable and to sustain and increase their own activities without needing outside support, but also stay focused on providing optimal goods and services. It means a business culture devoted to what is genuinely worthwhile and admirable as well as to the many disciplines required to flourish in a competitive marketplace.

At present, this usually sounds like a contradiction. We are haunted by the worry that it is impossible to do good things and make money at the same time. The worry goes to the very heart of our anxieties about capitalism. We fear that the economic system, which delivers so much productive efficiency, simply will not reward our nobler endeavours. There is certainly enough depressing evidence around that this may be the case; that when we try to do good things, we fail, and when we ignore taste, we succeed. In the mid-nineteenth century this issue was addressed head on by an artist who was also an entrepreneur, William Morris (102). Like many of his serious contemporaries, Morris was dismayed by the way in which industrialization was taking more and more people away from craft employment, where they tended to produce beautiful and noble products, and on to the production lines of factories, where they tended to produce sub-standard and ugly ones. He sought to combat this by starting a business dedicated to turning out high-quality, beautiful furniture by hand, in the traditional style, without the use of automated techniques, thereby also creating opportunities for satisfying, well-paid work. The finest achievements of the various arts and crafts would be made available for all, and a workforce would have healthy and meaningful employment.

Unfortunately, things didn't work out as planned. The business was moderately successful for a few years, but it never became a major competitor to the mainstream suppliers, it never employed more than a handful of people and in the end it went bankrupt because there was simply not a large enough client base willing to pay a high enough price for the goods on offer. From a distance, Morris seems like the Jesus of good capitalism: he was commercially crucified because

THE SUSSEX RUSH-SEATED CHAIRS
MORRIS AND COMPANY
449 OXFORD STREET, LONDON, W.

he was too good for this world. Meanwhile, the reverse fate seems often to attend those who don't care at all about quality and virtue. 'No one ever lost money by underestimating the taste of the public' is a cynical but alarmingly plausible aphorism.

The fate of Morris and Company (relative to the financial triumphs of Caesars Palace and the Chadstone Shopping Centre) may seem like proof that the market is evil and that the only salvation lies in censorship and the provision of artificial incentives to the most noble producers. Caesars Palace should be closed down by the taste police, while the government should subsidize the production of artisanal goats' cheese. Though charming as a daydream, a radical, large-scale intervention of this kind would lead to catastrophe: the value of the currency would collapse on the global money markets, taxation revenue would decline and governments would be unable to service their debts. In any case, democratic political parties are themselves competitors for attention in the marketplace, and the major parties are necessarily more attuned to the values of Las Vegas than of Morris and Company We should accept without further nostalgic regret that it is simply unfeasible to do away with the market. We need ways of improving it without the promise of any enlightened intervention.

Courage to undertake such a task begins with a focus on some of the more cheerful instances in capitalism's history. It doesn't take long to come across examples of businesses that have successfully reconciled an idea of the Good with capitalist strictures, and that have used the resources of profit-driven businesses to improve the world in their own area by caring about creating a high-quality product as much as they do about profit. In children's toys, one thinks of Lego; in aviation, of All Nippon Airways; in fruit juice, of Innocent Smoothies; in office construction, of Urban Splash; in taps, of Hansgrohe; in potato crisps, of Zweifel; in animation, of Aardman; and in pencils, of Caran d'Ache.

Pessimistic attitudes as to the chances of reconciling the Good with the market are often a distant echo of nineteenth-century Romantic theses about the relationship between noble art and financial and critical success. It is because one too many a nineteenth-century artist died in his garret unrecognized, because Édouard Manet's *Déjeuner sur l'herbe* was initially ridiculed by the artistic establishment and James McNeill Whistler's *Symphony in White, No. 1* was cast out of the official Salon, that an idea persists to this day that quality is fated to be ignored in a vulgar world. We all have enough failure in our lives to find such a tale seductive, but we should acknowledge that in art at least, the idea of such blindness to beauty has been much exaggerated. Manet died a wealthy and celebrated man, and Whistler's misfortunes (like Van Gogh's) owed more to personality than an inherent bias in the established order. Furthermore, the art market has been atoning for its nineteenth-century mistakes ever since, ensuring that a lot of work that is deeply challenging and lacking in ready charm has gained a surprisingly large and steady audience. That one of the most lauded and economically successful artists of the twentieth century should have been a taciturn Swiss-Italian who depicted the human body as a series of tortured, elongated metal stalagmites suggests that taste cannot be as averse to depth and quality as one might assume (103).

We may, in time, come to see that the drop in standards in so-called 'popular' taste that took place in the twentieth century owed less to any intrinsic limitations in the audience, than to specific market distortions in many advanced economies. We may come to see the age of sub-standard television, patronizing housing, unhealthy

A highly successful capitalist enterprise.
— 103. Alberto Giacometti, *The Forest (Composition with Seven Figures and a Head)*, 1950

food and exploitative media as a historically limited one sandwiched between the collapse of the previous aristocratic value system and the emergence of more responsive, interactive and evolved methods of judgement. This dispiriting age was one when corporations were able to exploit a customer base that was passive, artificially constrained in its choices and unable to exchange knowledge of its experiences. In these monopolistic conditions, the goods and services that flourished were not necessarily those that answered properly to people's own enthusiasms; they were simply what certain businesses knew they could get away with.

However, as the world becomes more interconnected and consumers are able to exchange information and understand their tastes in a more accurate way, so the monolithic approach of the twentieth-century corporation might make way for a far more varied and inventive business ecosystem. The process of raising taste that Herbert Read accomplished in art through lectures and books may now occur almost spontaneously, thanks to the vast and sharp-eyed citizen armies of the internet.

Enlightened Investment

Nasser David Khalili is one of the world's richest men. Iranian-born and resident in London, he amassed a fortune (estimated to be in the many billions) by building and selling shopping malls and other forms of commercial and residential property. His money safely accumulated, he has now begun to give away large chunks of it to philanthropic causes. His dominant interest is art, and the greatest share of his surplus wealth has been directed towards the acquisition and display of masterpieces in a variety of genres. He has sponsored exhibitions at the Hermitage Museum in St Petersburg and the Institut du Monde Arabe in Paris; he has given large sums to the University of Oxford and lent his art collection, revolving around Islamic masterpieces, to the Victoria and Albert Museum in London and the Metropolitan Museum of Art in New York.

In its combination of money-making and art, Khalili's trajectory follows in the footsteps of great plutocrats such as Andrew Carnegie or Andrew Mellon. Like them, he has made money in so-called 'low' areas of the economy not associated with the pursuit of goodness, truth and beauty. However, once wealthy, he has wholeheartedly turned his attention to 'higher' causes, among which art looms especially large.

One might suggest a different path. Rather than ignoring the higher needs of mankind for many decades while pulling together an astonishing fortune, then rediscovering these higher needs later in life through acts of immense generosity towards some localized shrine of art (an opera house, a national museum), would it not be better and truer to the values underlying many works of art to strive across the whole of one's life, within the money-generating day job, to make truth, kindness and beauty more alive and accessible to the public at large? The difference between beauty and ugliness in most enterprises is a few percentage points of profit. Would it not be wiser if business people agreed to sacrifice a little of their surplus wealth in their main area of activity and in the most vigorous period of their lives, in order to render this activity more noble and humane, then focused a little less attention on dazzling displays of artistic

philanthropy in their later decades? Would it not have been better for all of us if, rather than making money through selling Scotland's hideous Cameron Toll shopping centre and giving away a portion of the cash to the Hermitage Museum, Mr Khalili had simply made slightly less money, but done so by building beautiful shops and houses that could have enhanced the tenor of everyday life across the modern world? The plea here is for a form of enlightened investment in which the return sought on capital would, over long periods, be moderated by an interest in the good that was produced from the enterprise in hand.

Part of the problem lies in the bestowing of status. Honour and fame are given to those who make very public gestures of philanthropy towards the arts. You don't get much respect from limiting your wealth-making potential or from investing your funds in ways that make daily life slightly better in non-dramatic but still substantial ways. There is more status to be found in exploiting a mine, rainforest or a call centre for three decades, then funding an opera house from the proceeds, your animal energies having run dry. This strategy has a glamour and apparent logic greater than the more modest task of steadily building a more agreeable world for people at a 3% annual rate of return, which at the end of life leaves you little except the inherent satisfaction of having done something worthwhile with your years.

Enlightened capitalism will require a new kind of patron who is interested in making money but willing to sacrifice returns for the sake of higher goals. London's Regent's Park and Regent Street are both beautifully elegant and brilliantly commercial developments, and we might learn from the attitude of their backer, the Prince Regent, later George IV (104, 105). The Prince had more than one motive for the huge scheme. He wanted and needed a commercial return from leasing the new buildings, so there was a capitalist impetus for the project. He also wanted, however, to make a fine and permanent contribution to the beauty and grandeur of his capital city. He succeeded in both aims. His streets and terraces enticed people to live in areas that had hitherto been backwaters; they would not have gone there had it not been for the elegance and charm of the new buildings. In order to succeed commercially, it was crucial that the development

Built in pursuit of profit.
— 104. John Nash,
Cumberland Terrace, 1826

— 105. Thomas Shepherd,
The Quadrant and Lower Regent
Street (demolished in the early
twentieth century), *c.*1850

be elegant, but the Prince could not afford to make his city more beautiful unless the development could also be commercially successful. The crucial point is that he brought to this project of urban development an ambition to attain the love, admiration and gratitude of future generations, and to create, with his great resources and with the help of commerce, the noblest of all human products: a majestic city.

Capitalism has not yet learnt to harness fully the longing for honour to generate good outcomes. It hasn't grasped the profound need to feel that one's life is directed towards fine and worthy goals, and the possibility this brings for people to be attracted to invest for the sake of other ends than the absolute maximization of private wealth. Money is the most basic kind of reward because in principle it can be converted into so many other things, but there are other kinds of rewards that the successful might seek, such as glory, dignity, the love of succeeding generations. These are noble goods. It has been unfortunate that the value system of capitalism has accelerated at a time when our collective hold on the meaning of such things

has, for other reasons, weakened. It can now feel pompous or silly to talk of glory or an immortal name. It feels somehow old-fashioned or unsophisticated, especially when you could be talking of money instead. Such ideas, though, are important counterweights to purely financial standards of achievement. They have the potential to grip the soul and guide ambition. If it is to flourish, a society needs to motivate people to undertake goals that go beyond the economic. Many great human achievements could only have been undertaken by people who focused on other things alongside money. This isn't to advocate the pursuit of honour over money; rather, a more judicious balancing between the legitimate claims of both elements.

In eighteenth-century Germany, Goethe and Schiller both cared a great deal about making a good income (106). Honour was not the only thing they cared for, and being able to live in decent house or eat well did not seem irrelevant. They didn't feel, however, that every venture had to be assessed purely in terms of economic return once there was enough cash around to ensure some feeling of safety.

This message isn't going to be useful for everyone; most of the planet is still engaged in a basic struggle for survival. It is extremely important, though, for the overall direction of capitalism. The appetite

for money shorn of moral value, which can be observed at the top of the commercial hierarchy, has been ruinous in its effects on society as a whole. Yet it doesn't stem from greed. It is caused by the fact the money has been left in sole possession of the field of honour; that it is the only standard that we know how to aim for and can reliably be congratulated for having attained. The good news is that most successful business people are already not working for money: they are pursuing money not for its own sake, but for the love and respect it affords them. They seem relentlessly focused on making money because they are competitive people, and because winning currently means doing so in the money game, the primary gateway to status and, to stretch the word a little, love. For everyone's sake, we need to make sure that we can give these competitive types a more diverse set of laurel wreaths to aim for.

A responsible society would recognize the strength of this hunger for honour and exploit it properly for the good of all. We will live in

more beautiful, wise and humane communities when we have learnt to reorient the system of ambition, when the most driven and energetic individuals have the chance to win honour through work that taps into mankind's highest needs. We should ensure that the longings for beauty, truth and kindness, which are innate in the human soul, but which currently emerge for plutocrats only in bursts of late-life philanthropy, have a chance to flourish across their whole career in everyday economic activities. In a nuanced version of capitalism, the rich would be happy with slightly lower returns on their money in exchange for acquiring more diverse and beguiling laurels, and in return ordinary citizens would be blessed with greatly more dignified places to work, live and shop for tennis rackets and toasters in.

Career Advice from Artists

As economies develop, so a troubling ambition arises in many of its most educated and driven workers. It is no longer enough that a job merely pays a living wage; it should also, ideally, prove to be meaningful. A search for greater meaning in work may be so powerful that it can lead us to make dramatic and apparently reckless swerves in our careers; it may make us leave well-paid and secure occupations in a search for tasks that more accurately answer to certain inchoate inner needs that we capture with the term 'meaningful'. There seem to be two elements required to make a job meaningful. Firstly, we want a job to give us a feeling that we are helping in some way, large or small, to make the world a better place, either by reducing suffering or else by eliciting delight, understanding or consolation in others. Secondly, and more challengingly still, a meaningful job should feel aligned with our own deepest talents and interests. It has to give us a chance to externalize certain precious capacities that lie within us, so that we can look back at our work and feel that it speaks to others and ourselves of our most sincere, authentic and valuable qualities. No wonder we can spend many years, especially early on in our careers, wondering what we should try to do with our lives.

In moments of confusion, the career of an artist can seem attractive, and, perhaps more often than is wise, inspire the hope

that we could one day try to become artists ourselves. The ambition to be creative has taken many a young person by the throat and never let them go. The successful artist seems to live out the modern ideal of what work might be: Andrew Wyeth, for instance, would take his easel into the countryside, look at the fields, rivers, trees and clouds and translate his most intimate reactions into touches of paint on canvas. The market would convert the motions of his soul into money, in exchange for delighting and moving his audience. Anthony Caro could visit scrap merchants, pick up odd pieces of metal that interested him, weld them together following the dictates of his imagination and then, in the wake of worldwide exhibitions, receive large cheques from his galleries in London and New York (a knighthood was to follow). We admire blessed individuals who pursue activities that have a unique origin in their own personalities and then make a decisive difference in the lives of others; this is demonstrated by the money the audience is willing to pay for the effect.

Attractive though this may be, the prospect of an artistic career is hopelessly disconnected from what most of us are capable of, let alone what the world needs. Nevertheless, there are some important lessons to be drawn from the trajectories of artists, such as how one might discover a vocation, turn moments of inspiration into a career and commercialize one's talents, and these may be of use in cases that stretch far beyond the restricted and economically challenging realm of art.

Problems with careers often start with an unusual sensation: we know a hundred things that we would hate to do with our lives, but beyond vague longings we don't have a clear picture of where we should in fact direct our ambitions. We want to change things, to do something interesting and worthwhile, but we can't bring our interests into any kind of realistic focus. At this point, we tend to panic. We blame others for our woes, we declare the playing field rigged against us, we exaggerate our deficiencies or we leap into the nearest so-called 'safe' occupation that we know will not answer any of our inner needs, but which, we reassure ourselves, will at least earn us money and keep authority figures off our backs.

We would be wise to apply a little patience, realizing that

confusions about one's direction are a necessary part of a legitimate search for an authentic working life. Rather than evidence that one is doomed, feeling lost is the necessary first stage of a fruitful quest. In this process there are two signals to which we should pay particular attention: envy and admiration.

From a young age, we acquire so many compelling stories of envy being corrosive and damaging that we fail to identify its constructive and essential qualities. We don't use envy for what it can really help us to construct: a map of the future. Every person we envy holds out a piece of the jigsaw about our possible later achievements. There is a portrait of our true self to be assembled from sifting through the envious feelings we experience when we flick through a magazine, scan the room at a party or hear the latest moves in the careers of those we went to school with. We may experience envy as humiliating, as the confirmation of our own failure, but instead we should ask the one essential and redemptive question of all the people we envy: what can I learn here? Sadly, envious feelings tend to be confusingly vague. We envy entire people and situations, when in fact, if we gave ourselves the opportunity to analyse the targets of our envy calmly, it would turn out that it was only a small part of them that really held the clue to our ambitions. If we could stick with envy long enough, if we could probe it rather than deny it or let it throw us into despair, we would learn to pull from its sulphurous depths a range of vital clues as to how we might become who we are.

Aside from envying badly, we are also at risk of admiring others in a way that prevents us from emulating them. Our respect can be so powerful that we are at risk of failing to see our heroes as people we might – in the best sense – steal from. A healthy relationship to one's idols involves a sense that one might one day, after suitable respectful study, outgrow them, rather than merely pay lifelong, uncreative homage to them. Although admiration and envy are universal experiences, they are played out in the careers of artists in ways that allow us to inspect their inner workings with particular clarity. In the biographies of artists we have a chance to observe that success has an uncommon amount to do with a capacity to use admiration and envy constructively.

*Building on what one loved
in another painter's work.*
— 107. Philip James
de Loutherbourg,
Lake Scene, Evening, 1792

RIGHT
— 108. J. M. W. Turner,
*A Mountain Scene,
Val d'Aosta, c.*1845

J. M. W. Turner began his career with overwhelming respect,
and not a small amount of envy, for the distinguished landscape
painter Philip James de Loutherbourg (107–108). Turner appreciated
Loutherbourg's way of painting mountains, fields, waterfalls and trees.
At first Turner copied this range of enthusiasms faithfully, in
a sterile and unimaginative way. With time, he learnt to examine his
admiration with a critical eye. He learned to ask himself with greater
vigour what it was he really responded to in Loutherbourg's work,
and discovered, when he examined matters closely, that his respect
was more selective than he had at first imagined. The true target
of his admiration was the way that Loutherbourg painted the effect of
sunlight on clouds and rain, and it was this he decided to highlight
in his most characteristic later works. Turner had the wisdom to study
what it might be about an admired predecessor that really excited him
and the courage to devote himself to building upon it singlemindedly.

His example suggests that one way of dealing with one's heroes is to focus on something that they have done, single it out from the multiplicity of their achievements and throw a new emphasis upon it. What we call novelty may just be a case of judiciously highlighting what was once a mere sub-theme in a predecessor's work. Turner might have taken his admiration in a vaguer direction. He might simply have continued along the same general lines set by Loutherbourg and remained a follower rather than a creator. He might have ignored the particularly loud signals of interest and excitement that he would have felt when looking at Loutherbourg's skies in his early twenties. If he had, the world would never have known the mesmerizing, intense beauty of his great final phase.

Another technique artists have used to discover their own identities through an engagement with admired predecessors is that of combination: taking a number of different and well-known influences and combining them in ways that have never yet been tried. The style of Francis Bacon now appears obvious and complete, but the path to this achievement was based on a gradual blending of a range of disparate artistic interests. When he began painting, Bacon was

deeply impressed by Vincent van Gogh, as his studies for a portrait of him attest (109).

The process of becoming the artist we know meant throwing together a range of different themes into the crucible of his feelings for Van Gogh. Over many years, from the 1930s to the 1950s, Bacon slowly assembled a diversity of sympathies and enthusiasms. In 1935, for instance, he came across a book on diseases of the mouth in a second-hand bookshop in Paris; the coloured plates, which would have struck most people as unbearably repulsive, fascinated him. In the same year he saw Sergei Eisenstein's film *Battleship Potemkin*, with its striking scene of a nurse screaming, which he joined up with his own asthmatic struggles for breath and with memories of his bullying father's face distorted in rage (110). Half a decade later, he would discover Titian, and be struck by the atmosphere of dignity and

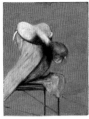

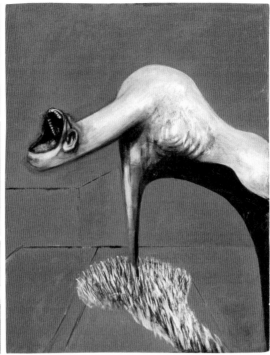

solemnity in his canvases, achieved by simplifying the visual plane and relying on backgrounds of deep ochre tints. All of these elements might have had an independent life, but Bacon was able to digest and organize them in a way that brought out new, mutual sympathies never before suspected, and which together contributed to the genius of his mature style.

It is sometimes observed that everyone has a novel, or perhaps a painting, inside them. This seems right; almost all of us have passing intuitions about what our creations and careers might look like. The issue is whether we can also develop the tenacity and perseverance to turn an insight into a product. Here too artists are of help. Like many of us, Le Corbusier started off with a sketch of what he wanted his life to be like (111). His early notebooks, when he was a student and then an apprentice, are filled with swift pen-and-ink renderings

The patience it would take until the armchair and the room could be real.

— III. Le Corbusier, sketch from *La Maison des Hommes*, 1942

of buildings that have an atmosphere we recognize from his later built projects. The sketches are moving because they show us how the young Le Corbusier was when he knew where he wanted his career to go – and yet how many decades he had to wait for it to do so and how much effort he had to make to ensure it would. They remind us of the cost of going from the dream to the creation.

What can this teach those of us who don't want to be architects or artists? Principally, that difficulty is normal, that we have much to learn from others and ourselves and that we should be patient. The capacity to work in complex jobs requires many strands of one's personality to be developed. To put up buildings, to run a school, to manage a bottle-manufacturing business, to invest successfully in the stockmarket, to plan an election campaign: these require overcoming a range of our native defects. These could include a tendency to wishful thinking, a reluctance to look danger in the face or to absorb the painful lessons of failure or a disinclination to listen to advice when it comes from unwelcome sources. Furthermore, success requires the nurturing of many positive qualities, including a capacity to explain

— 112. Stained Glass,
Chartres Cathedral,
c. 1150

one's ideas to people who do not yet share them; the strength to disappoint people and still like oneself; the capacity to let go of a lesser good for the sake of the whole. Such disparate sources of maturity need to be gradually bound together and deployed. The development of the artist provides a profound model of the process of maturation.

One aspect of a good relationship with anything is an appropriate set of expectations. For example, a good marriage will almost certainly have a lot of conflict and anguish, but if one takes this as an expected level of pain, the allure of leaving and finding something better is diminished. The same constructive lowering of expectations can be applied to work. A task for art, here, is to dignify our sorrows: humiliation, self-doubt and anxiety over money are parts of life that we struggle with, but not because we are idiotic or inept. We should learn a lesson from religious history and make a private and public habit of honouring images of suffering with repeated attention. Christian art made a point of presenting its most central figure in situations of misery and despair (112). The aim was to remind us that pain and sadness are not the results of getting life wrong in some way,

Life is not elsewhere.
— 113. Nicolas Poussin,

Landscape with a Man
Washing his Feet at a Fountain,
*c.*1648

but the ordinary accompaniments of trying to do the right thing.

Although it is now a prestigious object of art, Poussin's *Landscape with a Man Washing his Feet at a Fountain* has a sobering message about all kinds of work (113). The man on the left, washing his feet in the fountain, is representative of labour. We don't know exactly what his job may be, but it is highly unromantic. We sense that he has walked far already and that he must push on much further. There is no guarantee of any special reward when he gets there; he must fight against his own weariness. The younger man on the right is being upbraided by his wife for not working hard enough. In this picture, labour is the unavoidable and unexciting condition of life. It is painted with the hope of getting us to share this attitude, and therefore to be less dismayed, less angry, when life feels continually difficult. Poussin is challenging our excessive expectations, our fantasy that somewhere, over there, round the corner, is the easy, well-rewarded, exciting, pleasurable existence, which is unfairly denied us, or

which we just haven't been smart enough to locate. By making this a visually grand picture, with majestic trees, ruins and a quiet sky, the artist gives emphasis and stature to a message that might otherwise strike us as a tiresome lesson.

This is not to say that it does not matter what job you do, but the message from Poussin is that most worthwhile work, administrative positions, ambitious commercial enterprises or creative endeavours – irrespective of how they are seen from the outside – do not feel or look glamorous from the inside. Poussin is trying to tell himself and his friends that life is not elsewhere, and that trouble and toil are the inescapable accompaniments of the human condition. The picture is the visual equivalent of a striking line from T. S. Eliot's 'Little Gidding' in *Four Quartets*, 'History is now and England.' Eliot is working against the powerful inclination to underestimate the significance of what is going on in the present. The things that are happening now may seem messy, confusing, slow, banal, frightening, but, argues Eliot, this is what even the most revered and catalogued historical periods would have felt like when they were actually happening. And so too with work: it is likely to feel repetitive, uninspired, inadequately appreciated and underpaid, even when it is entirely worthwhile and on course.

Politics

What Should Political Art be Aiming At?

Until now, we have largely been looking at art in relation to the problems of the individual. But throughout its history, art has also been involved with the issues of group life. It has recorded and, more ambitiously, attempted to direct how we live among each other in communities. In terms of its sympathies, political art – particularly in the nineteenth and twentieth centuries in the West – has tended to take the side of the weak against the strong. It has focused on economic and social injustices and sought to give a voice to marginalized communities, creating feelings of sympathy and outrage in the hope of prompting political change. Art has also periodically been employed by the powerful as an instrument of aristocracies or national governments. At their worst, these have harnessed the emotive power of art for tyranny, thereby tainting the very idea of political art in the eyes of some. So thorough has the corruption been that it occasionally looks as though art simply cannot remain honest unless it renounces all political ambitions, a stance embodied in the call that art should remain 'for art's sake', and in W. H. Auden's resigned yet proud declaration that 'poetry makes nothing happen'.

Although political art can be abused, as can most good things, its potential for goodness deserves to be recognized at a theoretical level, and explored at a practical one. If artists are capable of helping individuals, they must also be allowed to exert the power to heal states.

Rural poverty was increasing in Belgium in the late nineteenth century. Emile Claus's *The Beet Harvest* is a huge painting – 4.5 metres (15 ft) wide – that makes the cold, heavy work of the farm labourer unforgettable (114). We cannot escape a powerful sense of how harsh and unrewarding it must have been to collect the sugar beet. However, Claus's painting wasn't meant to speak to the labourers themselves, but to affluent, well-established viewers in museums in towns and cities. The point of the picture was to bring attention to suffering that had been kept out of mind by vested interests. It aimed to make the sight of suffering unbearable to those who had the power to change things, if only their consciences could be stirred. Claus was doing in paint what Charles Dickens and Emile Zola had been doing in

Art to help work
be more humane.

— 114. Emile Claus,
The Beet Harvest, 1890

literature: he was giving poverty a human face. In this analysis, the task of artists is to pick on examples of maltreatment and immorality and make them unforgettable to the governing and powerful classes of society. Art's role is to generate guilt, and thereby change.

Claus's ambitions live on. We encounter them in the street art of the Chilean-born, New York-based artist Sebastián Errázuriz (115). Shocked by the behaviour of bankers in the decade prior to the financial crisis of 2007, Errázuriz travelled around Wall Street creating dollar signs out of ordinary street markings, in the hope that these would help his audiences question the role of capitalism and to adopt a more equitable model of wealth creation and distribution. Consciousness-raising was the intended move, and Errázuriz, like so many political artists before him, hoped his work would allow us to see as problematic behaviour that, until now, we had regarded as no cause for alarm – and gird us for change.

Errázuriz's work is vulnerable to a criticism often levelled at political art: it may be outraged, but isn't in itself doing enough to bring about the change it longs for. It is shouting forlornly in the

What to do if you are — 115. Sebastián Errázuriz,
angry with a banker. *Wall Street Nation*, 2012

wind. In order to be effective, political art can't simply say that something is wrong; it needs to make this error feel vivid enough to generate the emotion necessary to stir us into reform. What this requires, artistic talent aside, is an original understanding, whether psychological, social or economic, of the problem in question.

The other kind of bad political art isn't only ineffective, it's plain dangerous. It gets us to fight for the wrong causes, for motherlands that don't deserve sacrifice and regimes that torture the innocent. It persuades us to think well of villains.

These failings help point us towards a notion of what good political art should be about. It should take the pulse of a society, understand some of what is wrong with group life, arrive at an acute and intelligent analysis of its problems, then push the audience in the right direction through supreme mastery of a chosen artistic medium. If this is the goal, we should be ready to stretch our conception of what political art includes. For a start, abuse doesn't only involve

An attempt to guide the
psyche of a nation.

— 116. Christen Købke,
Outside the North
Gate of the Citadel, 1834

economic injustice; it may lie in any number of small intra-personal behaviours that corrupt daily life. For example, one might argue that one of the leading problems of affluent societies is that their citizens are becoming ever more aggressive and impatient. Therefore, one mission for modern political art might be the encouragement of serenity and forgiveness.

Viewed from this perspective, Danish artist Christen Købke's *Outside the North Gate of the Citadel* is a superlative piece of political art because it attempts to change how citizens relate to one another (116). In the painting, an officer cadet can be seen lounging on the bridge, quite at ease with an itinerant young salesman and a couple of poor local children, all enjoying the sunshine on the water. Without labouring the point, it presents an attitude of informal companionship

A political agenda for
changing the way we talk
to one another.

— 117. Tino Sehgal,
Tate Modern Turbine Hall,
2012

between different levels of society, where there could easily be tension and distrust. It is a moment of quiet simplicity. The beholder is invited to recognize patient thoughtfulness as a public virtue, and thus it acts as a counterweight to the general tendency to get instantly agitated whenever we see things we dislike in the political realm. One could imagine this image being beamed into every home before the news, to reduce the likelihood of people screaming at the screen or posting an irate comment online.

Købke is trying to tell Danes what they should be like, and to nudge them in a good direction. Remarkably, the picture has had some tangible success in this endeavour. Along with many others, it has helped crystallize a conception of what it is to be Danish, what a Danish attitude to life might be like. You see Købke's work in postcards and posters across the country. Art has played its part in the development of one of the world's sanest and most decent societies.

In 2012, the Anglo-German artist Tino Sehgal produced an updated version of this kind of political art in London for the Tate Modern's Turbine Hall (117). He trained a group of strangers to become experts at talking to one another with the help of some specially positioned conversational prompts. A small army of volunteers approached visitors at the Tate, told them something about their lives and asked them for their personal stories, based on big, intimate questions formulated by Sehgal ('When did you feel a sense of belonging?' 'What does 'arrival' mean to you?' 'Of whom are you afraid?') Many an artist has highlighted our social isolation. Sehgal – more interestingly – tried to solve it, and did so as an artist, with intelligence and originality, yet without any of the traditional tools of art. Though a political artist, Sehgal understood his brief with refreshing broadness. He didn't feel the need to attack the obvious abuses of English society. He knew that one of the prevalent but quasi-invisible problems of living in England is that very few people know how to talk honestly with one another, and that they like to hide their vulnerability behind a detached, ironic air. He was internally strong enough to know that addressing this problem also counts as changing the world (like Købke, he wasn't in love with the grand gesture). Finally, he stretched our preconceptions of what an artwork is and

what an artist should be doing. No longer does being an artist have to mean making anything tangible. It may mean choreographing a form of interaction in a public space so that people will be less frosty and boring with one another. Sehgal is refreshing in his understanding that the task of political artists is to analyse and then refine the collective personality – and that this can involve making use of all means at one's disposal, even marshalling a band of volunteers to approach strangers for a chat. This, too, can be good art – and good politics.

What is There to Be Proud of?

Political art often points out what is wrong with a country, but an important part of its mission is to show what is right with it, in order to highlight what we can be proud of. We tend to feel awkward connecting pride with art. We shouldn't be. National pride is quite readily embraced in other parts of cultural life. Sporting triumphs are regularly experienced as matters of national euphoria, especially when the success appears to flow from some feature of the collective self-image.

Huge crowds acclaimed Jonny Wilkinson and the England rugby team as they made their way to a reception at 10 Downing Street following victory in the 2003 Rugby World Cup (118). It was not merely the fact of winning that 'made all England feel wonderful' (as a writer for the *Guardian*, a newspaper usually sceptical of triumphalism, put it). Wilkinson's last minute drop-goal against Australia fitted perfectly with the national mythology of resilience in adversity and coolness under fire. Even the persona of the team – a mixture of roughs and gentlemen – played up to the idea of who the English are and fed the sense that the nation itself, and not merely a few individuals, had done something magnificent.

We should learn from this. One of the surprising lessons of late twentieth-century history was that lack of pride is really a problem. Sophisticated culture had been quite stern in its hostility to national pride. This did not make pride go away; it only left it unguided and undeveloped. The desire to feel proud of one's community is in itself a natural and good impulse. It deserves the attention of artists. The task of art is not necessarily or only to condemn society's worst

The task of art is also to show us what we might be proud of.

— 118. England Rugby Team Victory Parade, London, 2003

failings; it is to direct our capacity for pride. Pride can be dangerous and loathsome, of course, when focused on unworthy or idiotic things ('we are great because we have lots of iron ore mines' or 'because we have white skin'). We need to channel this natural impulse in the most intelligent and valuable directions. Collective pride is important because there isn't enough to be proud of as a single individual. The psychological frailty that we very much need art's help with is that we are more or less compelled by nature to be proud of something collective, but we don't know what to be proud of.

A comparatively minor but intriguing opportunity to address this frailty, and teach us the true shape our pride could take, is presented whenever a nation commissions an embassy building or ambassador's residence. In order to design the new Swiss ambassador's residence in Washington, DC, the architect didn't only have to consider practical spatial needs, he also had to ask himself about the identity of an entire country (119). The residence is more than just the place where a senior diplomat happens to live: it is a home of a nation in a foreign land.

*What Switzerland can be
in its best moments.*
— 119. Steven Holl,
Swiss Ambassador's
Residence, 2006

*A nation confused about
grandeur.*
— 120. Michael Wilford,
British Embassy, Berlin,
2000

It can hence be seen as a built response to the collective question of those who paid for it: 'What should we, the Swiss, be proud of in our country?'

In some ways the building provides a poor answer. It isn't setting out a manifesto. It doesn't provide a mantra to chant at a rally. Nevertheless, the building is quietly but profoundly eloquent about what is best and most attractive about the country that owns it. For a start, it is quite upfront about formality and elegance. The pin-striped, sand-blasted glass is carried across the facades so that there is minimum visual disruption. The whole is neat and clean. One could imagine a more apologetic architect feeling that the Swiss obsession with such things was slightly embarrassing in the modern world, but Steven Holl has decided to give this attitude a noble visual expression. What could have been petty and fussy is presented in its grander, more ambitious manifestation. The edges of the building are picked out in charcoal-coloured concrete blocks. Visual boundaries are made as distinct as possible. The pursuit of precision in thinking and feeling has been translated into architecture. It is as if the architect were saying to the Swiss: 'This exactness, which you know people mock you for, is, in fact, something worthy of pride.' The contrasting veiling of many of the windows, which lie behind the surface of the glass walls, creates an effect of inner cosiness, muted and soft in its outward display. At night, when seen lit up, these facades tell us that the things to be proud of about Switzerland are not secrecy and numbered bank accounts, but warmth, care and elegance.

The natural opposite of pride in one's country is shame, or, in a less dramatic way, embarrassment. When a society is troubled by its past, public architecture has an especially important but difficult task. The British Embassy in Berlin, designed by Michael Wilford, struggles with the idea of national pride (120). The upper levels, with their strongly neo-classical rhythm of wall and window, like a squared-off aqueduct, are noble and pure. They could belong as much to the history of German architecture as to British, which is fine, since it helps the embassy live like a good citizen in an already crowded street. Above the entrance, Wilford has made eccentric, strongly coloured forms emerge, as though a crazy guy is hiding behind the stony face,

and here he is punching his way out. One could see this as an attempt to say what Britain should be proud of: its inner oddity. But this feels like the work of embarrassment. The embassy seems to be saying, 'I'd love, really, to be grand and noble and dignified; I'd love to be charming and honourable, only I'm worried you will misunderstand me and think I am pompous and arrogant, as I might have been in the past. So I'll play the fool instead – then you won't get angry with me.'

Pride is closely connected with identity. Before you can feel proud of your community, you need to have a positive and contemporary image of who you actually are. This isn't always easy; identities have a habit of lagging behind a nation's current realities by a few generations. We see plenty of examples of countries trying to forge identities that build on traditions but aren't slaves to them, however. Bhutan, the small Himalayan Kingdom on the border of China and India, has a distinctive architectural tradition based around monastic fortresses. It also has a tourism industry crucial to its economy. At the Amankora resort, Australian architect Kerry Hill has been loyal to that tradition with wide eaves, elaborate wooden cantilevered windows, and massive, inward-sloping walls, but all this is adapted to modern technology and the pleasure and convenience of visitors (121). Hill's architecture judiciously sums up key themes in the country: its traditions and its need to engage effectively with the global economy; its proud sense of individuality and its need to be understood and liked by the world; its devotion to purity and its curiosity about the pleasures of comfort. In other words, the resort development is saying that Bhutan is committed to being a traditional country in quite a profound and detailed way, but it wants to pursue this without being defensive; that is, without a rejection of sophistication.

Embassies and hotels are crucial for national identity because they are the places where outsiders encounter a society. War memorials are another kind of structure with a responsibility to sum up what a country is at its best. Like many nations, Australia places a great emphasis on them. At an imaginative level, and at certain moments of collective self-consciousness, its large war memorial in Canberra has simply *been* the nation (122). The memorial was designed by Emil Sodersten and John Crust to commemorate the Australian dead

ABOVE

*Letting visitors know 'who'
Bhutan might be.*
— 121. Kerry Hill,
Amankora Hotel, Bhutan,
2007

BELOW

*One is moved by the sacrifice,
but unsure quite in whose name
it took place.*
— 122. Emil Sodersten and John
Crust, Australian War Memorial,
Canberra, 1941

An Australia to love – and,
if it came to it, die for.

—123. Glenn Murcutt,
Murcutt House, Woodside,
South Australia, 1995–6

of World War I, and was inaugurated in 1941. It is a solemn and grand structure. It invites us into an elevated sense of history, but then becomes reticent. While we might be sad that so many people died for Australia, the memorial doesn't in itself tell us why they made this sacrifice or what is so special about this nation that one might want to die for it. It evokes the sacrifice, not the entity in whose name it occurred. In other words, the building could be anywhere. This matters a lot, given the seriousness of what is at stake.

For a better answer to the dilemmas of Australian identity, we might turn to the works of the architect Glenn Murcutt, whose buildings have done a great deal, arguably more than the war memorial in Canberra, to articulate the spirit of Australia. In a house he designed for himself in South Australia, Murcutt used all the familiar architectural elements of the country he loves: the corrugated iron, the big cylindrical water tanks, and the shed and garage doors (123). These are not only rural features, but are also very common

in the suburbs where almost everyone lives. Despite this ubiquity, Murcutt has brought them together in a refined and beautiful composition. Water tanks are usually situated conveniently to catch the run-off from the roof, and tucked away on the assumption that they are unworthy of notice, or because it is slightly embarrassing to pay attention to the aesthetic merits of an avowedly utilitarian structure. Murcutt's house, however, is a lesson in pride. It does not simply assert that water tanks are great, and that the house is great because it has lots of them. Rather, it seeks a way of showing what can be lovely about these elements. In the composition they are reminiscent of the defensive towers on either side of a castle gate. Those, too, were utilitarian in origin, but their beauty and poetry of association have gradually come to the fore. Murcutt helps us recognize the dignity of a building style that is only regarded as humble because its practical elements have not, until now, been attended to properly or integrated with adequate skill into domestic design. Along the way, he also points Australians towards what they can be proud of in a realistic and practical way. He gives reasons to love and, if it were to come to it, to die for a nation.

Who Should We Try to Become?

In 1956, the Brazilian architect Oscar Niemeyer was invited to play a central role in the creation of his country's new capital city, Brasilia. Among the most impressive of the buildings he designed was the Brazilian National Congress (124). Brazil is a country of frenetic economic activity, of rainforest and Amazonian villages, *favelas*, soccer, beaches and intense disagreement about political priorities… none of which is apparent upon contemplation of the National Congress. Instead, the building imagines the Brazil of the future: it is a glass and reinforced concrete ideal for the country to develop towards. In the future, the building argues, Brazil will be a place where rationality is powerful, where order and harmony reign, where elegance and serenity are normal. Calm, thoughtful people will labour carefully and think accurately about legislation; in offices in the towers, judicious briefing notes will be typed up; the filing systems will be perfect – nothing will get lost, overlooked, neglected or mislaid; negotiations will take place in an atmosphere of impersonal wisdom. The country will be perfectly managed.

The building, therefore, could be seen as an essay in flattery. It hints that these desirable qualities are already to some extent possessed by the country and by its governing class. Ideals flatter us because we experience them not merely as intimations of a far distant future, but also as descriptions of what we are like. We are used to thinking of flattery as bad, but in fact it can be rather helpful, for flattery encourages us to live up to the appealing image it presents. The child who is praised for his or her first modest attempts at humour, and called witty as a result, is being guided and helped to develop beyond what he or she actually happens to be right now. They grow into the person they have flatteringly been described as already being. This is important because the obstacle to our good development is not usually arrogance, but a lack of confidence.

The Spanish general Spinola, on the right in Velázquez's painting *The Surrender of Breda*, is depicted receiving the key to the city of Breda, in the southern Netherlands, from the representative of the defeated Dutch forces, Justinus van Nassau (125). This is a painting

An advance fragment of — 124. Oscar Niemeyer,
Brazil in 2095. Brazilian National Congress,
 Brasilia, 1957–64

of an ideal: that a victorious general should recognize the merits
of his opponents and treat them with respect and consideration.
It is a memorial to unusually good and noble conduct. It is not trying
to present a comprehensive or accurate account of war, just as the
National Congress building in Brasilia is not trying to give an accurate
presentation of what Brazil is like as a country. Instead, each latches on
to an important and highly relevant ideal. The painting is not a fiction
– Spinola did in fact behave well towards Nassau. The Congress is not a
fiction – there are indeed aspects of elegant seriousness in Brazil. The
point in each case is that these very desirable qualities are, so far,
unusual, and art is attempting to make them a little less so.

 Art can help us with our tendency to lack hope because we
think the best kind of behaviour is too far above us, too difficult and
too hard. We too often lack the self-conception that makes noble
conduct available to us. Art should not berate us for our failings in
the forlorn belief that self-disgust will lead to goodness. Rather, we
need to strengthen our better natures, and flattery is one of the ways

A guide to honourable defeat. — 125. Diego Velázquez,
The Surrender of Breda,
1634–5

of helping ourselves and others to become better people.

In many countries' histories there are particularly painful things
that need to be digested. The hope is that a country can heal itself
with the help of political art. This challenge is raised to a pitch
of difficulty and importance in Germany. The appalling tragedy of
Germany in the late 1930s and early 1940s calls for atonement, rather
than denial or pure lamentation. The need is not merely to say that
terrible things happened, but to deal with the legacy of guilt in the
name of improvement. However urgent the need to acknowledge past
evils may be, this on its own does not create a better society.

Anselm Kiefer talks to us all, and especially to his German
compatriots, as adults about how to recover after terrible things have
happened. *Innenraum* presents a magnificent hall in the neo-classical
style of Albert Speer, the Third Reich's favourite architect (126).

A country that needs great political art like few others.

— 126. Anselm Kiefer, *Innenraum*, 1981

This noble place is seen as though through a veil of tears, represented by a distempering, dripping and peeling surface. The grey and black ball in the middle of the foreground might be a hint of a fallen chandelier or a suggestion of a world consumed in cold fire. There is sadness and anguish here, but the architecture of the room is genuinely beautiful and the painting fully acknowledges this.

In its frontal display, with a geometry of a hall that maps perfectly onto the painted surface, *Innenraum* is like Nicolas Poussin's *Sacrament of the Holy Eucharist*, one of the most confident and serious presentations of the possibility of salvation in the history of Western art (127). Poussin believed the Eucharist cleansed an ancient sin, and thus set people free. It is not that Kiefer expects people who view his

Salvation via art.

— 127. Nicolas Poussin,
*The Sacrament of the Holy
Eucharist*, 1647

work to be conscious of the similarity. It is rather that both painters
have reached for the same scheme of classical order. Poussin is closer
in; Kiefer looks from farther away. In Poussin, the oil lamp still hangs
above the redemptive scene.

Kiefer's title, *Innenraum*, makes a plea for inner space, for mental
and emotional room. If our minds are large we can separate and hold
apart ideas that have been forced together in the past. Maturity is often
displayed by an ability to hold contradictory ideas in mind, and Kiefer
invites us to think that not everything about the Nazi past was wrong.
Certain authentic emotions and longings were skilfully engaged
by the regime. The difficult fact is that Nazism co-opted themes that
life in a good society actually needs. National pride, a sense of mission
in the world, grandeur, honour, collective energy and loyalty: these
are important for good societies, but their corruption and abuse
in Nazi ideology have made them appear imaginatively completely
unavailable to many Germans, as though they belong exclusively
to villains and must be hated and rejected forever as a result. Kiefer
is a good adult guide to the possibilities of hope and recovery

The rebirth of national pride. — 128. Christo and Jeanne-Claude, *Wrapped Reichstag,* 1995

in the face of a horrifying past. He makes it bearable to approach an agonizing but important theme: 'How can Germans recover health, vigour and grandeur in a sane and substantial way?'

In 1995, the artists Christo and Jeanne-Claude also had a go at this task by wrapping up the Federal parliament in Berlin (128). Although a nineteenth-century work, the Reichstag had a particularly painful memory attached to it. The Nazi party rose to power in 1933 on the back not of force, as it might be convenient to believe, but of popular electoral success. This has traumatized modern Germany, but a vote cast in 1933 hardly entails agreement with every element of party policy up to 1945, let alone the actions of the government over the massacre of European Jewry or the behaviour of its armies on the Eastern front. Nevertheless, the election results are a fraught reminder of collective responsibility.

Jeanne-Claude and Christo did not change the Reichstag, but by covering and then unveiling it, they set up a grand public opportunity for a renewal of the nation's relationship to its most important political building. It allowed Germany to give its parliament back to itself.

The *Wrapped Reichstag* was a secular political form of baptism. Baptism is a symbolic moment in which past wrongs are put aside and the individual is re-dedicated to the future. Political art has a pivotal role to play in allowing nations to learn to start again, even while they acknowledge guilt for past sins.

Perhaps the most impressive political speech ever made was the funeral oration delivered by the Athenian statesman Pericles in 430 BC. At the heart of the speech is an attempt to sum up the character of Athens as a society. He is asking his audience: who are we? In a central section he gives part of the answer: 'We are seekers of beauty, but avoid extravagance. We admire learning, but are unimpressed by pedantry. For us, wealth is an aim for its value when used, not as an empty boast. And the disgrace of poverty lies not in the admission of it, but more in the failure to avoid it in practice.' He is describing a set of attitudes: how Athenians think about money, success, failure and beauty. To be like this is to be Athenian. What is refreshing is that we are reminded that Athens, which we may know well through its buildings, was also a set of characteristics. Pericles was searching for admirable traits in the best people of his city. He was also putting his finger on a crucial problem of politics. Great monuments and the chief buildings of a capital city may loyally express ideals, but ideals die if they are confined to occasional grand architectural statements. They need to be identified and mirrored back in the ordinary activities of the community.

The great problem with monuments and cities is that they are small instances of goodness that one wants to be more widely spread. The War Memorial in Canberra highlights ideas of loyalty, sacrifice and solemnity, but these fine qualities shouldn't be locked away in a memorial. They belong in the everyday life of a society; they shouldn't only come into focus when schoolchildren make a once-in-a-lifetime visit to a shrine. Likewise, the spirit of reasonableness and calm so finely conveyed by the National Congress building in Brasilia needs to permeate the marital bedrooms, family kitchens, classrooms and boardrooms of the whole of Brazil.

This is a reminder that the term 'politics' has two rather different meanings. On the one hand, politics is legislation, government, policy

England might be in here. — 129. English Creamware
Tureen and Cover, *c.*1790–1805

papers, elections and political parties – politics as we see it in the news. On the other hand, politics is the collective life that exists every day in the *polis*, or city. A clue as to how this aspect of politics might be improved through art is provided by the art critic Nikolaus Pevsner. In 1955, Pevsner delivered the BBC's Reith Lectures, later published under the title *The Englishness of English Art.* Pevsner set himself the challenge of discovering where one could locate England's national identity in the art of its past. What was revolutionary was *where* he found it. Unlike other historians, he didn't locate it in the monuments, the big governmental buildings or the war memorials of previous centuries. He found the Englishness of English art – and identity – in the nation's soup tureens, chairs, bookshelves and doorhandles.

If any of Jane Austen's most likeable characters, such as Admiral Croft or Elizabeth Bennet, had bought a bowl for serving soup, one imagines they might have gone for a plain creamware example, typical of its age and country (129). It is like them: direct, graceful, unfussy, but noble, in an undramatic way. There is dignity in the tureen,

Politics

ABOVE LEFT
A portrait of Britain.
— 130. Margaret Calvert
and Jock Kinneir, Children
Crossing Sign, 1965

ABOVE RIGHT
— 131. Mary Quant,
Mini Dress in Wool Jersey,
*c.*1960s

BELOW LEFT
— 132. Robin Day,
Polypropylene Chair
for Hille, 1963

BELOW RIGHT
— 133. David Mellor,
Cutlery, *c.*1960s

certainly, but it does not force itself upon you; rather, it expects that you will be kind enough to pay attention and notice its charms. For an obviously upmarket item, it is beautifully well-mannered. Thus it exhibits qualities that have been the ideal of secure, middle-class English prosperity for several centuries: do not stress your merits, but be quietly confident that others will appreciate you. This is the articulation of an attitude one might feel proud of, but it hasn't required a monument to convey it.

Such objects may seem incidental when we first encounter them. Pevsner's point, though, is that bowls and plates and chests of drawers are where national identity is principally forged, and – for better or worse – revealed. This should tell political leaders something vital about what needs to be addressed in order to create a sense of identity that a nation can be proud of. Governments shouldn't just be concerned with war memorials or iconic public buildings: they should get more interested in street furniture, park benches and the modern equivalents of soup tureens. To update Pevsner's project, a modern British identity to be proud of can be found in the road signage of the graphic artists Margaret Calvert and Jock Kinneir (130), in Alec Issigonis's Mini, Mary Quant's mini dresses (131), David Mellor's cutlery (133) and Robin Day's stackable plastic chairs (132).

In other words, a country achieves dignity and identity through small details, and getting these right should be recognized as part of a political programme in the same way as legislation and economic policy. The Mini suggests a crowded island, a dislike of showing off, a preference for practical solutions rather than grand statements, small families, independence, respectability and conformity; lots of people could have them. Plastic chairs speak of a commitment to resilience, simplicity, lack of snobbery and a spirit of making do. If a David Mellor cutlery set were magically brought to life as a person, we would recognize it as an exemplary citizen of the country that made it – and might want to befriend it, too.

The underlying idea in Carlo Crivelli's *Annunciation with Saint Emidius* is well known in the context of religious art: the concept of incarnation (134). Although the term sounds arcane and scholarly, it points us to something important and recognizable, the process

How an idea takes on
a physical form.
— 134. Carlo Crivelli,
The Annunciation, with Saint
Emidius, 1486

through which something intangible – spiritual, if you will – becomes physical, and hence more present and real to us. This is dramatized by the golden shaft of light from heaven entering the body of Mary; in Christian theology, this is the moment when God becomes man, takes on human characteristics and walks among us.

The very same process can be seen at work in a secular context: the 'idea' of Britain can be fleshed out and made tangible in a road sign, a dress, a chair or a car. This is why we can also read the object in the reverse direction, going from the sign, dress, chair or car to the idea of the nation that it represents. This is one of the most ambitious concepts of art. Art is the skill of incarnating an abstract idea in a material object, of finding a way to make an idea palpable and direct. Just as in religion, where the point of Jesus was that a distant and vague concept of God could be brought into contact with ordinary life, so secular art can take the distant and vague idea of being proud of one's country and turn it into a reality observable as one scoops some strawberries into a bowl or dresses for a party.

Repetition is key here: only if we keep seeing the spirit of something again and again does it have chance to achieve a hold on us. We need to be in touch with it when we go to kindergarten and when we come home in the evening, when the street lamps come on and when we prepare the supper. A visit to a museum once or twice a year won't be enough to fulfil the underlying promises of art.

A Defence of Censorship

Censorship does not meet with much enthusiasm these days. We tend to think of it as a small-minded, defensive interference with a cherished freedom to express ourselves. We associate it with book burning, political repression and ignorant intolerance. The heroic events that pulled down censorship bear this out. For instance, the suppression of Diderot's *Encyclopédie* in 1752 – after the publication of the first of what eventually became twenty-seven volumes – was clearly a narrow-minded attack by vested interests on the most sophisticated intellectual project of an era. The publication of D. H. Lawrence's *Lady Chatterley's Lover* was delayed in England until 1960, having been

privately printed in Italy in 1928. When the publishers, Penguin, were tried under the Obscene Publications Act, the prosecution appeared dowdy and dim, while the defence was passionate and intelligent. In the heroic instances of the history of censorship, it is always something of real value, profound, earnest and true, that is condemned because it is unpalatable or unfavourable to corrupt authority.

However, it is time to recognize that, in most countries, this phase has definitely passed. We should revisit the idea of censorship, and potentially consider it not as an unenlightened suppression of crucial ideas, but as a sincere attempt to organize the world for our benefit. The threat now is not that wonderful truths will be repressed by malign authorities, but rather that we will drown in chaos, overwhelmed by irrelevant and unhelpful trivia, unable to concentrate on what is genuinely important.

The key argument of those who attack censorship today is to claim that we need to hear all the messages. But we don't. We don't, for example, need to hear a message about what kind of perfume it would be nice to buy when taking in a great piece of urban architecture (135). There's nothing wrong with the advert itself – the problem is the location. It is depressing to the human spirit because it enacts on a large scale, in a conspicuous and prestigious place, a weakness that we know we need to overcome in ourselves: our tendency to distraction and inner chaos. I am looking at the facade of an interesting, and rather lovely, building. Then, suddenly, I am being prompted to consider a new toiletry item. The advertisement unintentionally supports our lack of focus and attention. Things that draw us away from our best potential should not be paraded in front of us, asking for admiration. In this case, censorship would be entirely justified. It would be about taking care that the public environment should reflect, and thus comfort and support, our better natures. Censoring an incongruous billboard on the side of a much-loved building, in a city where people visit explicitly to appreciate the architecture, is hardly controversial, but such an example reveals underlying principles that can be put to further use.

The most beautiful cities in the world are almost never produced by accident. They get to be the way they are because of rules about

A temporary monument to insensitivity.

— 135. Perfume Advertisement, Musée d'Orsay, Paris, 2011

what you are not allowed to do, as well as what you should. The New Town of Edinburgh was built from the late eighteenth to the early nineteenth centuries by the efforts of many private speculative builders who bought plots of land and constructed houses on them (136). A magnificent and harmonious result was only achieved, however, because of a masterplan indicating the line of the streets and squares and the positioning of major public buildings. There were elaborate regulations about what could be built. The houses were to be put up in a continuous line, no signposts were to project from the walls, there were rules about the height of buildings in different streets, the

The triumph and benefits — 136. Edinburgh New
of censorship. Town, *c.*1765–1850

number of storeys they could have and the kind of stone they had to
be faced with. In an Act passed in 1782, the magistrates paid special
attention to roofs:

> The casing of the roofs shall run along the side walls immediately
> above the windows of the upper storey, and no storm or other
> windows to be allowed in front of the roof, except skylights and that
> the pitch of the roof shall not be more than one third of the breadth
> or span over the walls.

Finally, the plans and elevations had to be approved by a committee
of the Town Council, who were to be guided by the Lord Provost's
demand for frontages 'not much ornamented, but with elegant

simplicity', and specifically holding up the work of Robert Adam as an example of what they were looking for. The willingness to be explicit and restrictive – that is, censorious – resulted in a magnificent achievement. The rules must have been irksome to some people, but we see their point when we compare the beauties of Edinburgh with cities that have taken a more relaxed approach to collective art.

We typically think that if there is a case for censorship, it should be made against extremism. If we are to ban anything, it should be images of horror and exploitation. However, the rationale for censorship is better seen in terms of the desired atmosphere of the general environment. Advocates of a so-called 'free market' complain that to restrict certain activities is to deny us freedom, but there's a distinction to be made between the freedom to allow anything to take place, from the ruin of nature to random violence, and the freedom to foster what is good. The latter may, paradoxically, require censorship. Freedom is not, despite what we are often told, a cardinal virtue across all areas of life.

The underlying issue is that we are deeply sensitive to visual stimuli. The modern world is conflicted about how much what lies in front of our eyes matters. On the one hand, it is suggested that art is an extremely important medium and that a painting no larger than a few centimetres in diameter may have a power to alter our lives. On the other hand, we are quite happy to abandon large tracts of the Earth to the haste and greed of developers and assume that we will not significantly be affected by their work. Our willingness to understand harm too often stretches only to the non-visual senses. We admit the harm of air pollution, even of some kinds of noise, yet we are not at a stage when 'ugliness' is seen as an ill like any other. A politician who ran on a platform of wanting to make his or her country more beautiful would immediately be laughed off the stage. We fall back on falsely robust notions that such a priority would be fey or elitist, or accept the pernicious suggestions from developers that attractive environments cost too much. They don't, necessarily; they just require talent, a little thought, and some rules.

We should accept that the visual sensitivity we're happy to recognize and honour in our responses at the museum continue when we walk out the door. We are the same people when we have to

confront an ugly assortment of buildings or negotiate a smashed-up underground station as we were when we were contemplating Giovanni Bellini's *Madonna of the Meadow*. If we allow that art has the power to alter us for the better, we must also be aware that the opposite of art, by which we mean the opposite of the values that are embedded within good works of art, can also harm us. We cannot claim both that art will elevate us and that ugliness will leave us unaffected. The rightful celebration of freedom as an organizing principle in democracy has blinded us to an awkward truth: that freedom should, in some contexts, be limited for the sake of our wellbeing.

Television broadcasts have long been censored on grounds of violence and sexuality, and there is widespread agreement that this is an acceptable, and even welcome, restriction on liberty. We know perfectly well that extreme images are readily available elsewhere, but there is an important distinction in our minds between what people do in private and what is acceptable in public. The insight that leads us to censor images because they are too graphic or gory actually applies more broadly than the two usual categories. The problem is not primarily to do with sex or violence in themselves; our concern is really that some scenes are humiliating to our collective dignity. They give us a shameful view of human nature. Censorship is not about making it impossible to view such material; what it does is insist on the private and personal character of the interest, and refuse public endorsement. The most sinister programmes are those that are confident about their own merits, when they are in fact spectacularly unworthy of regard. They arm idiocy with wealth, pride and fame.

It is a longstanding problem of the human condition that we find it hard to form an accurate and bearable view of ourselves. We are beset by narcissism and self-loathing. Ameliorating this psychological frailty is one of our most important undertakings, and one in which we need the help of our contemporaries and our culture. Some television shows work against the purpose of art; they constitute an obstacle to self-knowledge by encouraging us to give special weight to, and construct our identity around, marginal, unhelpful or dangerous parts of ourselves.

We are now faced with the task not of liberation, but of organization.

We have freedom of expression; the problem now is how to use that to our advantage. The strange and disconcerting fact is that benefiting from freedom is not at all the same as winning freedom. We arrived at freedom by casting off censorship, but to benefit from it we need to get more interested in good restrictions. Even if there is some admission that censorship might have merits, we have to confront two questions, which give voice to widespread worries: Who decides? And how do you know what should be censored?

The question of who decides always seems unanswerable, because if the advocate of censorship offers their own services as the arbiter of what should be allowed in the public realm, they inevitably sound unhinged and egotistical. There is a reasonable answer, though: the elected government. We should give the task to the very same people who decide tax policy, workplace safety regulations and the highway code. We already accept the positive role of government in hugely significant areas of our lives.

As for how we can know what is good or bad, too often the impulse to order and beautify the world has been undermined by the claim that 'no one knows what is beautiful'. This expediently places an impossible burden of proof on something that should not require it. If we are asked to 'prove' why the skyline of Edinburgh is 'better' than that of Frankfurt or Brisbane (137), we will not be able to deliver an answer in the scientific terms that are implicitly demanded. We can't point our (usually impatient) interlocutors to a mathematical equation, or at least not yet. Our answer will have to be a humanistic one, couched in careful but not iron-clad arguments. Much of life requires this sort of carefully worded but ultimately still tentative and not impregnable defence: why Shakespeare is better than the prose on a cereal packet, why it is good to be nice to small children, why forgiveness is better than anger, and so on. We can't prove these truths any more than we can prove the importance of beauty, but they seem widely relevant and applicable nevertheless. Postmodern relativism only makes sense if we refuse to be convinced by anything other than mathematical equations.

At the heart of the pro-censorship case is a view about our needs in the modern world. The case for unrestricted freedom of expression

Why we sometimes need
censorship.

— 137. The skyline
of Brisbane

was developed during the first three-quarters of the twentieth century. It was a necessary liberation from the tyranny of inherited assumptions about how to live, in which some very important and insightful ideas were prohibited or regarded as shocking. It looked as though increasing the freedom of what could be said or shown was in itself a vehicle of social progress. Although that goal has long since been attained, the momentum of that heroic campaign is so great that we keep on imagining our needs in terms of its narrative. We keep on supposing that if only we could go yet further in that direction we would be assured of equally great returns. However, in reality, we are like Arctic explorers who have already reached the Pole. We have already found, and benefited from, all there is to be gained in the direction of complete freedom. Now comes the greater challenge of selective, organizational censorship.

And Now... to Change the World

In the history of revolutions and coups – which tell us the most condensed and dramatic stories of political change – there are no records of militants heading first for the art galleries. If you were trying to change a country, you would go to the TV stations, not the museum. This is not an oversight, but a sober recognition of the limits of art as an agent of change. It does not mean that art is irrelevant to progress; it's simply a limitation that those who love art most should be aware of. The problem can be put like this: art is the carrier of a set of concerns, skills and experiences that we need to make powerful in the world. But art in the traditional gallery sense is a very imperfect agent for helping these values to become more significant in the world. Loving art should therefore, and rightly, be connected with the skills and projects that aren't those of the traditional art enthusiast.

Poussin was interested in marriage, and in *The Sacrament of Marriage* he shows us a very beautiful and serious conception of the institution as the spiritual union of two people, enshrined in vows made in the presence of their family and community and in full awareness of their deepest views about the meaning of life, represented in this image by their religious convictions (138). Our problem is likely to be not so much that we are unmoved by such ideals, or indifferent to the atmosphere of commitment, but rather that we are unsure of what to do next. If you admire the picture and its moral, what should you go on to do? The traditional scholarly and prestigious strategy has been explored by the History of Art Department at the University of California, Berkeley, as revealed on the news section of its website:

March 5 and 6, 2010
Featuring a much-anticipated keynote address on Friday evening by Professor T. J. Clark, the conference was so well attended that several rows of chairs had to be added to the Clark Kerr Garden Room to accommodate the crowd, which included out-of-town visitors and prospective students. Clark's lecture, 'What Bernini Saw', concerned Poussin's *Sacrament of Marriage* (1648) and addressed Bernini's special admiration for the woman at the far left of the painting. Clark discussed symmetry and asymmetry in the Sacrament, and the

Advice to the married. — 138. Nicolas Poussin,
The Sacrament of Marriage,
1647

tension between the central (sacramental) action and the incomplete
but transfixing figure at the picture edge.

The scholarly vision of honouring a work of art typically involves
going into immense detail about the influence of the painting on other
artists. In this case, great care has been taken by a professor to map
an unexpected influence: the sculptor and architect Bernini was more
indebted to Poussin's work than was ever previously supposed.

However, our real problem with Poussin's picture is not that we are
puzzled by it, but that we are unsure of how to foster the ideal to which
it points us; that we don't know how to get better at having permanent
relationships. People powerfully impressed by art traditionally become
its scholars. But it is the marriage counsellor who puts into action the
values that Poussin merely painted, however tenderly and nobly. The
impulse behind his work, surely, was to help strengthen relationships,
and he did this by getting us to contemplate the moment when a
couple make formal vows to one another. This is only the start, not the
conclusion of the project, however. Despite the conventional decor

of his or her office, a marriage counsellor may well be more loyal to Poussin's values than the students in the art history class. A confusion about the value of art will lead some sophisticated people to shudder at the comparison. The irony, to put the point gently, is that disdain for the comparison does not arise because they love Poussin so much, but because they trivialize the work and aspirations of the artist they only think they admire.

The ultimate ambition of our engagement with art is that we should find ways to enact the values of art in the world. This might not involve 'making art' in the traditional sense of the term. Consider one of the most celebrated portrayals of city architecture. *The Ideal City*, traditionally ascribed to Piero della Francesca, imagines a perfect urban space: a sequence of noble but fairly restrained buildings, which probably have administrative and commercial roles as well as providing domestic accommodation (139). They are grouped around a circular, temple-like structure, which is a focus for civic life. There is a great sense of harmony and dignity here, but there is variation in the details of individual buildings. Some have open arcades, others have widely protruding eaves; some have balconies, and the delicate colouring of the materials moderates the rigour of the composition. It does not fear formality, but knows how to make it humane and charming.

If we are impressed by this work of art, what should we do? Perhaps we should get worried about who actually painted it? Is this really by Piero? Such concerns have been taken seriously. Following extensive X-ray investigations, it turns out that the picture is probably not by Piero at all, but by the architect and theorist Leon Battista Alberti. This kind of investigation has cachet. However, there is another reaction, which is perhaps more important but less explored: to want to know how the fine urban qualities that the artist, whoever he was, cared about could be made more widespread in the minds of property developers and legislative bodies. To pursue this aim, we do not need to take the picture to the X-ray laboratory. We need, metaphorically speaking, to take it to establishments such as Eland House in Bressenden Place, London, the home of the UK government's Department for Communities and Local Government, where key decisions are made about the country's housing policy and the design of its cities (140).

A blueprint, not a work of art.

— 139. Attr. Leon Battista Alberti, *The Ideal City, c.*1475

A true act of reverence for art isn't necessarily to study it without end; it is to bring the goodness powerfully displayed in a work into active circulation. Fascination with art has often led people to become artists or academic researchers, when instead they might more fairly go into business, recruitment and career advisory services, government, dating agencies, advertising or couples' psychotherapy. These are not careers in which you must climb down from the higher ideal of understanding art. They are, in fact, the places where the values that have traditionally been explored and developed in art can, in theory, be taken seriously and made real. Good relationships, elegant cities, work that is honourable and emotionally satisfying, as well as financially rewarding, are the true works of art, to which the objects we call art are only pointers and partial guides.

Art is a picture of a destination – it indicates where we should go. However, it may give few clues about how to get there. We too often treat it as a magical object, which will in itself cure alienation, disease, confusion and hardness of heart. It is moving, for example,

to encounter a copy of Henry Moore's evocation of an ordinary, close, cooperative family in the Botanical Garden in Brooklyn, because we know how often families are not like that, and that the garden has witnessed plenty of bitter frustration, heartbreaking conflict, sullen cruelty and mutual incomprehension (141). Moore was astonishingly adept at shaping bronze, but the specialist programmes in adolescent education held nearby at City University, New York, are more precisely devoted to making real the hopes that the artist alludes to.

Proper appreciation of the benefits of art must involve an awareness of when to put art aside. At a certain point, we should leave the museum, or the sculpture in the park, to pursue the true purpose of art, the reform of life; not because we are ungrateful or unappreciative, but because we have found much that is genuinely precious in art, and that we need to make more real. Over the course of this book we have been looking at the benefits of art: how it can enhance our capacities in relationships, improve our ideas about money, help us cope with our natural selves and shape our ambitions in politics.

Where beauty and ugliness
are decided upon.

— 140. The Department
for Communities and
Local Government, 1998

This already represents a marked departure from the way most of the
art establishment has hitherto invited us to consider art. We should
go further. The true purpose of art is to create a world where art is less
necessary, and less exceptional; a world where the values currently
found, celebrated and fetishized in concentrated doses in the cloistered
halls of museums are scattered more promiscuously across the Earth.
It should not be incongruous to say both that we can be lovers of art and
that we may hope that society will one day make less of a fuss about art.

The true aspiration of art should be to reduce the need for it. It is not
that we should one day lose our devotion to the things that art addresses:
beauty, depth of meaning, good relationships, the appreciation of
nature, recognition of the shortness of life, empathy, compassion, and so
on. Rather, having imbibed the ideals that art displays, we should fight
to attain in reality the things art merely symbolizes, however graciously
and intently. The ultimate goal of the art lover should be to build a world
where works of art have become a little less necessary.

How do we get
to be a bit more like this?
— 141. Henry Moore,
Family Group, 1948–9
(cast 1950)

Politics

Appendix: An Agenda for Art

A HYPOTHETICAL COMMISSIONING STRATEGY

For most of human history, artists were expected to make works of art, but not to decide what those works would be about. In the West, the agenda of art was to glorify the Christian message. All artists were given the same pre-prepared themes and invited to do their best. There was still room for individual greatness, but it was held in check (or sometimes even enhanced) by a set of shared parameters.

By contrast, our age believes in originality – a sometimes dangerous presumption, for it can lead to novelty being mistaken for artistic greatness. Many excellent artists are better at making art than settling on its purpose. In this book, we argue that we should reclaim the idea of defining an artistic agenda. Rather than any supernatural purpose, this would focus on strictly human ends. Artists would be invited to follow an unapologetically didactic mission: to assist mankind in its search for self-understanding, empathy, consolation, hope, self-acceptance and fulfilment. No longer would the questions 'What is art about?' or 'What is art for?' be opaque. There would still, of course, be greater and lesser artists, but what they were up to would be obvious – and their benefit to society would be easier to grasp and to defend.

I. THE VIRTUES OF LOVE

CONTENT: Works would illustrate the qualities required for the adequate functioning of a relationship with another human, including (but not restricted to) forgiveness, patience, sacrifice, kindness and imagination.
PURPOSE: A corrective to the belief in the spontaneous nature of love. A demonstration of what 'working at' relationships might practically involve. A focus on ideals that could guide everyday conduct.

2. THE CONFLICTS OF LOVE

CONTENT: Works would depict the central causes of disputes within relationships, reconciling viewers to everyday complexity and behaviour, encouraging self-acceptance and increased empathy. Sub-themes might include 'The Stages of the Affair', 'The Phases of the Argument' and 'The Sorrows of Divorce'.
PURPOSE: A reminder of everyday, universal relationship struggles, rather than the cata-strophic events (such as divorce or murder) that the media tends to focus on, and to reduce the punishing sense of loneliness and guilt. These works would make us feel less absurd for struggling as we do to keep our relationships going.

3. SEXUALITY

CONTENT: Images of sexuality would be related to depictions of other aspects of our humanity, amounting to a demonstration of the possibility of being both fully human and adequately sexual.

PURPOSE: An alternative to pornography on the one hand, and lingering neo-Christian shame on the other. A prompt towards a more appropriate integration of sex and intelligence, dignity and care.

4. SADNESS, ANXIETY

CONTENT: Works would lend perspective to the individual ego pressed up too hard and painfully against its own problems. Works would play with scale, restoring a redemptive sense of one's position in the universe, and promoting a calming sense of awe by focusing on nature, emphasizing its separateness and indifference to our desires and concerns.

PURPOSE: A corrective to a loss of perspective; a catalyst for calm and stoicism.

5. RESTLESSNESS, ENVY

CONTENT: Works would argue for the neglected beauty and fascination of the everyday.

PURPOSE: A rebuttal of the misguided preoccupation with glamour promoted by the media in our commercial societies; an effort to glamourize the maligned ordinary instead.

6. HOPE

CONTENT: Works would refocus attention on a set of fragile qualities associated with hope: imagination, creativity, calculated naivety, faith and playfulness.

PURPOSE: To exert a pull away from routine, inner deadness, sterility and knowing cynicism.

7. THE AGES OF MAN

CONTENT: Following people through their lives, these works would depict us as time-bound creatures, with all the implications therein. Series of works would illuminate distinctive features of different periods of life: for example, 'The Twelve Sorrows of Adolescence', 'The Longings of the Middle Period', 'The Griefs of Age', and so on.

PURPOSE: To help us overcome the extraordinary difficulties we have in imagining ourselves in any other period of life than the one we happen to be in. They would promote a sense of life as a whole, nevertheless made up of distinct phases.

8. MEMENTO MORI

CONTENT: These works would be reminders, more or less macabre or direct, of the end.

PURPOSE: Not to render life meaningless, but rather to encourage us to keep in mind our priorities, so easily submerged within our day-to-day concerns.

9. THE PLEASURES OF WORK

CONTENT: Works would afford the viewer a sense of the creativity, cooperation, ingenuity and beauty of work.

PURPOSE: A corrective to the ignorance of the processes of work outside our own given professional spheres and a demonstration of the benefits that can be found there.

10. THE SORROWS OF WORK

CONTENT: Works would highlight the dehumanizing effects of labour; the disappearance of human suffering behind numbers; the plunder of the Earth for the sake of mediocre ends; the destruction of stillness and calm; and the prevalence of hypocrisy and cruelty.

PURPOSE: To evoke a sense of the costs that commercial organizations can impose upon humanity. A corrective to numerical abstraction.

11. THE OTHER

CONTENT: Works would depict ways of life that are likely, initially, to threaten or question the viewer's sense of what is normal.

PURPOSE: To re-humanize us in each other's eyes. To provide a backdrop against which political negotiation between apparently opposed factions can occur.

12. PRIDE

CONTENT: Works would zero in on aspects of the community and nation in which legitimate pride can be placed. They would demonstrate a selective idealization of national life, and a responsiveness to objects and scenes in which national traits can be found and celebrated – a road sign, the evening light.

PURPOSE: To correct the tendency towards national depression; to encourage an intelligent kind of collective pride.

List of Works

1. Jean-Baptiste Regnault (1754–1829), *The Origin of Painting: Dibutades Tracing the Portrait of a Shepherd*, 1786. Oil on canvas, 120 × 140 cm (47¼ × 55⅛ inches). Musée National des Châteaux de Versailles et de Trianon, Versailles.

2. Johannes Vermeer (1632–75), *Woman in Blue Reading a Letter*, c.1663. Oil on canvas, 46.5 × 39 cm (18³⁄₁₆ × 15⅜ inches). Rijksmuseum, Amsterdam.

3. John Constable (1776–1837), *Study of Cirrus Clouds*, c.1822. Oil on paper, 11.4 × 17.8 cm (4½ × 7 inches). Victoria & Albert Museum, London.

4. Claude Monet (1840–1926) *The Water-Lily Pond*, 1899. Oil on canvas, 88.3 × 93.1 cm (34¾ × 36⅔ inches). National Gallery, London.

5. John Vanbrugh (1664–1726) Blenheim Palace, c.1724 Woodstock, England.

6. Henri Matisse (1869–1954), *Dance (II)*, 1909. Oil on canvas, 259.7 × 390.1 cm (102¼ × 153⁹⁄₁₆ inches). Hermitage Museum, St Petersburg.

7. 'Sainte-Chapelle Virgin and Child', before 1279. Ivory, 41 cm height (16¼ inches). Musée du Louvre, Paris.

8. Henri Fantin-Latour (1836–1904), *Chrysanthemums*, 1871. Oil on canvas, 35 × 27 cm (13¾ × 10⅝ inches), Private collection.

9. Henri Fantin-Latour (1836–1904), *Self Portrait as a Young Man*, c.1860s Oil on canvas, 25 × 21 cm (9¾ × 8¼ inches). Private collection.

10. Thomas Hamilton (1784–1858), The Royal College of Physicians, Edinburgh, 1845.

11. Antoine Watteau (1684–1721), *Rendez-vous de chasse* (Meeting on the Hunt), c.1717–18. Oil on canvas, 124.5 × 189 cm (49 × 74½ inches). Wallace Collection, London.

12. George Grosz, 1893–1959, *The Pillars of Society*, 1926. Oil on canvas, 200 × 108 cm (78¾ × 42⅛ inches). Neue Nationalgalerie, Staatliche Museen, Berlin.

13. Angelica Kauffmann (1741–1807), *The Artist in the Character of Design Listening to the Inspiration of Poetry*, 1782. Oil on canvas, 61 cm (24 inches) diameter. Kenwood House, London.

14. Richard Serra (1939–), *Fernando Pessoa*, 2007–8. Weatherproof steel, 300 × 900.4 × 20.3 cm (118⅛ × 354½ × 8 inches). Gagosian Gallery, London.

15. Nan Goldin (1953–), *Siobhan in My Mirror, Berlin*, 1992. Silver dye bleach print, 39.4 × 59 cm (15½ × 23¼ inches). Matthew Marks Gallery, New York.

16. Caspar David Friedrich (1774–1840), *Rocky Reef on the Sea Shore*, c.1825 Oil on canvas, 22 × 31 cm (8¾ × 12¼ inches). Staatliche Kunsthalle, Karlsruhe.

17. Ludwig Mies van der Rohe (1886–1969), Farnsworth House, Plano, Illinois, 1951.

18. Catedral de Santa Prisca y San Sebastián, Taxco, Mexico, 1751–8.

19. Richard Mique (1728–94) and Hubert Robert (1733–1808), The Queen's Hamlet, Petit Trianon, Versailles, France, 1785.

20. Thomas Jones (1742–1803), *A Wall in Naples*, c.1782. Oil on paper laid on canvas, 11.4 × 16 cm (4½ × 6¼ inches). National Gallery, London.

21. Cloister, c.1175, L'abbaye du Thoronet, late twelfth and early thirteenth century, near Draguignan, Provence.

22. Robert Braithwaite Martineau (1826–69), *The Last Day in the Old Home*, 1862. Oil on canvas, 107.3 × 144.8 cm (42¼ × 57 inches). Tate, London.

23. Fra Angelico (active 1417–55), 'The Pains of Hell' from *The Last Judgement*, c.1431. Tempera and gold on panel, 108 × 212 cm (42½ × 83½ inches). Museo di San Marco, Florence.

24. Eve Arnold (1912–2012), *Divorce in Moscow*, 1966. Gelatin silver print, 40.6 × 50.8 cm (16 × 20 inches).

25. Choson dynasty, Korean 'Moon Jar', 17th–18th century. White porcelain, 34.8 cm (13¾ inches), Private collection.

26. Joseph Cornell (1903–72), *Untitled (Medici Princess)*, 1948. Wood box construction, glass, wood and paper collage, 49 × 30.5 × 9.8 cm (15¾ × 12 × 3⅞ inches). Private collection.

27. Cy Twombly (1928–2011), *Panorama*, 1957. House paint and crayon on canvas, 256.5 × 591.8 cm (101 × 233 inches). Private collection.

28. Christen Købke (1810–48), *View of Østerbro from Dosseringen*, 1838. Oil on canvas, 39.5 × 50.5 cm (15¼ × 20 inches), Museum Oskar Reinhart am Stadtgarten, Winterthur, Switzerland.

29. Richard Riemerschmid (1868–1957), 'Blaue Rispe' Plate, 1903–5 Meissen

Porcelain Manufacture, Germany.

30. Sebastiano Ricci (1659–1734), *The Vision of Saint Bruno*, 1700. Oil on canvas, 91.4 × 121.9 cm (36 × 48 inches), Private collection.

31. Chokwe People, East Angola, Mwana Pwo Mask, 19th century Wood, 19.1 × 8 × 14 cm (7½ × 3⅛ × 5½ inches). Brooklyn Museum, New York.

32. John Singer Sargent (1856–1925), *Portrait of Lord Ribblesdale*, 1902 Oil on canvas, 258.4 × 143.5 cm (101¾ × 56½ inches). National Gallery, London.

33. Diego Rodríguez de Silva y Velázquez (1599–1660), *Las Meninas* or *The Family of Felipe IV*, c.1656. Oil on canvas, 318 × 276 cm (125¼ × 108¾ inches). Museo del Prado, Madrid

34. Pablo Picasso (1881–1973), *Las Meninas*, 1957. Oil on canvas, 129 × 161 cm (50¾ × 63½ inches). Museu Picasso, Barcelona .

35. Jasper Johns (1930–), *Painted Bronze*, 1960. Oil on bronze, 14 × 20.3 × 12 cm (5½ × 8 × 4¾ inches). Museum Ludwig, Ludwig Donation, Cologne.

36. Ben Nicholson (1894–1982), 1943 *(painting)*, 1943. Gouache and pencil on board mounted on painted wood frame, 24.6 × 25.3 cm (9¾ × 10 inches). Museum of Modern Art, New York.

37. Jean-Baptiste-Siméon Chardin (1699–1779), *A Lady Taking Tea*, 1735 Oil on canvas, 81 × 99 cm (31 × 39 inches). Hunterian Museum and Art Gallery, University of Glasgow.

38. Caravaggio (1571–1610), *Judith Beheading Holofernes*, c.1599. Oil on canvas, 145 × 195 cm (57 × 77 inches). Palazzo Barberini, Galleria Nazionale d'Arte Antica, Rome.

39. Paul Cézanne (1839–1906), *Mont Sainte-Victoire*, 1902–4. Oil on canvas, 73 × 91.9 cm (28¾ × 36³⁄₁₆ inches). Philadelphia Museum of Art, Pennsylvania.

40. Thomas Gainsborough (1727–88), *Mr and Mrs Andrews*, c.1750. Oil on canvas, 69.8 × 119.4 cm (27½ × 47 inches). National Gallery, London.

41. Vittore Carpaccio (1460–1520), *The Healing of a Man Possessed by a Demon (The Miracle of the Reliquary of the Holy Cross)*, c.1496 Tempera on canvas, 365 × 389 cm (143¾ × 153⅛ inches) Gallerie dell'Accademia, Venice.

42. Chris Ofili (1968–), *Holy Virgin Mary*, 1996. Acrylic, oil, polyester resin, paper collage, glitter, map pins and elephant dung on linen, 243.8 × 182.8 cm (96 × 72 inches). Museum of Old and New Art, Hobart, Tasmania.

43. Jan van Eyck (1395–1441) and Hubert van Eyck (1385–1426), *Ghent Altarpiece or The Adoration of the Mystic Lamb*, 1423–32. Tempera and oil on panel, panels open 350.5 × 457.2 cm (138 × 180 inches). Cathedral of St Bavo, Ghent, Belgium.

44. Paul Gauguin (1848–1903), *Christ in the Garden of Olives*, 1889. Oil on canvas, 72.4 × 91.4 cm (28½ × 36 inches). Norton Museum of Art, West Palm Beach, Florida.

45. Jessica Todd Harper, *The Agony in the Kitchen*, 2012. Photographic print. Private collection.

46. Banksy, *I Can't Believe You Morons Actually Buy this Shit*, 2006. Screenprint. Private collection.

47. Michelangelo (1475–1564), *The Creation of Adam* (Sistine Chapel ceiling), c.1511. Fresco, 480.1 × 230.1 cm (189 × 90½ inches). Sistine Chapel, Vatican Museum.

48. Juan de Flandes (c.1460–1519), *Christ Appearing to His Mother*, 1496. Oil on wood, 62.2 × 37.1 cm (24½ × 14⅝ inches). Metropolitan Museum of Art, New York.

50. Basilica di Santa Maria Gloriosa dei Frari, 1250–1338, Venice.

51. Louis I. Kahn (1901–74) Kimbell Art Museum, 1966–72. Fort Worth, Texas.

52. Donatello (c.1386–1466), *Virgin and Child (The Borromeo Madonna)*, c.1450. Terracotta, 83.5 × 52.1 cm (32⅞ × 20½ inches). Kimbell Art Museum, Fort Worth, Texas.

53. Henry Raeburn (1756–1823), *The Allen Brothers*, early 1790s. Oil on canvas, 152.4 × 115.6 cm (60 × 45½ inches). Kimbell Art Museum, Fort Worth, Texas.

54. Gerrit Rietveld (1888–1964), *Red Blue Chair*, c.1923. Painted wood, 86.7 × 66 × 83.8 cm (34⅛ × 26 × 33 inches), seat height 33 cm (13 inches). Rietveld Schröderhuis, Centraal Museum, Utrecht.

55. Gerrit Rietveld (1888–1964), *Bolderwagon*, 1918 (designed), 1968 (made). Wood. Rietveld Schröderhuis, Centraal Museum, Utrecht.

56. James Abbott McNeill Whistler (1834–1903), *Nocturne: The River at Battersea*, 1878 (designed), 1887 (printed). Lithograph, 17.2 × 26 cm (6¾ × 10¼), Metropolitan Museum of Art, New York.

57. Salomon van Ruysdael (c.1600–70), *River View*, 1642. Oil on oak panel, 51.75 × 80.64 cm (20⅜ × 31¼ inches). Albright Knox Gallery, Buffalo, New York.

58. Richard Long (1945–), *Tame Buzzard Line*, 2001. Flint, 35.15 m × 71 cm (115 feet 4 inches × 2 feet 4 inches). New Art Centre, Roche Court, England.

59. Niccolò Pisano (1470–1538), *An Idyll: Daphnis and Chloe*, c.1500–1. Oil on poplar panel, 85.9 × 62.2 cm (33¼ × 24½ inches). The Wallace Collection, London.

60. Pieter de Hooch (1629–84), *The Courtyard of a House in Delft*, 1658. Oil on canvas, 73.5 × 60 cm (29 × 23⅝ inches). National Gallery, London.

61. Hugo van der Goes (1440–82), 'The Adoration of the Shepherds', from the *Portinari Altarpiece*, c.1475. Oil on wood, 253 × 304 cm (100 × 120 inches). Galleria degli Uffizi, Florence.

62. Richard Long (1945–), Waterlines, 1989. Screenprint on paper, 127.7 × 92.4 cm (50¼ × 36⅜ inches).

63. Leonardo da Vinci (1452–1519), *Studies of a Foetus*, c.1510–12. Pen and ink over red chalk, 30.4 × 22 cm (12 × 8¾ inches). The Royal Collection, Windsor Castle.

64. Judith Kerr (1923–), Illustration from *The Tiger Who Came to Tea*, 1968. HarperCollins Publishers.

65. Oscar Niemeyer (1907–2012), Casa de Canoas, 1953, Rio de Janeiro, Brazil.

66. Filippo Brunelleschi (1377–1446), Loggia, Ospedale degli Innocenti, Florence, c.1430.

67. Nicolas Poussin (1594–1665), *Winter or The Deluge*, 1660–4. Oil on canvas, 118 × 160 cm (46½ × 63 inches). Musée du Louvre, Paris.

68. After Leochares, 4th century BC *Apollo Belvedere*, c. AD 120–140 (Roman copy of a lost fourth-century BC original, c.350–325 BC) 224 cm (88 inches) Vatican Museum, Vatican City.

69. Pablo Picasso (1881–1973), *Faun and Bacchante with Battle of Fauns in the Distance*, from 347 Suite, 1968. Etching, 32.7 × 25.6 cm (12⅞ × 9⅞ inches). Metropolitan Museum of Art, New York

70. Sandro Botticelli (1445–1510), *The Madonna of the Book*, 1483. Tempera on panel, 58 × 39.5 cm (22¾ × 15½ inches). Museo Poldi Pezzoli, Milan.

71. Édouard Manet (1832–83), *Bunch of Asparagus*, 1880. Oil on canvas, 46 × 55 cm (18 × 21⅝ inches). Wallraf-Richartz-Museum, Cologne.

72. Frederic Edwin Church (1826–1900), *The Iceberg*, 1891. Oil on canvas, 72 × 100 cm (28⅓ × 39¼). Carnegie Museum of Art, Pittsburgh, Pennsylvania.

73. Hamish Fulton (1946–), *Ten One Day Walks from and to Kyoto*, 1994, 1996. Screenprint, 60.4 × 99.9 cm (23¾ × 39⅜ inches). British Embassy, Tokyo.

74. Jean-Baptiste-Camille Corot (1796–1875), *A Rising Path*, 1845. Oil on canvas, 17.8 × 28.6 cm (7 × 11¼ inches). Private collection.

75. Claude Lorrain (1600–82), *Jacob with Laban and his Daughters*, 1676 Oil on canvas, 72 × 94.5 cm (28⅜ × 37⅛ inches). Dulwich Picture Gallery, London.

76. Johann Heinrich Wilhelm Tischbein (1751–1829), *Goethe at the Window of his Roman Apartment*, 1787. Watercolour, chalk, pen and pencil on paper, 41.5 × 26.6 cm (16⅜ × 10½ inches). Goethe-Museum, Frankfurt.

77. Karl Friedrich Schinkel (1781–1841), Court Gardener's House, Potsdam, Germany, 1829–33.

78. Le Corbusier (1887–1965), Solarium at Villa Savoye, Poissy, 1931.

79. Sir Lawrence Alma-Tadema (1836–1912), *A Favourite Custom*, 1909. Oil on wood, 66 × 45.1 cm (26 × 17¾ inches). Tate, London.

80. David Hockney (1937–), *Portrait of an Artist (Pool with Two Figures)*, 1972. Acrylic on canvas, 213.35 × 304.8 cm (84 × 129 inches). Private collection.

81. Jan Gossaert (1478–1532), *An Elderly Couple*, c.1520. Oil on parchment, painted surface approximately 46 × 66.9 cm (18⅜ × 26⅜ inches). National Gallery, London.

82. Ian Hamilton Finlay (1925–2006), *Little Sparta*, Dunsyre, Scotland, 1966–2006.

83. Ian Hamilton Finlay (1925–2006), *Et In Arcadia Ego*, 1976. Stone, 28.1 × 28 × 7.6 cm (11 × 11 × 3 inches). National Gallery of Scotland, Edinburgh.

84. Jacques-Louis David (1748–1825), *Belisarius Begging for Alms*, 1781. Oil on canvas, 288 cm × 312 cm (113 × 123 inches). Palais des Beaux-Arts, Lille.

85. Ansel Adams (1902–84), *Aspens, Dawn, Autumn, Dolores River Canyon, Colorado*, 1937. Gelatin silver print, 23.6 × 34.5 cm (9⅜ × 13⁹⁄₁₆ inches). Art Institute of Chicago, Illinois.

86. Hiroshi Sugimoto (1948–), *North Atlantic Ocean, Cliffs of Moher*, 1989. Gelatin silver print, 42.3 × 54.2 cm (16⅝ × 21¾₆ inches) Metropolitan Museum of Art, New York.

87. NASA, ESA and the Hubble Heritage Team, *Globular Cluster NGC 1846*, 2006. Taken by the Advanced Camera for Surveys, Hubble Space Telescope.

88. Bernd Becher (1931–2007) and Hilla Becher (1934–2015), *Water Towers*, 1980. Nine gelatin silver prints, approximately 156 × 125 cm (61¼ × 49¼ inches). Sonnabend Gallery, New York.

89. Andreas Gursky (1955–), *Salerno*, 1990. Chromogenic colour print, 129.5 × 165.5 cm (51 × 65¼ inches).

90. Albrecht Dürer (1471–1528), *The Large Piece of Turf*, 1503. Watercolour and gouache on paper, 41 × 32 cm (16⅛ × 12⅛ inches). Grafische Sammlung Albertina, Vienna.

91. James Turrell (1943–), *Roden Crater*, 1979–. Earthwork. Flagstaff, Arizona.

92. Antony Gormley, (1950–) and David Chipperfield (1953–), Observation Tower, Kivik Art Centre, Sweden, 2008.

95. Michelangelo (1475–1564), *Night and Day*, c.1534. Marble, 630 × 420 cm (248 × 165⅜ inches). Medici Chapel, Basilica di San Lorenzo, Florence.

98. Barbara Hepworth (1903–75), *Pelagos*, 1946. Elm and strings on oak base, 43 × 46 × 38.5 cm (17 × 18⅛ × 15³⁄₁₆ inches). Tate, London.

99. Leonardo da Vinci (1452–1519), *Mona Lisa*, 1503–6. Oil on poplar wood, 77 × 53 cm (30 × 21 inches). Musée du Louvre, Paris.

101. Giuseppe Mengoni (1829–77), Galleria Vittorio Emanuele II, Milan, 1865.

102. William Morris (1834–96), Advertisement for the Sussex Range, illustrated in the Morris & Co. Catalogue, 1915.

103. Alberto Giacometti (1901–66), *The Forest (Composition with Seven Figures and a Head)*, 1950. Painted bronze, 58.4 × 60 × 48.3 cm (23 × 23⅝ × 19 inches). Museum of Modern Art, New York.

104. John Nash (1752–1835), Cumberland Terrace, Regent's Park, London, 1826.

105. Thomas Shepherd (1792–1864), *The Quadrant and Lower Regent Street*, c.1850. Coloured aquatint. Private collection.

106. Ernst Friedrich August Rietschel (1804–61), The Goethe-Schiller Monument, 1857. Bronze casting, 3.7 m (12 feet). Weimar.

107. Philip James de Loutherbourg (1740–1812), *Lake Scene, Evening*, 1792. Oil on canvas, 42.5 × 60.3 cm (19¼ × 23¾ inches). Tate, London.

108. J. M. W. Turner (1775–1851), *A Mountain Scene, Val d'Aosta*, c.1845. Oil on canvas, 91.5 × 122 cm (36 × 48 inches) National Gallery of Victoria, Melbourne.

109. Francis Bacon (1909–92), *Study for Portrait of Van Gogh V*, 1957. Oil and sand on canvas, 198.7 × 137.5 cm (78⅛ × 54⅛ inches). Hirshhorn Museum, Washington, DC.

110. Francis Bacon (1909–92), *Three Studies for Figures at the Base of a Crucifixion*, c.1944. Oil paint on three boards, each 94 × 73.7 cm (37 × 29 inches). Tate, London.

111. Le Corbusier (1887–1965), Sketch from *La Maison des Hommes*, 1942. Pen and ink on paper.

112. 'Crucifixion and Deposition' from the Passion and Resurrection Lancet Window, Stained Glass, Chartres Cathedral, c.1150.

113. Nicolas Poussin (1594–1665), *Landscape with a Man Washing his Feet at a Fountain*, c.1648. Oil on canvas, 74 × 100.3 cm (29⅛ × 39½ inches). National Gallery, London.

114. Emile Claus (1849–1924), *The Beet Harvest*, 1890. Oil on canvas, 320 × 480 cm (126 × 189 inches). Museum van Deinze en de Leiestreek, Belgium.

115. Sebastián Errázuriz (1977–), *Wall Street Nation*, New York, 2012.

116. Christen Købke (1810–48), *Outside the North Gate of the Citadel*, 1834. Oil on canvas, 79 × 93 cm (31⅛ × 36⅝ inches). Ny Carlsberg Glyptotek, Copenhagen.

119. Steven Holl (1947–), Swiss Ambassador's Residence, Washington, DC, 2006.

120. Michael Wilford (1938–), British Embassy, Berlin, 2000.

121. Kerry Hill (1943–), Amankora Hotel, Bhutan, 2007.

122. Emil Sodersten (1899–1961), and John Crust, Australian War Memorial, Canberra, Australia, 1941.

123. Glenn Murcutt (1936–), Murcutt House, Woodside, South Australia, 1995–6.

124. Oscar Niemeyer (1907–2012), Brazilian National Congress, Brasilia, Brazil, 1957–64.

125. Diego Rodríguez de Silva y Velázquez (1599–1660), *The Surrender of Breda*, 1634–5. Oil on canvas, 307 × 367 cm (121 × 144 inches). Museo del Prado, Madrid.

126. Anselm Kiefer (1945–), *Innenraum*, 1981. Oil, acrylic and paper on canvas, 287.5 × 311 cm (113³⁄₁₆ × 122⁷⁄₁₆ inches). Stedelijk Museum, Amsterdam.

127. Nicolas Poussin (1594–1665), *The Sacrament of the Holy Eucharist*, 1647. Oil on canvas, 117 × 178 cm (46 × 70 inches). National Gallery of Scotland, Edinburgh.

128. Christo (1935–) and Jeanne-Claude (1935–2009), *Wrapped Reichstag*, 1995, Berlin, Germany.

129. English Creamware, Tureen and Cover, c.1790–1805. height 24.1 cm (9½ inches), length 35.5 cm (14 inches).

130. Margaret Calvert (1936–), Children Crossing Sign, 1965

131. Mary Quant (1934–), Mini Dress in Wool Jersey, c.1960s.

132. Robin Day (1915–2000), Polypropylene Chair for Hille, 1963.

133. David Mellor (1930–2009), Cutlery, c.1960s.

134. Carlo Crivelli (c.1430–c.1494), *The Annunciation, with Saint Emidius*, 1486. Egg and oil on canvas, 207 × 146.7 cm (81½ × 57¼ inches). National Gallery, London.

138. Nicolas Poussin (1594–1665), *The Sacrament of Marriage*, 1647. Oil on canvas, 117 × 178 cm (46 × 70 inches). National Gallery of Scotland, Edinburgh.

139. Leon Battista Alberti (1404–72), *The Ideal City*, c.1475. Tempera on panel, 67.5 × 239.5 cm (26⁹⁄₁₆ × 94³⁄₁₆ inches). Galleria Nazionale delle Marche, Urbino, Italy.

141. Henry Moore (1898–1986), *Family Group*, 1948–9. (cast 1950), 150.5 × 118 × 75.9 cm (59¼ × 46½ × 29⅞ inches). Museum of Modern Art, New York.

Index

Picture credits

Phaidon Press Limited
2 Cooperage Yard
London E15 2QR

Phaidon Press Inc.
111 Broadway
New York, NY 10006

phaidon.com

First published 2013
Reprinted 2015
Published in paperback 2016
Reprinted 2017 (twice), 2018, 2019,
2020, 2021, 2022, 2023, 2024
© 2013 Phaidon Press Limited

Text © 2013 The School of Life
The moral rights of the authors
have been asserted.

ISBN 978 0 7148 7278 0

A CIP catalogue record for this book
is available from the British Library and
the Library of Congress.

Editors: Laura Gladwin & Norah Perkins
Production Controller: Leonie Kellman
Design: Hans Stofregen

Printed in China